3D Animation

3D Animation

From Models to Movies

Adam Watkins

CHARLES RIVER MEDIA, INC.
Rockland, Massachusetts

Publisher: Jenifer L. Niles
Interior Design/Comp: Publishers' Design and Production Services, Inc.
Cover Design: The Printed Image
Cover Image: Adam Watkins

CHARLES RIVER MEDIA, Inc.
P.O. Box 417, 403 VFW Drive
Rockland, MA 02370
781-871-4184
781-871-4376(FAX)
chrivmedia@aol.com
http://www.charlesriver.com

This book is printed on acid-free paper

3D Animation
Adam Watkins
ISBN 1-58450-023-9
Printed in the United States of America

00 01 02 7 6 5 4 3 2 1

CHARLES RIVER MEDIA titles are available for site license or bulk
purchase by institutions, user groups, corporations, etc. For additional
information, please contact the Special Sales Department at
781-871-4184..

To my incredibly intelligent and
boastfully beautiful wife, Kirsten.
Your patience and help makes writing (and living) worthwhile.

Contents

Preface

3D is hot. It's hard to find any form of entertainment today without some form of digital art incorporated. The number of professional 3D production and digital art teaching jobs is staggering. The technology moves so fast that without one eye fixed on the emerging trends, a 3D artist quickly finds his equipment obsolete. To top it all off, with all this technology, there are a lot of people making digital images, but not a lot making good digital art. We have all seen it. The Web is littered with images made with all sorts of 3D packages. When the images are made by those fooling with all the buttons, pull-down menus, and random features offered in a particular application, the results are, well, less than inspiring. When these images are made by those who understand 3D and its athletics, the results are fantastic.

The Purpose and Organization of This Book

Good 3D art is a curious combination of astute technical prowess and acute artistic observation and understanding. In this book, we will approach both areas in a variety of ways. First, we will take a look at the theory behind the various principles of 3D. There are many places to look to find "push this and this will happen, pull down that menu and that other thing will occur." But if you understand why something happens and what the principle behind it is, you will be better able to manipulate the tool to create what you have in mind.

Once you have a general idea of the theory of the 3D principle, we will dive right in to look at the technical concerns. What *do* you push to get the result you want? When *should* you use *which* methods to achieve the desired affect?

Finally, this book will deal with aesthetic issues of 3D and composition. We will look at ways to make sure your work is not created by a 3D tech-

nician, but by a 3D artist. To do this, we will be analyzing trends in motion picture and animation. We will look at design issues and the ideas behind effective composition. More ethereal concepts such as timing and editing will be addressed, and we will lend an ear to the nonvisual elements of good animation like music and sound effects.

Is This Book for You?

Since this book contains both theoretical and hands-on treatment of 3D issues, it is a book that beginner, intermediate, and advanced users can use. Most every area of current 3D will be touched upon. If you are just beginning your exploration of 3D, start right from the beginning and work through to the end of the book. By the end, you will have an excellent grasp of 3D concepts and techniques. If you have some modeling experience and just want to brush up on some of the ideas behind the various methods, you may want to skim Chapters 3 and 4 and jump right into the texturing sections of Chapters 5 and 6. If you are an advanced user and know your modeling and texturing, you may want to skip Chapters 3 through 6 and jump directly into the sections on lighting and composition. If you happen to be one of those folks who has a good grasp on the whole enchilada of 3D construction and animation, Chapters 5–6 and 13–16 will still be of tremendous help in putting those polishing touches on your projects.

How to Use This Book

This book's chapters are all tied together by some unifying tutorials. The purpose of these tutorials is to allow a hands-on approach to understanding the ideas presented. If you are just getting started, use these tutorials as you read along. The CD contains a demo version of Cinema 4D XL and a full version of Strata 3D that are used to create some of the tutorials, and will give you a good chance to see which packages work for you while helping you understand the theory presented.

However, each chapter can also stand on its own as a piece of reference or a sort of mini-tutorial. If you are an experienced 3D user, jump right to the chapters you are most interested in. Chapters can be referenced at a later time without having to do a lot of backtracking into previous chapters to understand the train of thought. Hopefully, this book will be one that will stay well used on your desk and referred back to as your projects merit. So, regardless of your past 3D experience, let's get started.

Acknowledgments

Thanks to Jenifer for her patience in guiding me through the process.

Thanks to my fuzzy, rowdy fish Roz for keeping me sane.

Thanks to Mrs. Eva Torres and Ms. Francis Till for their invaluable instruction those many years ago. Without their excitement for writing and knowledge, and their deft skill in passing it on, I wouldn't know or be able to write about what I know today.

Thanks to my thesis committee, Alan Hashimoto, Dennis Hassan, and Bob Winward, for their help and suggestions through the process.

Extra thanks to Alan Hashimoto for his provided opportunities and guidance.

Thanks to Maxon, Newtek, and Strata for their assistance in securing demos and other versions of the software used to prepare this book.

Thanks to the quake-posse (Amber, Kyle, Nate, Anson, Colleen, Grandpa, and Kirsten) for those late-night-sanity-saving frag-fests.

Special thanks to my folks, Kaye and Dr. Will Watkins, for all their love and support, and for always teaching me to work hard and do right.

CHAPTER 1

The 3D Workflow

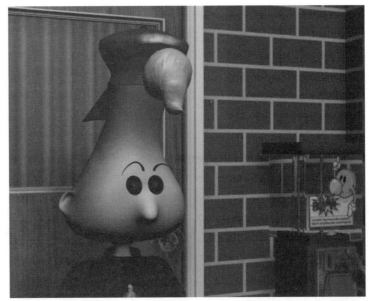

Some General Terms

Before we go any further, let's take a moment to make sure that we are speaking the same language. 3D, like any other field, is full of jargon and terms that need to be defined before we can move on to the concepts behind 3D.

Most of us have built some sort of real-time model—you know, those plastic airplanes or cars, or models of ecosystems for that junior-high science class. Either way, the point of models is not to really recreate the target object, but rather to create a representation of it. A computer *model* is the same; it is a collection of digital instructions interpreted by the computer to form the geometrical appearance of an object. The geometry of models only exists in the computer's digital space. They are a file, like a Word or Photoshop file. Models can be sent over the Internet, stored on a disk, and backed up on a CD. In reality, a model is just another collection of 1s and 0s. However, this collection of 1s and 0s is the basis for most all effective 3D. It is the building block of the rest of the 3D concepts to follow. But remember, since a model is a representation of an object, do not try to make it into the actual object. Be frugal with your modeling, and the time you spend modeling. Good projects incorporate good models, but also exploit the other aspects of 3D. Too often, people get so caught up in the modeling that they don't get around to the other important parts of the project. Remember that while models are an essential part of 3D projects, good models do not necessarily equal good 3D projects unless the other aspects of 3D are addressed as well. Plan your time carefully to include all the areas of 3D. Employers are much more impressed by a good model that is textured, lit, rendered, and animated well, than by just a good model (see Chapter 3, "Carving Out Modeling Basics").

Once models are created, *textures* are applied. Textures are like a colored shrink-wrap or veneer applied to the surface of the model. Some textures allow the model to be clear like a sort of invisibility cape, while others make a model appear bumpy, sheeny, or coarse. Some textures (displacement maps) even change the geometry of the model. Textures can be projected like a slide through a slide projector, laid over like a blanket, or shrink-wrapped around the model's geometry. Textures take the same ball of geometry and change it from one object to another. For instance, you can change a golf ball to a tennis ball then to a baseball or a basketball and finally to an earth ball or even to the actual earth. See Chapter 6, "Advanced Texturing Techniques," and Chapter 7, "3D Illumination Systems," for more on the tremendous power of texturing.

No matter how exquisite your models or textures are however, without

light the 3D project is as visually appealing as radio. And even with light, if it's not done effectively, the viewer is left with a flat and uninteresting vision. Virtual 3D light, like everything else in digital space, is virtual. It is a set of algorithms that attempt to imitate light as it occurs in the real world. And even though there have been tremendous strides in the way 3D applications handle lighting instruments (the objects that actually produce the light), and the way those light particles (or waves) behave within digital space, there is still a tremendous amount of artistry and interpretation needed to produce effectively lit scenes. Lighting is one of the most powerful, yet most often overlooked areas of 3D. See Chapter 8, "Seeing the Power of Rendering," to read more about the theory behind lighting design and the practical applications of these theories.

Some 3D is illustrative in nature. Some 3D's purpose is to create beautiful still figures. Other 3D is narrative in purpose like animation. While the same 3D application is used to create both stills and animations, ultimately, the goal and media of the two are different. Animation is bringing the geometry of models to life; giving them life, a motion personality. *Animation* is a complex process, and even the simplest ideas of a bouncing ball require careful study of the world around us and the physics of weight. To top it all off, the most believable animation is the one that transcends the heavy technical requirements of animation to a level of organic movement. You will usually find that about one-fourth of your time is spent creating the models, textures, and lighting setups, and the rest is spent animating. It is a challenging but tremendously rewarding aspect of 3D, and is covered in Chapters 10–14.

Once a scene is modeled, textured, lit, and sometimes animated, the computer must paint the geometry, color, and light we have given it. This rendering is produced by the computer and is usually our final still or animation. There are many different ways to render, including everything from photorealistic to cartoon shading (Figure 1.1).

Keep in mind as you work that complex scenes take large amounts of time to *render*, and even when your work is done, the computer has to interpret all of your instructions, and often even the fastest computers will take a *long* time to do this. Finishing up your lighting and clicking the "render" button as your client walks in the door is a very bad idea. (It is my experience that clients are usually unimpressed by a black screen.) There is a lot to discuss about rendering, so a whole chapter is dedicated to it (Chapter 9, "*Moving* on to Animation")—be sure to read it.

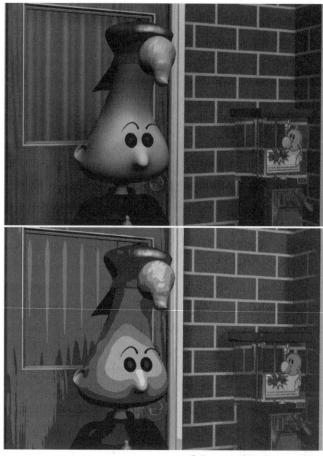

FIGURE *Photorealistic vs. Toon-Shader.*
1.1

Building a 3D Project

Now with all those definitions laid out in a linear fashion, I am going to tell you how the 3D creation process is anything but linear. Figure 1.2 shows a chart of the quasi-linear nature of the 3D process.

The first step to a 3D project is to plan, plan, plan. I know, everyone wants to jump in and get started right away, which is an important thing to do when just beginning in 3D, but sooner or later, you will want to actually create an entire project. In my experience, every hour spent developing effective plans for a project saves 10 hours in actual production time. A large part of the planning process involves numerous drawings.

Michelangelo had volumes and volumes of sketches. To us today, these

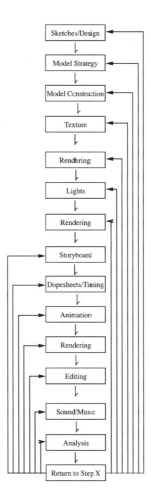

```
┌──────────────────┐
│  Sketches/Design │◄──────┐
└──────────────────┘       │
         │                 │
         ▼                 │
┌──────────────────┐       │
│  Model Strategy  │◄──────┤
└──────────────────┘       │
         │                 │
         ▼                 │
┌──────────────────┐       │
│ Model Construction│◄─────┤
└──────────────────┘       │
         │                 │
         ▼                 │
┌──────────────────┐       │
│     Texture      │◄──────┤
└──────────────────┘       │
         │                 │
         ▼                 │
┌──────────────────┐       │
│    Rendering     │◄──────┤
└──────────────────┘       │
         │                 │
         ▼                 │
┌──────────────────┐       │
│     Lights       │◄──────┤
└──────────────────┘       │
         │                 │
         ▼                 │
┌──────────────────┐       │
│    Rendering     │◄──────┤
└──────────────────┘       │
         │                 │
         ▼                 │
┌──────────────────┐       │
│   Storyboard     │◄──────┤
└──────────────────┘       │
         │                 │
         ▼                 │
┌──────────────────┐       │
│ Dopesheets/Timing│◄──────┤
└──────────────────┘       │
         │                 │
         ▼                 │
┌──────────────────┐       │
│   Animation      │◄──────┤
└──────────────────┘       │
         │                 │
         ▼                 │
┌──────────────────┐       │
│   Rendering      │◄──────┤
└──────────────────┘       │
         │                 │
         ▼                 │
┌──────────────────┐       │
│    Editing       │◄──────┤
└──────────────────┘       │
         │                 │
         ▼                 │
┌──────────────────┐       │
│   Sound/Music    │◄──────┤
└──────────────────┘       │
         │                 │
         ▼                 │
┌──────────────────┐       │
│    Analysis      │◄──────┤
└──────────────────┘       │
         │                 │
         ▼                 │
┌──────────────────┐       │
│ Return to Step X │───────┘
└──────────────────┘
```

FIGURE *The 3D process.*
1.2

sketches are masterpieces; to him, they were a means toward an end. Some were studies of the form and shape of anatomy, objects, or people. Others were layout plans, draftings of different compositions, balances, and designs. While some artists today are able to create fantastic pieces of artwork based on reactions to what they just laid on canvas, all of the great artists of the past took time to plan how their final project would appear.

3D should be no different. If the final project is a still image of a set of gears and cogs, sketches on how the cogs look, how they will be laid together to form a cohesive image, and notes on color and lighting are important. If the final project is a character, sketches of the character, its personality, and form provide a valuable visual resource during those tedious

modeling hours (Figure 1.3). If the final project is an animation, many minutes of final footage can be saved if an effective storyboard is laid out with careful attention paid to camera angles, timing, and shot composition (Figure 1.4).

"Ah, a few extra minutes of footage, or a few extra renderings? That's not the end of the world!" It may not seem so now, but when a few extra renderings take 10–12 hours, and a few extra minutes in a complex scene take days to render, those 45 minutes it takes to make a sketch ahead of time will be well worth the time.

Once the form of the model and composition of the shot has been worked and reworked on paper, it is time for strategizing the modeling process. There are lots of different ways to model that will be covered later, but remember, it is easy to get caught up in the intricacies of the folds of skin under the eyes, or the pock marks on the surface of the gear. Do not be seduced by the dark side! Modeling is fun, but it is only a part of the final project. I have seen many friends spend so much time creating perfect models that they never get around to texturing or animating the model, and end up with a portfolio full of models but no finished projects. Will the backside

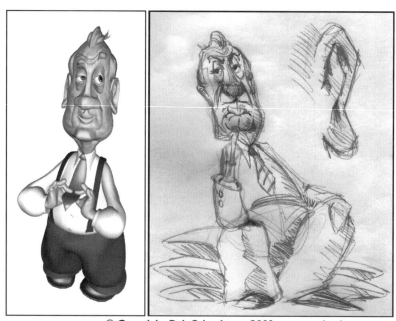

FIGURE *Robert Schuchman's sketch and realized model.*
1.3

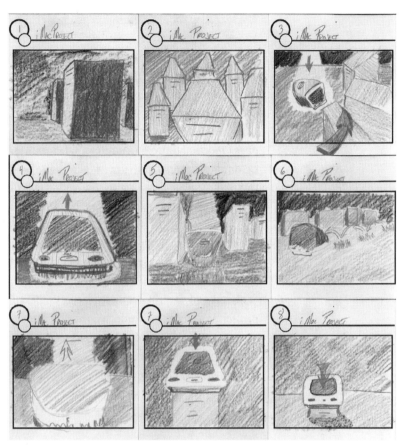

FIGURE *Storyboard.*
1.4

of the model ever be seen? Will the model or camera be moving when it is in the shot? How well lit is it? What kind of modeling can I do with textures (Chapter 6)? Ask yourself all of these questions before you start modeling. There is really no reason to create model parts if they are not going to be seen. And, there is no use spending hours on details if they flash through the shot with high-motion blur in less than one second.

Once all the planning and strategizing is done, it is time to actually touch the computer. The first step in the computer phase of 3D is to model. If planned effectively, modeling can be a fun process of sculpting, lathing, and creating that really cannot be done the same way in any other media. Sometimes, you may find that your software or your modeling skills are not quite up to the task of realizing the original design. Thus, the "return to step X" cycle begins. Redesign a bit, and then remodel.

Once the model's geometry is created, the texturing process begins. Sometimes texturing involves using stock textures (although keep "canned" textures to a minimum), while other times texturing involves creating your own through photographs or other images you may have. And still other times, creating textures is done by drawing your own textures in another image creation program (e.g., Photoshop, Illustrator, etc.). Once the textures are created, the focus shifts to mapping those textures to the geometry of the model. Sometimes during this process, you will find that the texture needs altering, or that the texture does not cover up flaws in the modeling that you thought it would, so some backtracking is needed.

When applying textures, do many interim renderings to see how the texture is falling across the surface of the model. Then model, texture, render, retexture, rerender, sometimes remodel, rerender, retexture, rerender—you get the idea. When you render at this stage, be sure to use faster rendering algorithms; this is only a preview, after all.

After applying the textures to the model, dive into the lighting of the project. Spend quality time on lighting, as good lighting can bring the most boring of models and textures to life, or it can kill the most vibrant of designs. Again, render often here. During the lighting phase, you may find that the mood lighting you use is dulling the colors of the textures, so be sure to adjust the textures.

Now, if the project calls for a still, a final render is in order. If the project is an animation, make sure that the storyboard is well worked and understood. If the animation calls for sound-sync (matching motion to sound), then building a dope sheet is an important step. Create your dope sheets to match your needs. Dope sheets (Figure1.5) are basically a way to map out the motion planned to the sound planned over the frames needed, and will be covered in detail later.

Once you have mapped out how the timing works, you need to start putting *time* into your project. Animation is sometimes called 4D, with time as the forth dimension. How you time your animations and how you design the movement is what gives animations personalities, what makes them interesting, and what makes them art. Since the last half of this book is devoted to animation, I'll leave this discussion until then. The key is to remember that animation is also a means to a finished project, and will obviously undergo revision after it is rendered.

When all of the rough footage from animations is finally done, you will probably have a variety of QuickTime, AVI, or other formatted "clips" (depending on how many shots are planned in your storyboard). The time has come to figure out which parts of the animation are truly needed to drive

SPOON DESIGN & PRODUCTION (SPOONDESIGNS.HOMEPAGE.COM)						
Time	Frames	Action Description	Dialogue	Animation	Background	Camera Instruction

FIGURE *Dope sheets.*
1.5

the story, and which need to be left on the virtual cutting floor. We all fall in love with our projects, especially when we are pleased with a new technique we learned or when it is going well over all. However, audiences do not always share our love of new found techniques, and are usually bored if the elements we include do not facilitate in pushing the story forward. Plan some good time for editing. Good editing does not come quickly or easily, and usually several different editing sessions are needed to trim away unnecessary clips that made it past the storyboard cutting stages. It is during the editing process that you can begin to see if all the elements we just discussed have come together. If not, back up, rework, and try again.

Often, during the editing process, sound is added as an afterthought. However, sound is so important that it really deserves its own mention and category step. Animations work best when there is a clear concept of sound from the beginning of the project. Sound can help dictate motions, timing, and feeling. Take some time to create a *sound design*. Be careful not to just use stock sounds over the top of a creation. Putting stock sound over the top of a meticulously created 3D animation that took you weeks or months to painstakingly and lovingly create is like buying the whitest flour from Nebraska, the finest cocoa-beans from South America, the purest sugar from Hawaii, and then getting water from the gutter to make a cake.

The biggest issue for many computer artists is the lack of outside feedback and influence. It is easy to get buried in the project at hand, and finish the project without ever getting any advice. After you have finished a good edit and a good sound design, realize that the work is still in process and get feedback—lots of it. You'll be surprised how much your friends, family, and colleagues can help. Do not assume that when they say, "I don't understand what's happening there," they are telling you they do not understand the medium of 3D; it means that you are not as clear as you should be in communicating your story. Besides getting friends or colleagues to look at projects, get those who *know* about 3D to look at it. There are a variety of newsgroups, postforums, and other listservs that will allow you to post

work for criticism. Usually, the criticism that comes from these sources is constructive and comes from very knowledgeable people. Sometimes, a few well-placed constructive criticisms can take you in far more interesting and successful directions on a project. When the critique comes, and it *always* does, disregard that which is of no use and adhere to the valid. After criticism, you might find that you need to rework all the way back at the storyboard stage, or you might find that it is just a small matter of a tighter edit. Either way, the 3D cycle continues.

Now that we have looked at all the times to return to another step, it needs to be said that there is also a time to stop. The last step of the process is to know when to stop and let the project stand. There is always something that could be done a little better, but there are other stories to tell, more motion to study, and ideas to explore.

Tutorial Introduction and Explanation

Throughout the course of this book, as we look at the different modeling, texturing, and animation techniques, you will notice screen shots from several different programs and projects. The programs that will be covered specifically are Maxon's Cinema4D XL v6 (C4D), Strata's 3D (SSP), and Newtek's Lightwave v6 (LW). These programs were selected because they are powerful industry packages that are also cross platform (can be used on both Mac and PC). A demo for Cinema4D is included on the CD and the full version of Strata 3D can be found there as well.

However, one thing that is clearly emerging as the 3D market evolves, is that the most important aspect is the content of your work, not the tool you used. Some other influential and powerful tools include Auto•Des•Sys' Form•Z, Hash's Animation:Master, Discreet's 3D Studio Max, AliasWavefront's Maya, and Avid Technology's SoftImage. Most of the techniques used to create any one of the projects can be used in any of these other applications. So if you are a Lightwave fanatic and see screen shots to describe a procedure in StudioPro, still take note. Strategies are cross application and cross platform.

One more note: the CD-ROM includes all the images that you see on these pages. Many of the images included here are by very talented artists and should be enjoyed in full color. In addition, in many places (especially during texture tutorials) there may be some files you may want to use to follow along. Use the CD-ROM as you follow the tutorials for maximum efficiency, or you may wish to ignore the files included and create your own. Just have fun!

2 Understanding the Digital 3D World

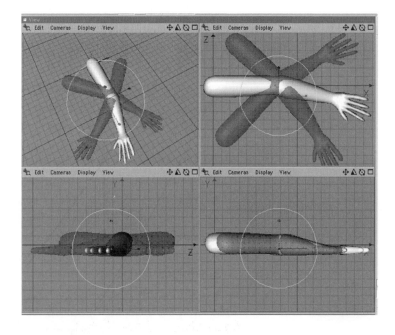

Art has been and continues to be an evolutionary process. Although it has probably been around for as long as humankind, the goals and methods have changed dramatically from the French cave paintings of Lascaux to the Egyptian *Geese of Medum* to Hokusai's *The Great Wave* to Boticelli's *The Birth of Venus* to Ingres' *Grande Odalisque* to Rothko's *Four Darks in Red* to the work of John Lasseter and his crew in *Toy Story*, *Toy Story 2*, and *A Bug's Life*. All of the methods used to depict real or mystical three-dimensional occurrences on a two-dimensional plane have been new steps in new directions.

The 3D World Around Us

With two eyes, our brain is able to take the two different figures that each eye sends and process visual cues of depth. Perspective is the attempt to fool the eye into understanding depth, distance, and relative position on a two-dimensional space. The understanding of how to depict depth on the two-dimensional plane of a painting or drawing has been one of the most important developments in art history and the foundation upon which 3D applications of today are built.

The basis of perspective is that the surface of a painting or drawing acts as an invisible plane, called the *projection plane*, that sits perpendicular to the viewer. The viewer stands at a point referred to as the *viewpoint*. As the viewer looks through the projection plane, he sees a horizon usually depicted by a straight line that includes a vanishing point. The vanishing point is the point at which all parallel lines parallel to the viewer converge. As perspective advanced, artists realized that lines not parallel to the viewer had their own vanishing points, some of which were out of the projection plane. There are a lot of terms to learn in the beginning, but they all come in handy—hang on. To illustrate these ideas, see Figure 2.1.

WHAT IS DIGITAL SPACE?

An important idea behind perspective is that every shape and object depicted on the projection plane sends a "ray" to the viewpoint, or our eye. Computer 3D applications rely heavily on this concept through a process called *ray tracing*. Imagine that all objects in a scene emit these theoretical "rays." On their way to the viewpoint, they will pass through the projection plane that, in the case of computers, is the screen. In theory, the screen records what shade, hue, and intensity the pixels on your monitor will appear. Ray tracing works backwards by working down these "rays" to the ob-

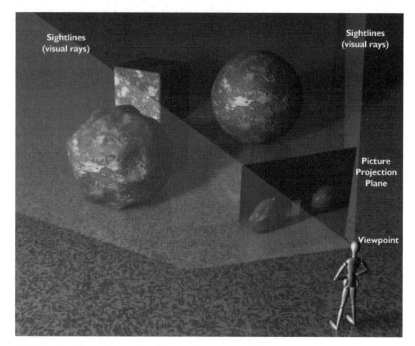

FIGURE *Projection plane, viewpoint, and perspective illustration.*
2.1

jects, while considering if the visible light is from a source or is reflected. There are many different ways besides ray tracing that computers actually use to figure out what should be displayed on your screen (see below), but it is a good way to picture how the computer is "painting" or "projecting" the 3D objects present in its digital space.

DIGITAL SPACE THROUGH PROJECT WINDOWS AND VIRTUAL CAMERAS

The forms of perspective we most readily accept are the linear forms that most closely resemble the world around us. Because of this, most of the figures we see in 3D art have been displayed in perspective projection. However, although perspective is best for finally understanding a composition, it isn't always the best way to view digital space when creating that composition.

Depending on the application you are using, you can look at the same digital space and the objects contained in that space from a variety of different viewpoints. Top, front, left, right, back, bottom, and isometric (a

kind of angled bird's eye view) are all different angles from which a model can be viewed. Now, while you can look at the digital space in perspective from all of these points, perspective provides some obstacles between you and the 3D application.

When the computer projects the space in perspective, it is showing you all three dimensions on your two-dimensional screen. The problem is, your mouse can only move in two dimensions across the projection plane of your screen. So, when your mouse clicks on an object, it becomes very difficult for the application to decide if you are just moving an object horizontally (x) and vertically (y), or if you are attempting to move it in depth (z) as well. To rectify this, 3D applications use something called an *orthographic view* or *projection*.

Orthographic projections are views in which the parallel lines in the model do not converge on a vanishing point like they do in perspective; instead, they remain parallel, or at right angles with the projection plane (*Ortho* means "at right angles to"). This is very unlike the world as we observe it. For instance, since there are lines converging, objects appear the same size whether they are close or far away (Figures 2.2 and 2.3).

FIGURE *Front orthographic view.*
2.2

FIGURE *Coupled with perspective view of same digital space.*
2.3

The advantages of this sort of viewpoint include the ease in which you can align objects. However, one orthographic view by itself is fairly useless because you cannot tell depth. Therefore, the best use of orthographic views is one in which you have multiple orthographic views open so that you can adjust the vertical aspects from one angle, the horizontal from another, and the depth from the third—a view for each dimension. Most 3D applications allow you to place a virtual camera that you can move around within the digital space and look through. Cameras are the views from which 3D projects are usually finally rendered and presented. Because of this, most cameras present perspective views. One of the most popular ways to view digital space is to have three orthographic views open (front, side, and top), and another view or camera view that is using perspective projection.

COMPUTER "DRAWING" METHODS

As you give the computer directions on what to do in its digital space, the computer tries to let you know what is going on by drawing or rendering the information on your screen. We have already looked at the ways the

computer attempts to show the shapes of the objects, but there are also a variety of ways that it tries to show the form.

Rendering refers to the way the computer draws or paints the information it has on the projection plane (your computer screen). 3D is the process of creating the world and then telling the computer to paint it and how to paint it. Sometimes, you will want the computer to paint or render for you in beautifully finished ways. However, at other times, more informative forms of illustration will be necessary.

The most intuitive form of rendering is the various algorithms of shaded rendering. Shaded rendering forms are those where you see an object that is shaded to show roundness of form, or source of light. Figure 2.4 shows a variety of shaded rendering formats. We'll talk much more about the higher-end rendering methods (Phong, Ray tracing, Radiosity, etc.) in Chapter 9, "Moving on to Animation." However, for now, suffice it to say that the more photorealistic the rendering, the longer it takes the computer to figure out how to paint all the details of an image; so long in fact, that those forms are not really feasible for easy maneuvering and modeling within digital space.

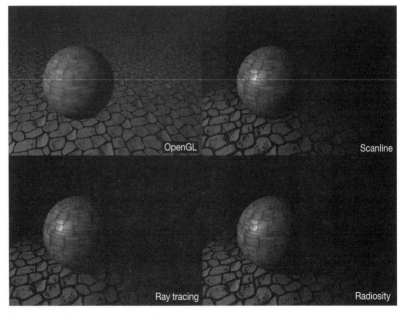

FIGURE *Rendering comparison of a variety of shaded renderings.*
2.4

There are some forms of shaded rendering that are fairly feasible for today's technology to handle. The most popular form of late is the technology developed by SGI (Silicon Graphics Inc.) called OpenGL. OpenGL is a fast rendering algorithm that can be very effectively sped up by the right hardware. Most mid- to high-end video cards now are OpenGL accelerated. OpenGL is powerful in its ability to quickly draw lit models that show the textures (Chapter 6, "Advanced Texturing Techniques") applied to the model's surface. It is still a rough form in many instances, but it gives a good idea of overall color and position. Both Strata's StudioPro and NewTek's LightWave, which we will cover, use OpenGL heavily.

Not all applications use OpenGL, however. For instance, Cinema4D, another program covered, uses gouraund shading. Other applications use other high-speed libraries (e.g., Heidi, Quickdraw3D, etc.). The point of all of these low-end shaded renderers is to provide the modeler a quick look at roughly how the light and texture falls across the surface of the objects present.

Sometimes, understanding the form is more important than seeing color and light on the surface. For instance, a typical exercise in almost every beginning drawing course is to "draw through" the object; that is, the student draws the backsides of the objects through the space presenting the front side. The motive behind this exercise is to better understand the form. The computer has many ways of "drawing through" objects to allow you, the creator, to understand the form of the models present more fully. These include *outline*, *pointcloud*, and *wireframe*. Figure 2.5 shows the same object rendered in these three renderers.

Perhaps the biggest benefit of these rendering systems is the speed in which they redraw; the computer is able to quickly paint pictures on your screen using these methods. As models become more complex and the computer has to deal with more and more information, it takes longer and longer for it to draw the information you have given it. Sometimes, the models become so complex that using any other form of rendering is simply too time consuming, and these methods are how you work the majority of the project.

While working on an animation, do several wireframe renders of the animation, because the computer can render out 300 frames in as many seconds. This saves a lot of time by giving you a chance to see quickly if the motion is not right, or the camera angle is not giving you the desired effect. Other rendering methods would take hours or even days to render 300 frames. Most people never see outline, pointcloud, or wireframe

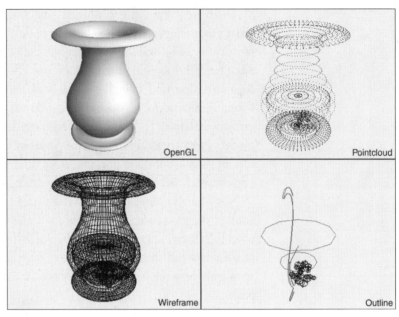

FIGURE *Outline, pointcloud, and wireframe renders.*

2.5

renderings—they are primarily a tool for the artist. However, if you are working with a client and want to show what you have done so far, they are often very impressed by an animation that is rendered in wireframe. Somehow, it makes you look like some sort of techno-wizard-genius.

MOVING IN THE DIGITAL 3D UNIVERSE

Computers work in mathematical equations and algorithms. Because of this, they think of digital space in terms of a three-dimensional axis with x, y, and z planes. This *Euclidean geometry model* depicts x as horizontal, y as vertical, and z represents depth. These values can be positive or negative, depending on their relative position to the center of the digital universe where all values of x, y, and z are 0. This is why most 3D applications' default screens include at least one grid and small key to let you know how they are displaying the digital space (Figure 2.6).

The computer thinks of all the objects, parts of objects, vertices of objects, or points on that object as a series of three numbers (x, y, z). Although users do not usually need to concern themselves with the exact numbers

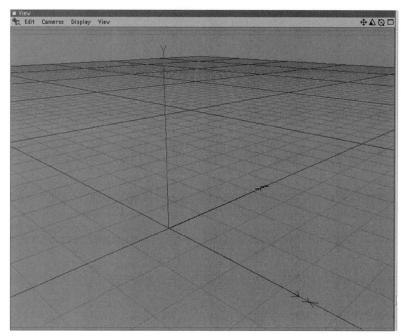

FIGURE *Default plane and axis key.*
2.6

involved, it is still important to know which values represent which direction, as almost every 3D application allows for the manual entering of numeric values. Further, understanding how computers think and keep track of digital space helps to understand how the computer shows it to us, the users.

Figure 2.7 shows a cube with an object center at (0,0,0). Each side of the cube is four units long, so each of the vertices of this cube is at (2,2,2), (–2,2,2), (2,–2,2), (2,2–2), (–2,–2,2), (2,–2,–2), (–2,2,–2), or (–2,–2,–2). It is important to keep in mind that as much as we are using those right-brained functions of creativity, the computer is essentially a left-brained thinker. This is important to remember as we try to tell the computer where to position objects.

When a 3D application shows us shapes in 3D space rendered in perspective (as it is in Figure 2.7), it is interpreting space on a two-dimensional plane. Since our mouse can only move in two dimensions across the plane of the screen, if we simply reach in with our mouse and grab hold of the object with a move tool and attempt to move it, the 3D application makes its

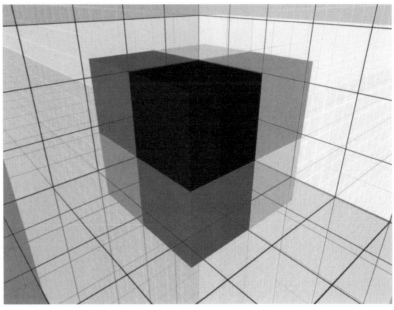

FIGURE *Four-unit-wide cube sitting at (0,0,0).*
2.7

best attempt at interpreting which of the three dimensions you want to move the object through it's two-dimensional mouse movement. Using the typical four-view method shown in Figure 2.8, we are given orthographic views of the object. That is, we are only presented with two dimensions in each window. This simplified view of the objects present in digital space assists in clarifying to the computer how the object is to move. If we wish to move the object along the horizon sideways (x axis) or in depth (z axis), we simply look at the view that shows the top of the objects, and no matter how we move it from this viewpoint, it won't move the object up and down. This is an effective tool if you are arranging furniture in a room and do notwant the furniture to end up floating above the plane of the floor. Similarly, if you grab an object from the front view, you can move it up and down (y axis) and sideways (x axis) without affecting its depth. From the side view, you can affect the up and down (y axis) and depth (z axis) position of the object without moving it in it's relative side-to-side position.

FIGURE *Four-view screen shot.*
2.8

Mastering Model Movement and Manipulation

When a sculptor undertakes an ambitious public commission project, he usually uses a variety of techniques and tools. When a painter undertakes a challenging piece of trompe l'oeil, even though it is a definite style of painting, he still uses a variety of brush sizes, medium, paints, and techniques. So it is with digital art. The techniques described in the previous chapter are all different methods and tools on the digital palette. No one single tool or method will produce a good finished project; only combinations of the right tools at the right time will produce the right model.

Because of the immense power that emerges from using a variety of modeling techniques, it becomes necessary to assemble the different segments of your model into one coherent shape. To do this, you must understand how to move, manipulate, and organize shapes within digital space.

TOOLS

Before we jump into digital space again, it would be prudent to discuss the idea of tools. As we work in 3D, we have a mouse that roams about the screen, scurrying hither and yon carrying out our orders. The orders carried

out by this mouse are largely dependent on what type of tools we are using. Most 3D applications have a sort of virtual toolbox with iconography representing different types of tools. Some tools are for moving objects, some for resizing, others for rotating, and still others for altering polygon structure and a host of other functions. Each tool has a separate function and cannot do the functions of any other tools. This may seem obvious, but when you reach a point of utter frustration, the first thing to do is to make sure you are using the right tool for the right job.

POSITIONING OBJECTS IN AXIS DEFINED SPACE

The Move tool is perhaps the single most powerful tool in your arsenal. Every 3D application has some tool that allows the user to move objects around in digital space. Often, this tool can be used by simply clicking on the object and dragging it to a new location. To further empower the 3D artist, most applications allow for some sort of *constrained movement*. Constrained movement is the ability to move an object in the direction of only one of the axes. Different programs handle the visual representation of this idea differently; however, all maintain the idea of having one symbol or region of the object that when clicked-and-dragged will move that object along only one axis. See your manual for details on your program of choice.

WORLD/OBJECT AXES

An important concept to remember is that objects have their own axes. When objects are first created, this object axis is usually at the same point as the world axis (0,0,0). However, as soon as you move an object (Figure 2.9), you will notice two axis keys. One represents (0,0,0) for the digital world's coordinate system, and the other represents the axis for the object. This becomes more important as we begin to look at other functions like rotation and rescaling.

ROTATION FUNCTIONS

Besides being able to move objects around digital space, we can also rotate the objects around the object's axes. Again, this varies from program to program, but the premise is the same. Each object has its own axis around which it rotates. For many programs, it is through the symbol for this axis that you are able to rotate the object. Like object movement, 3D applications allow for the unconstrained free rotation of objects, or a constrained

FIGURE *World and object axes comparison.*
2.9

rotation for those situations where you want the car to be facing North instead of East, but you do not want it sitting on only two tires.

An important part of the rotation process is the ability to move the object's axis and thus effectively change the axis of rotation. Imagine you have modeled an arm (Figure 2.10). Now, if the Rotation tool were used to rotate the arm, it would rotate around the geometric center of the arm. The problem is, arms do not rotate like that. Instead, we need the arm to rotate around the end of the arm where it would attach to the shoulder. To do this, we need to adjust the object axis so that it sits in that shoulder joint. 3D applications usually have a key command or separate tool that allows you to alter the axis of rotation for a given object. With this tool selected, you can use the Movement or Rotation tool to position the object's axis into position. Figure 2.11 shows the altered object axis and the resultant motion possible.

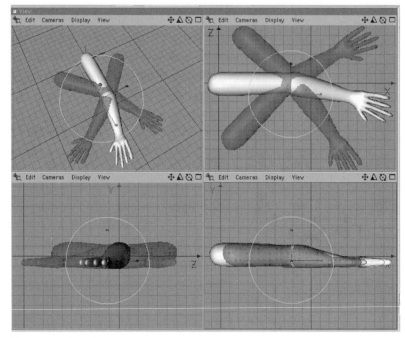

FIGURE *Unaltered center model arm.*
2.10

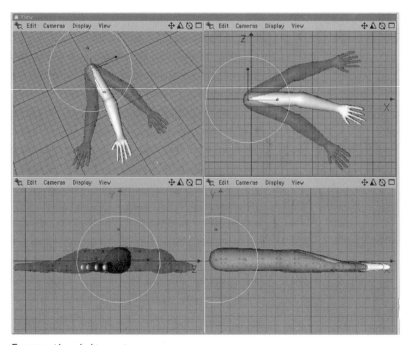

FIGURE *Altered object axis.*
2.11

SCALE FUNCTIONS AND RELATIVE SIZES

Once objects are created, we can define and alter their size. Again, like movement and rotation functions, 3D applications allow for *free scaling* and *constrained scaling* (sometimes called *free sizing* and *constrained sizing*). Further, most 3D applications allow for *universal scaling*, that is, allowing the user to scale the object in all directions at once. This becomes important when you wish to resize an object, and do not want it to suddenly have its proportions altered.

Duplicating to Avoid Duplicating Effort

Often, models will require many copies of the same object. One solution is to create new objects for each copy of a given shape. Another is to select a shape, and then copy and paste it in a similar position to copy-paste functions in word processing. The only problem with copying and pasting is that it is often difficult to determine where in space the new copy of the object appears.

To assist in adding control over where new copies of objects appear, most programs offer Duplication or Replication tools. Duplicating/replicating functions allow you to determine how many copies of an object will be created, and if these new copies will be moved, scaled, or rotated. See your manual or the tutorials later in the book for more information and details on duplication. With a little planning, these duplicating/replicating functions can make for a large variety of shapes on complex patterns that would be very laborious to maneuver by hand. Even more powerful is the ability in many programs to make duplicates that are mirror figures of the original. This cuts the modeling time in half for many objects like the human body that are essentially symmetrical in composition (Figure 2.12).

When duplicating objects, 3D applications create another object that is a clone of the original; this includes all the polygons that make up the object. Therefore, 20 duplicates of one object suddenly make the model 20 times heavier—it has 20 times the polygons. To assist in keeping poly-counts down, programs offer the ability to *instance* objects. The idea of instancing is that you tell the computer to display a copy of an object at a certain place in space; it is not actually keeping track of any more polygons since the instance acts as a placeholder. The computer refers back to the original object for geometry information. Therefore, if the original is altered, then all the instances are instantly changed as well. Figure 2.13 is not showing 40 cupcakes; rather, it is showing you one cupcake 40 times.

As powerful as instancing seems, it does not help when it comes to actu-

FIGURE *Mirrored duplication.*
2.12

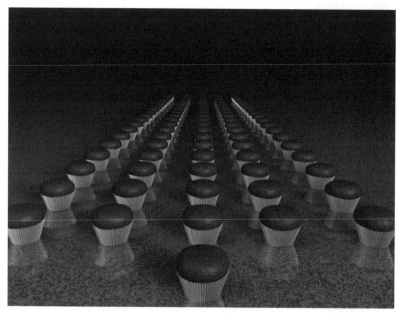

FIGURE *Instance cupcake.*
2.13

ally rendering the scene. Although the polygon count is much lower as you edit the scene, the computer still needs to be able to place the polygons where they need to appear when it renders. Therefore, a scene that moves quickly as you edit it may take hours to render, as the computer has to place the original in the place of each instance to render the result.

Power of Groups

Using basic shapes as building blocks is a great way to begin modeling. However, without proper organization, the list of objects in a scene will quickly become so long and cumbersome that it will become impossible to keep track of all the objects when it comes time to texture or animate them. To solve this problem, applications allow for various forms of *grouping*. Grouping takes several objects that you have selected and lists them under one *parent* object or one *parent group*. The objects contained within this parent group are called *children*. All changes made to the parent object or group are inherited by all the children objects. Usually, these children objects can still be altered separately without affecting the whole.

The exact details of grouping vary from application to application. Some applications allow you to simply select several figures and group them. Others require that one object be a parent while the other objects become the children. Some require the creation of a "null" object, or an object that has no geometry to act as the parent for the other objects in the group hierarchy.

Enough Theory Already

Alright. We have covered an awful lot of ethereal theory on how the computer thinks and communicates digital space. This knowledge is important in order to be able to quickly communicate what you want the computer to do, but enough is enough. Now that we know how the computer takes instructions, let's look at how to plan for these instructions and how to give the instructions to our 3D application that will make it a tool in our hands. To do this, tutorials for a project called, "The Amazing Wooden Man" are included throughout the book. The tutorials will be laid out in a rough step-by-step process, with passages of the theory behind the steps interspersed throughout. The specifics of each program and the tools used are not covered—those are covered in the manuals of the software. The idea is to provide a hands-on approach to *how* to create a project, while making sure to take the time to explore *why* the concepts work as they do.

3 Carving Out Modeling Basics

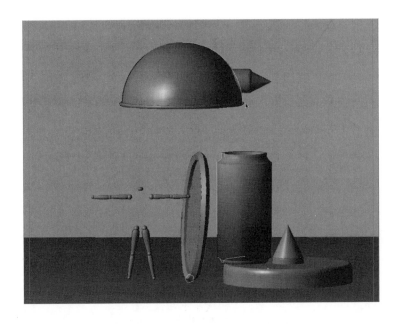

Efficient Modeling

Figure 3.1 shows an excellent digital character design by Mike Clayton. It is excellent in a lot of ways: 1) It is just a good design, 2) he carefully used the same shape for all parts of the body, and 3) this same shape is composed of some very simple geometric three-dimensional elements. Because he carefully *designed* the character, he already has a great idea of how to *construct* the character. Now, not every character or model is going to be as neat as the one the artist cleverly constructed, but sketches like the one presented in Figure 3.1 solve many of the problems encountered as people try to put polygons together to form an interesting shape—"what are the shapes?"

Once the shapes are understood enough in your mind to be understood on paper, you can begin to make them understood digitally. For instance, in the sketch, the shape used over and over is a sphere combined with a sort of distorted cylinder. A strategy can quickly be developed as to what methods of which sorts of modeling to use once the component shapes of a model are decided upon. The following sections are brief descriptions of some of the kinds of digital geometry that presently exist. Following the descriptions are specific looks at how to get started with some of the more basic techniques.

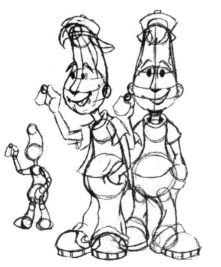

© Copyright Mike Clayton 2000

FIGURE *Mike Clayton character design.*
3.1

Modeling Types

There are a variety of modelers on the market with a wide range of features and prices. Some low-end packages are great at making simple shapes like spheres or cubes and are extremely easy to use, while high-end packages often include a plethora of modeling features but require quite a bit more time to master. No matter which kind of package you use, they fall into three basic categories in how they create shapes.

Polygon Modelers

Polygon models are the least taxing on a computer's processing muscles. Because of this, most low- to mid-range 3D applications rely heavily or solely on polygon modeling. The idea behind polygon modeling is that the computer takes two-dimensional shapes called *polygons* (usually squares or triangles) and organizes them in digital space to form the shells of 3D shapes. Figure 3.2 shows a cube made up of a combination of six squares. Likewise, Figure 3.3 shows the same principle in action using six triangles to make a pyramid.

For simple shapes like the pyramid and square shown in Figures 3.3 and 3.2, polygon modeling makes perfect sense. However, one rule of computer polygons is that they cannot be bent; they can be organized in any angle in relationship to the next polygon, but the two-dimensional shape itself cannot be bent. So, for an object like a sphere, many polygons (both square and

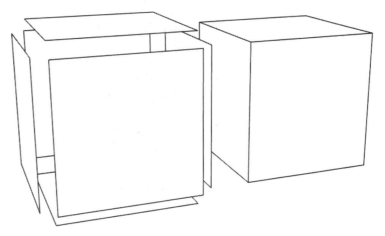

FIGURE *Polygon cube made of two-dimensional square polygons.*
3.2

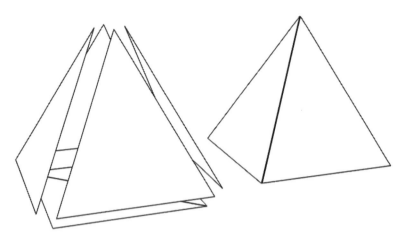

FIGURE *Polygon pyramid made of two-dimensional triangular polygons.*
3.3

triangular) are needed to create the round shape. If there are few polygons (Figure 3.4), then the sphere is not very round. As the number of polygons increases, the sphere becomes more like the EPCOT Center at Disney World (Figure 3.5). In fact, to make a well-rounded sphere takes a very large amount of polygons (Figure 3.6).

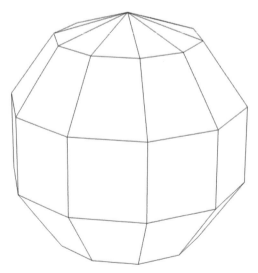

FIGURE *Blocky polygon sphere made from few polygons.*
3.4

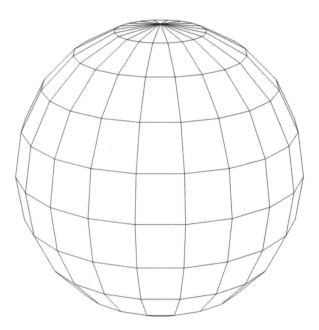

FIGURE *More rounded polygon sphere made from a medium number of polygons.*
3.5

FIGURE *Very round sphere from a large number of polygons.*
3.6

The problem is, the more polygons that are present in the model, the "heavier" it is; that is, the harder the computer must work to keep track of the extra information. For one sphere, a large amount of polygons is no problem; however, as models become more complex, the *poly-count* (number of polygons) can begin to really add up. Once the poly-count gets high, the computer slows down, the animator gets frustrated, the animator's coffee consumption rises, the animator's hair begins to disappear, the animator's spouse, kids, and pets begin to be neglected, and . . . well, the point is, high poly-counts are bad news. Lower polygon counts keep computers running quickly and the project rendering faster. When using polygon modelers, good sketches and storyboards become invaluable in planning where the extra polygons are needed, and where to leave them out.

| **Spline-Based Modelers and NURBS** | The technical explanations of *splines* are that they are a sequence of three-dimensional vertices that are connected by lines. The links between the vertices are sometimes referred to as *interpolation*. The most basic types of splines are made with straight lines; however, other types of splines have interpolation that are curves. The beauty of these spline-based curves is that they do not contain any sharp corners unless you tell them to. Spline creation works much the same way vector-based drawing programs work (e.g., Illustrator, Freehand). See the tutorial at the end of this chapter for some examples of spline creation and editing. |

Splines themselves are essentially two-dimensional. However, when splines are created, they can be arranged like the wire inside of Chinese lanterns, spun around as though they were on a lathe, or extruded like those Playdough toys of old to create three-dimensional shapes (Figure 3.7).

NURBS (sometimes called free-form polygons) is actually an acronym for Non-Uniform Rational B-Splines. By definition, NURBS are simply another form of the spline. The primary difference is that NURBS have control points (vertices) that are offset from the actual interpolation lines. However, in some programs, the difference goes beyond that. For instance, Cinema 4D allows for the use of NURBS and splines. Once a spline is extruded, lathed, or skinned, it is permanent (besides the traditional one-step undo). NURBS are another story. Cinema4D allows full control over the original shapes (NURBS), so if the shape created with them is different from what was originally planned, you can alter the NURBS to alter the shape. This sort of flexibility is better than gold as you work with hard-to-

FIGURE *A variety of splines and the shapes they can create.*
3.7

master organic forms. In fact, all high-end packages and an increasing number of mid-range applications use pure NURBS or NURBS hybrids as an important part of their modeling toolbox.

PRIMITIVES

Every 3D application has a collection of shapes that it makes very well. These stock shapes, whether polygon or NURBS based, are called *primitives*. Although primitives vary a bit from 3D application to application, most include a cube, sphere, cylinder, cone, and sometimes a pyramid (Figure 3.9).

Now, although these shapes are the most basic of the three-dimensional shapes available, don't underestimate the power of them. Primitives render quickly and are usually optimized as far as poly-count goes. If you can relay your design using primitives, that is a good idea. For instance, Figures 3.10 and 3.11 were both created entirely with primitives. Figures 3.12 and 3.13 are some great examples by talented artists of primitive-based shapes that end up creating not-so-primitive models and scenes.

FIGURE
3.8
Rendering of models used for the Amazing Wooden Man.

FIGURE
3.9
Standard primitives (cube, sphere, cylinder, cone, and pyramid).

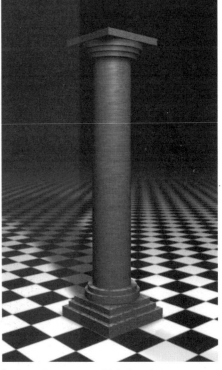

FIGURE
3.10
Primitive model (column).

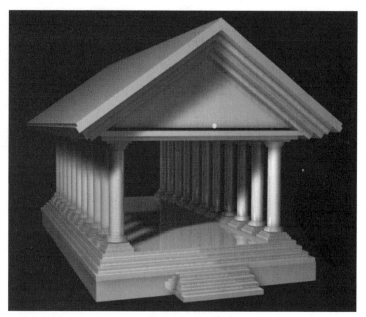

FIGURE *Primitive model (Greek temple and columns).*
3.11

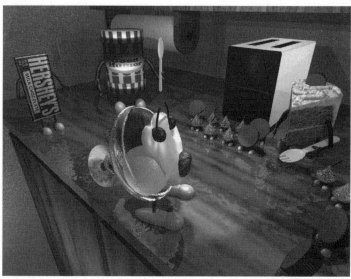

FIGURE *Nathan Skow's counter scene of simple shapes but complex figurery.*
3.12

FIGURE *Ryan Crippen's beautifully Bryce constructed shape of primitives and*
3.13 *Booleans.*

T
U
T
O
R
I
A
L

3.1: MODELING THE AMAZING WOODEN MAN

PRIMITIVES

Now to the nitty-gritty. Figure 3.8 showed a rendering of the models that we will use for the Amazing Wooden Man. Through the rest of this chapter and the next, we will be using a variety of modeling techniques to create those shapes.

In the scene shown in Figure 3.8, a surprisingly large amount of the models were created entirely or in part with primitives. Let's start with the table upon which our scene will take place. Most of the table is created with simple primitive cubes. Create a cube within your application of choice. Then, using the scale, resize the table in its x and z directions (depth and width) by clicking and dragging until it looks about the proportion of a table top (Figure 3.14).

Continuing with the table, create another cube that will serve as the woodwork just below the table top. Create two cubes, resize them, and position them so they match Figure 3.15.

Now that you have the underpinnings created, you can either copy each section and paste it into the scene again (Edit>Copy then Edit>Paste), or you can group the two elon-

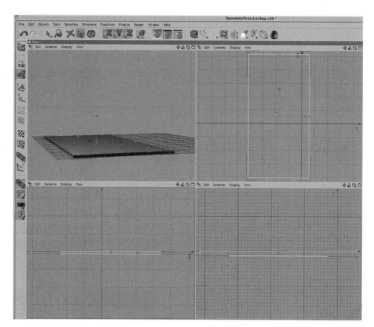

FIGURE *Table top.*
3.14

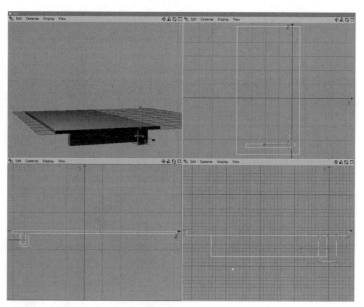

FIGURE *Table underpinnings (one section).*
3.15

gated cubes (see your application's manual for specifics on grouping functions) and then duplicate the grouped unit. Copy this group (Edit>Copy) and Paste it (Edit>Paste) back into the scene. Rotate the new copied group 180 degrees and position it on the opposite side of the table (Figure 3.16).

Now, paste another copy of the group and rotate it 90 degrees to act as the side underpinnings. Now select the longer cube within the group and lengthen it to match the length of the table (Figure 3.17). Copy this newly altered group, rotate it 180 degrees, and place it on the other side, making the top and the underpinning of the table complete (Figure 3.18). You may wish to take all of the shapes you have thus far and group them into one group called "Table."

Now, onto the lamp. The lamp shown in Figure 3.8 is created primarily of primitives. Depending on your program of choice, you may wish to alter the primitives used to better suit your capabilities. For instance, the base of the lamp in Cinema4D was created with the "oil tank" primitive, in Lightwave the "disc" tool, while the "RoundedCube Tool" was most appropriate for Strata StudioPro. No matter which shape you choose, create it in the same way we did in the steps for

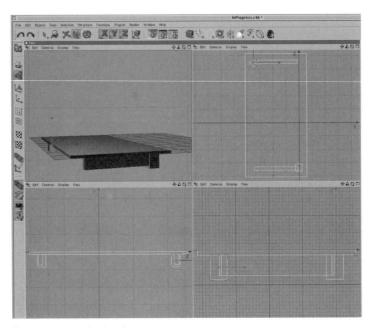

FIGURE *Two ends of underpinnings.*
3.16

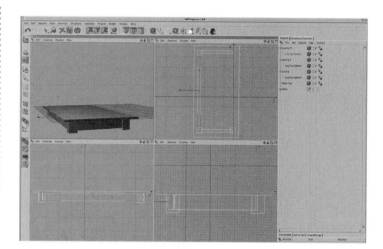

FIGURE *Lengthened side underpinning.*
3.17

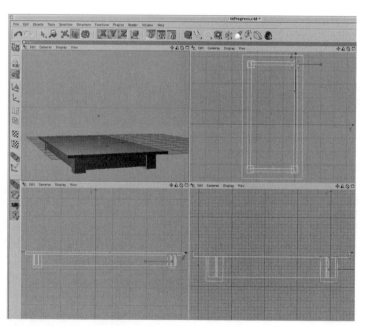

FIGURE *Completed table top.*
3.18

FIGURE *Table and lamp primitives.*
3.19

the top of the table. Resize it so the relative shape is about right. The rest of the base is a cylinder and a cone just placed one on top of the other. The base of the lampshade at the top of the lamp is the same cylinder-cone combination rotated 90 degrees (Figure 3.19).

Now, onto the star of the production: our little wooden man. This figure mostly uses other modeling techniques; however, there are the primitive spheres that act as all of his joints. To create these joints, create a primitive sphere with the Sphere tool and then resize it (with the Scale/Resize tool) to be a relative match to the table. Move this first ball into a rough position, and then Copy (Edit>Copy) and Paste (Edit>Paste) this sphere. Repeat this process 12 more times until you have 13 spheres organized, oriented, and sized approximately like Figure 3.20. The absolute location and size of these spheres will be changed as the rest of the model comes into place, so don't be too worried about specifics right now—we're still in the "rough-digital-sketch" stage of modeling.

FIGURE *Joints of spheres.*
3.20

Extrusions, Lathing, and Skinning

Most 3D modeling takes the form of creating some sort of two-dimensional or quasi-two-dimensional shape and altering it or adding other two-dimensional shapes and then placing a "skin" over the top of it to create a three-dimensional shape. 3D applications usually provide tools for creating the two-dimensional shapes (splines, NURBS or others) that will be used to extrude, lathe, or skin. However, if you are not comfortable with your application of choice's spline creation tools, or if you just want more control, most all programs will allow you to import paths from other applications such as Adobe Illustrator. So, when first getting started with the techniques described next, you may want to create your source two-dimensional files in a program you may already be comfortable with.

STRAIGHT EXTRUSIONS AND EXTRUSION PROFILES

Think of extrusion like the Playdough spaghetti makers. Remember how they have some sort of template with holes cut in them that when Playdough is pushed through it, it takes on the shape of the hole? If you use the round-holed template, the Playdough comes out in long, round tubes. If the star template is the tool of choice, the star-shaped spaghetti emerge. In

a nutshell, *extrusion* is taking a two-dimensional shape and pulling it into a third dimension. Figure 3.21 shows several shapes extruded. Notice also that you can add a bevel to extrusions to give them a different sense of depth. The extrusion profile refers to the path the source two-dimensional shape takes as it extends into three-dimensional space. Therefore, if the extrusion profile is straight, the shape goes straight back; if it is curved, then the object will be beveled. Different applications have different ways of referring to these bevels.

EXTRUSIONS ALONG A PATH

The extrusions in Figure 3.21 show extrusions extruded along a straight path. The path the extrusion takes is not limited to straight lines. Figure 3.22 shows a flower shape extruded along some twisted paths that give a very complex and interesting look and shape, and Figure 23 shows another good example of extrusions along a path.

A good application of this idea is the neck of the lamp in our "Amazing Wooden Man" project. To create the nice, smooth, curved shape, first cre-

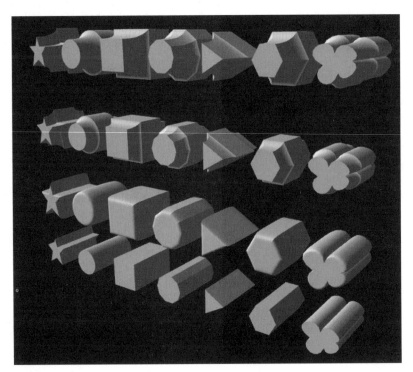

FIGURE *Straight extrusions.*
3.21

FIGURE *Curved extrusion rendering.*
3.22

FIGURE *Ryan Crippens' model using extrusions along a path.*
3.23

ate the shape you wish to extrude (in this case, a flat disc or circle) and the path along which to extrude this shape (Figure 3.24).

Then, in Cinema4D, use a Sweep NURBS with the path and the circle as children objects. In Strata StudioPro, use the Path Extrude tool from within the Extensions palette, and in LightWave, use a Rail Extrude.

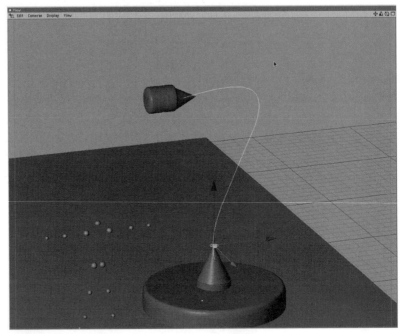

FIGURE *Spline and circle/disc.*
3.24

LATHING

Both straight extrusions and path extrusions work on the idea that the two-dimensional shape is pushed along a third dimension. However, two-dimensional shapes and curves can also be spun around an axis to create a symmetrical three-dimensional shape. Much like a real lathe cuts a profile out of a block of material, lathe extrudes begin with the profile desired and then are spun to create the shape. Figure 3.25 shows a basic lathe to create a vase.

When the capabilities of shifting the axis of revolution during the lathe are added, lathes can create very complex shapes. Lathing using just such a method made the spring in Figure 3.26. You can see the axis around which the shape was rotated, and how the shape was shifted vertically as it lathed.

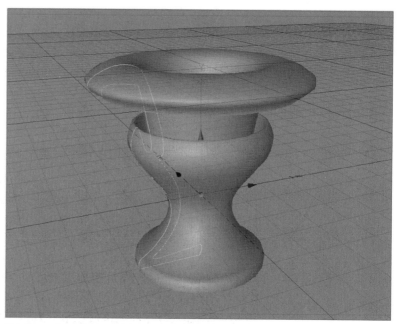

FIGURE *Lathed vase.*
3.25

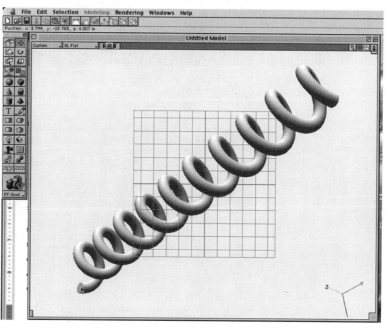

FIGURE *Lathed spring.*
3.26

Notice also that the spring was rotated more than 360 degrees. Lathes can be rotated any amount you wish.

Lathing is a tremendously powerful tool when working with fairly symmetrical shapes. Many of the shapes in our wooden man project are symmetrical, so lathing will work great. In particular, let's look at lathing the limbs of our wooden man.

The basic idea behind lathing is to first create a profile that will be spun to create a three-dimensional shape. In your program of choice, create an outline of the shape that will become the shinbone (Figure 3.27). Do not worry too much about the absolute size; just get a close approximation—all the details can be altered later.

In Cinema4D, create a Lathe NURBS object and drop the outline within it. In Strata StudioPro, use the Lathe tool and rotate the outline 360 degrees. If you are a LightWave user, use the Lathe tool (Multiply>Lathe) to lathe the shape. The resultant thigh should appear something like Figure 3.28.

Once you have created your lathed skin, copy and paste another into place for the other leg, and then rotate them into place. Repeat the process for the thighs and arms (Figure 3.29).

The can, the mirror frame, and the lampshade were made through lathing as well Figure 3.30).

FIGURE *Lathing profile.*
3.27

FIGURE *Cinema4D rotated shin.*
3.28

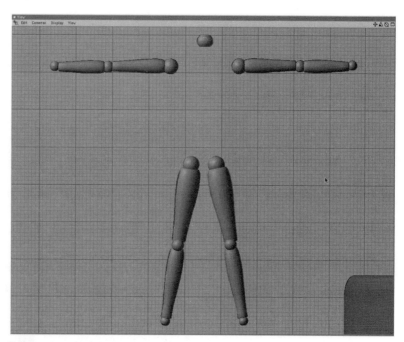

FIGURE *Completely lathed arms and legs.*
3.29

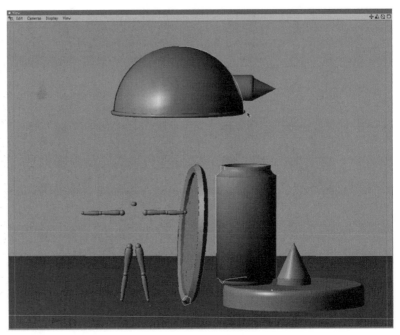

FIGURE *Lathed can, mirror, and lamp shade.*
3.30

SKINNING

Skinning is much like traditional Chinese lanterns (Figure 3.31). The lantern consists of fairly rigid rings inside that have a "skin" of paper or other material stretched over the top. The stretched skin takes on the shape of the skeleton rings underneath. To skin an object, start by creating two-dimensional shapes to act as the skeleton (Figure 3.32). Once the skeleton shapes are created and arranged, the skin can be stretched over the object (Figure 3.33). In reality, almost any shape can be constructed with this method, although there are more efficient methods for some shapes.

Skinning becomes a very useful tool in asymmetrical shapes like the dummy's hips (Figure 3.34). Begin by creating and organizing "ribs" that will define the shape of the hip (Figure 3.35). Use circles (splines) and then resize them into a more elliptical shape.

Repeat this process to create the chest and torso area (Figure 3.36). The book covers in the scene were all created using this method. The only difference is that the ribs actually curved all the way around into a horseshoe shape (Figure 3.37). The books were finished off with primitive spheres for pages, except for the open book that uses a straight extrusion for the pages.

We now have a good start on the model of our Amazing Wooden Man.

FIGURE *Chinese lantern.*
3.31

FIGURE *Chinese lantern ribs.*
3.32

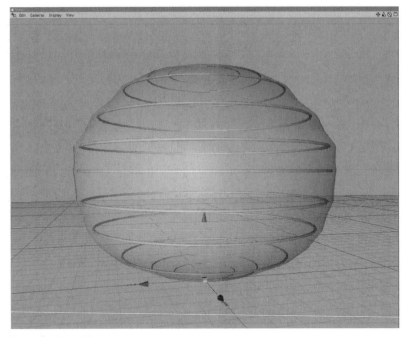

FIGURE *Skinned lantern.*
3.33

FIGURE *Finished dummy hips.*
3.34

FIGURE *Dummy ribs.*
3.35

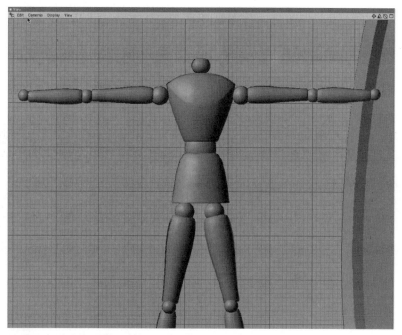

FIGURE *Dummy chest and torso modeled with skinning functions.*
3.36

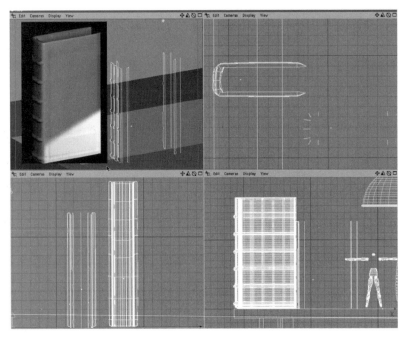

FIGURE *Skinned books.*
3.37

Keep in mind that there is more than one way to skin a model, and that there are always different ways to create the desired shapes. In the next chapter, we will be using some other advanced modeling techniques, some of which will create shapes that we could create using techniques covered in this chapter. Experiment with all the techniques, find those you feel most comfortable with, and keep all of them in mind.

T
U
T
O
R
I
A
L

3.2: PRIMITIVE TEMPLE

Now that we have talked in theory about a lot of modeling techniques and created some basic scene parts using primitives, let's truly explore the power of primitives by modeling entire scenes using primitive functions. To begin, let's create a column that will be used to create the rest of the temple. Figure 3.38 shows the finished target temple with columns.

Let's start from the bottom up. Begin by creating a primitive cube (Figure 3.39). Resize this cube so that it becomes the flattened base of the column (Figure 3.40). Now copy and paste this flattened cube (Figure 3.41), and resize the new copy so that it is slightly smaller than the first (Figure 3.42).

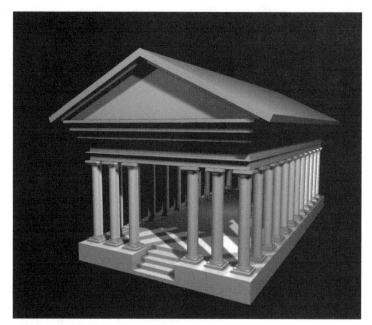

FIGURE *Finished target temple with columns.*
3.38

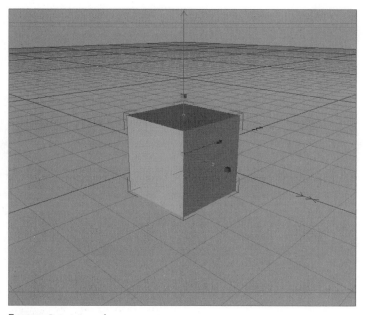

FIGURE *Primitive cube.*
3.39

FIGURE *Resized column base.*
3.40

FIGURE *Pasted copy of base cube.*
3.41

FIGURE *Resized secondary base.*
3.42

Now, since the column is to be round, let's create some round sections of the base. The best primitive for this is the cylinder. Create a cylinder and flatten it as shown in Figure 3.43. Then, copy and paste this cylinder twice, and resize each so that they are progressively smaller in the x and z directions (Figure 3.44). Now group this base together as a group "Column Base."

Now, continuing with the Cylinder tool, create another cylinder, and make sure it is long enough to be the entire shaft of the column (Figure 3.45). Don't worry about the absolute size of this column shaft; it can always be altered once all the pieces are together.

Now, to save time, just select the column base group created earlier, and copy and paste it back into the scene (Figure 3.46). Rotate the base 180 degrees along its z axis so that it can become the column top or capital (Figure 3.47). You may wish to rename this new group to "Column Capital." Position this new column capital on the top of the column.

You could make a multitude of alterations and refinements to this column (e.g., making the top smaller, bottom larger, changing the relative proportions of cylinders to cubes on the

FIGURE *Cylinder Primitive Creation for base.*
3.43

FIGURE *Extended base using duplicate cylinders.*
3.44

FIGURE *Cylinder for the column shaft.*
3.45

FIGURE *Pasted column base to become column capital.*
3.46

FIGURE *Rotated column capital.*
3.47

top, etc.), but for now, we'll leave it as is. Be sure now to group the column together into one group called "Column."

To create the temple, begin by creating 11 copies of this column and spacing them evenly apart (Figure 3.48) to make a row of 12 columns. Make sure that as you position them, that they do not move at all in the y direction. The best way to do this is make sure to position the columns from a top isometric view, and use constrained movement to make sure that the column copies only shift in one direction.

Group all of these columns into one group. This allows you to now copy and paste this group to the other side (Figure 3.49). This saves a lot of time because the columns stay lined up and you only need to place one group of columns rather than 12 individual columns.

Now to create the frieze or triangular region of the roof, simply create a primitive pyramid. Resize the pyramid so that it is equal to the width of the temple, but very shallow (Figure 3.50). Then, rotate this flattened pyramid so that one edge of the pyramid is flat or perpendicular to the ground (Figure 3.51). This may seem like an odd thing to do, but once we place the rest of the roof over this pyramid, all we will see is

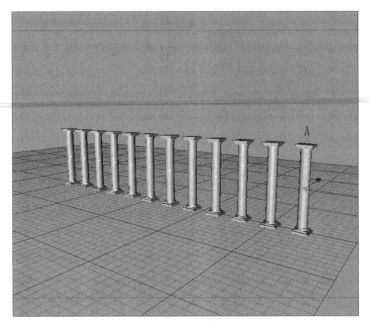

FIGURE *Copied and positioned columns.*
3.48

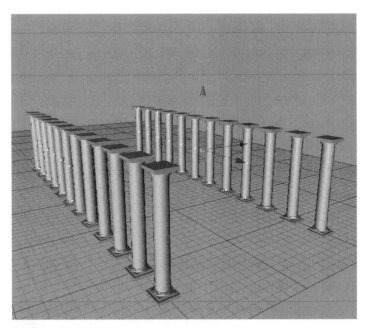

FIGURE *Copied column group.*
3.49

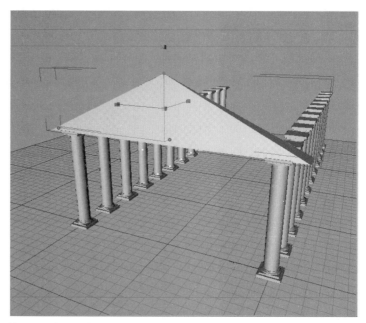

FIGURE **3.50** *Flattened primitive pyramid.*

FIGURE **3.51** *Rotated flattened pyramid.*

the perpendicular plane. One important key to 3D is to re-member that the actual construction of the objects is less im-portant than what is finally seen.

Now, copy and paste this flattened pyramid. Rotate it 180 degrees and position it on the back side of the temple (Figure 3.52).

Group these two frieze sections together and raise them up off the tops of the columns. Now create a cube that goes over the entire tops of the columns and flatten it. Copy, paste, and resize this cube several times to create a profile similar to Figure 3.53.

Group these new cubes into a new group called "Ceiling." Reposition the frieze so that it sits just atop this new ceiling. The temple thus far should appear as Figure 3.54.

To finish the top of the temple, we just need to put some slabs across the top of the frieze to create the roof. Again, a flattened cube is the tool of choice. Create and resize a cube so that it becomes the flattened cube shown in Figure 3.55. Then copy, paste, and rotate this slab so that it can be the

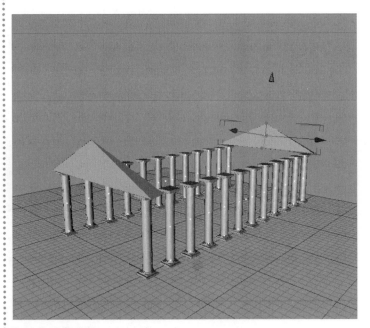

FIGURE *Copied frieze pyramid.*
3.52

FIGURE *Flattened cube for ceiling with target profile.*
3.53

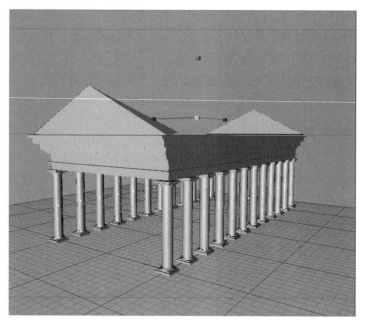

FIGURE *Frieze and ceiling thus far.*
3.54

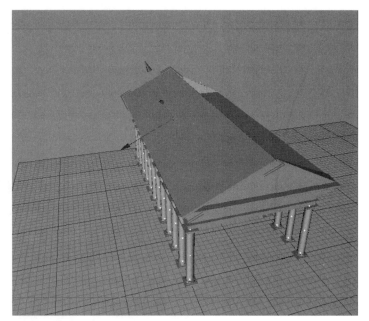

FIGURE *Flattened cube for roof slab.*
3.55

other side of the roof. The key here is to make sure that the slabs are rotated at the appropriate angle to the slope of the frieze, and that the apex where these two slabs meet is very tidy (Figure 3.56). If the connection is clean between the slabs, no one will ever know that they are actually two pieces (Figure 3.57). Repeat this process to create another set of slabs, only a little thicker (Figure 3.58).

For the base of the temple and the stairs, all we will use are primitive cubes. Create two cubes and resize them to appear like Figure 3.59. The stairs are made of other cubes (five, to be exact) arranged as shown in Figure 3.60.

Notice that even though the floor is made of seven different cubes, as long as they are lined up properly so that all of the tops match, the floor appears as one continuous shape. Make a few further fine-tunings by placing some extra pillars in the front and back of the temple, and the temple is done (Figure 3.61).

FIGURE *Clean apex of slabs.*
3.56

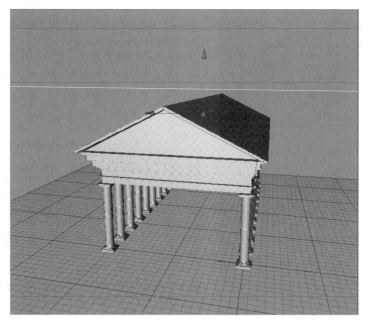

FIGURE *Beginning of final roof.*
3.57

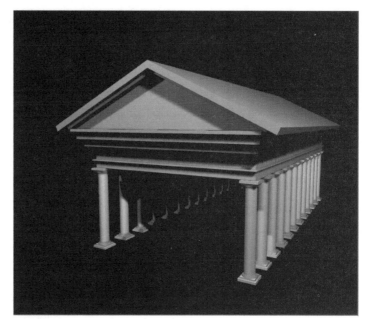

FIGURE *Completed roof.*
3.58

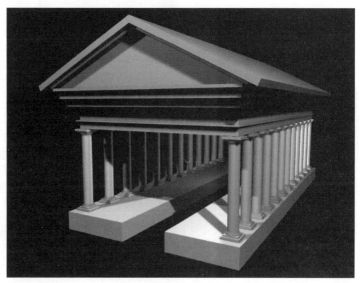

FIGURE *Cubes for the beginning of the floor.*
3.59

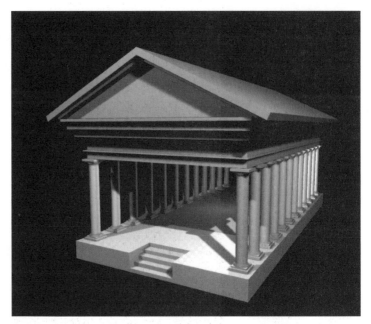

FIGURE *Stairs made from grouped cubes.*
3.60

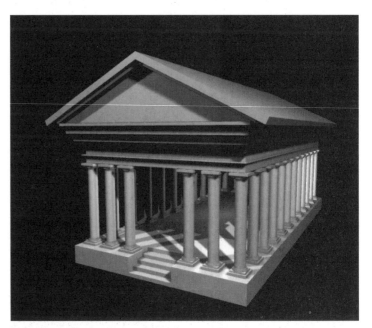

FIGURE *Completed temple.*
3.61

T
U
T
O
R
I
A
L

3.3: NURBS-BASED HUMAN FORM

NURBS are extremely powerful and flexible when it comes to creating organic forms. This tutorial will use NURBS in their most basic form to create a human torso. Remember that although in this tutorial we are only going to use circular splines, NURBS can be based upon any spline shape.

To begin, take a look at Figure 3.62, which is the finished torso we are going to be building. This entire shape is built using loft NURBS to define different cross sections of the form. Notice also that this shape is symmetrical, so we only have to build half of it and then mirror the definitive splines to the other side.

Begin by creating a circle spline and resizing it along its y axis to create a very flat form (Figure 3.63). This will be the tip of the finger.

Now copy and paste this shape, move it a little bit along the z axis, and resize it so that it is a bit larger in all directions. Make it considerably larger in the y direction (Figure 3.64). Use the skin, or loft NURBS function of your program of choice to begin placing the skin over the top of these guiding splines (Figure 3.65).

Continue with this process with at least two more copied, resized, and skinned splines until you have a form similar to Figure 3.66. Indeed, it looks like a fish, but we are keeping this form simple.

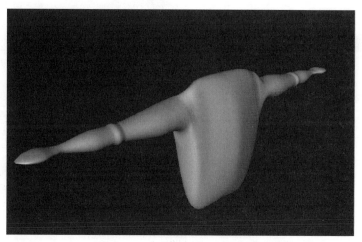

FIGURE *Completed form.*
3.62

FIGURE *Flattened circle spline for fingertip.*
3.63

FIGURE *Copied, pasted, and resized spline.*
3.64

FIGURE *Skinned splines.*
3.65

FIGURE *Completed hand.*
3.66

Work upward on the arm toward the elbow by copying, pasting, and resizing to create the proper form. Make sure to create a new spline at the widest and thinnest points of the arm. For instance, notice that in Figure 3.67, there is a spline at the end of the wrist (thinnest point), one at the upper fore-arm (widest point), another at the beginning of the elbow

FIGURE *Finished forearm.*
3.67

(thinnest), one in the middle of the elbow (widest), and another at the end of the elbow (thinnest).

The rest of the arm is made much the same way. The last spline shown in Figure 3.68 is a very elongated spline to form

FIGURE *Splines for the rest of the arm.*
3.68

the beginning of the shoulder. The shoulder is continued toward the center of the chest using continued pasted splines. Take time to view your model from all viewpoints to make sure proportions are as they should be and the relative position of splines is correct (Figure 3.69). Notice that immediately after the shoulder is created, there are several splines close together. This allows for fairly dramatic change in form along the y axis as would happen on the side of the body.

FIGURE *Half of torso completed.*
3.69

Now that half the torso is created, you can copy and paste each spline starting from the center chest and working out. As you paste the copy, be sure to place it as the mirror image of the spline copied. The result is shown in Figure 3.70.

FIGURE *Completed NURBS torso.*
3.70

Exercises

1. Using the scene that we built earlier in the chapter, add additional furniture to the room. Consider a chair at the desk. How about a bed? All these details can help round out the wooden man scene.
2. Try using straight extrusions to add a chair rail, foot board, and crown molding to the room. Look at the room around you and pick out three other architectural details that could be created with the tools explained thus far.

CHAPTER

4

Advanced Modeling Techniques

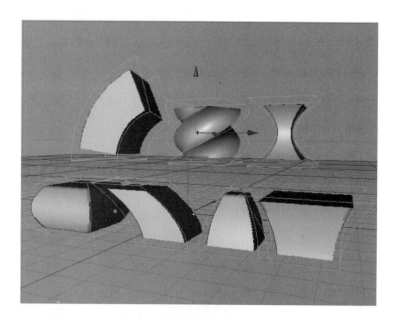

Well, all right, perhaps these are not really "advanced" as much as they are just different. However, although these tools are probably less used than the ones in Chapter 3, "Carving Out Modeling Basics," they are just as powerful when used in the right situation.

Boolean

Remember those Library Technology courses during the early classes the first years of college? If not, have you tried using the parameters of "needle+ straight" to find that online record in the haystack? Boolean searching is the idea of searching for one or more terms that are qualified by making sure the term is coupled with or excludes other terms. Boolean modeling is the same idea. Boolean lets you take one object (A) and add or subtract another object (B) to produce a third object that is the sum or difference of the two source shapes.

It used to be that Boolean modeling could only be found in high-end programs. Now, most every mid-range application includes some form of it. The best way to understand how Boolean modeling works is to see examples of it. Figure 4.1 shows an example of Boolean addition (A Plus B). By using Boolean, the two shapes become one mesh of polygons. This might

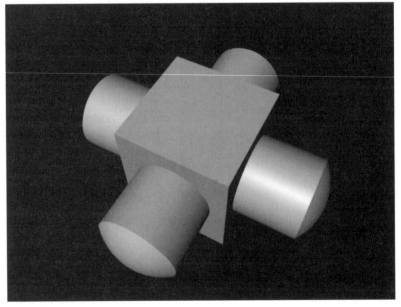

FIGURE *Simple Boolean addition.*
4.1

not seem like a big thing since it looks like the two intersecting objects. However, what is actually happening is that most computers think of models as just shells. Although a ball may look like a solid marble ball, it is really a hollow egg painted like marble. When several objects are intersecting, the 3D application keeps track of the shells of all the shapes that intersect. Figure 4.2 shows a shape with intersecting shapes with a semi-transparent texture applied.

Compare this with Figure 4.3, which is the same shape made with a Boolean function. When the computer uses Boolean addition, it forgets all the polygons that may be contained by shapes inside of other shapes and just remembers the shell that goes around the entire group of shapes. Think of intersecting shapes like taking solid chunks of clay in the form of the original shapes and squishing them together into the desired form. All the original polygons are still there, just inside one another. Now, paper maché over the entire shape and remove the clay from inside the dried maché shell. This shell of the outside shape is like Boolean addition. You can see the difference in Figures 4.2 and 4.3, and how the computer renders each.

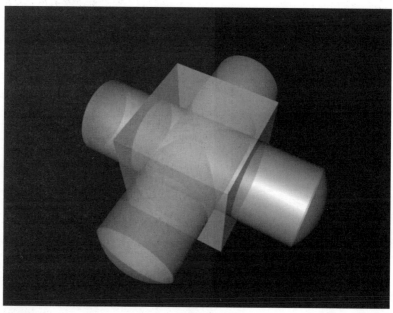

FIGURE *Intersecting shapes with transparent texture.*
4.2

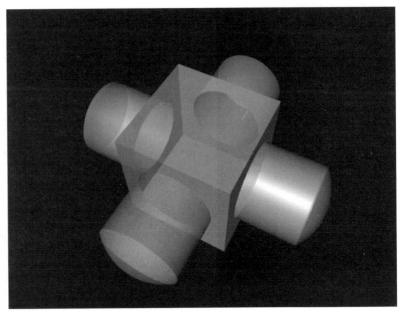

FIGURE *Boolean addition with transparent texture.*
4.3

Boolean subtraction (A Minus B) takes one shape and subtracts its geometry from another. Think of magic shapes that can be inserted into any shape. These magic shapes would then surround parts of the shape into which they were inserted. When these magic shapes are told to disappear, they do, taking with them any polygons that may be within them. Figure 4.4 shows a Boolean subtraction and its resultant shape. It is easy to see how Boolean subtraction allows for the creation of shapes that would be very difficult to create any other way.

Another powerful form of Boolean modeling is Boolean intersection (A*B). This takes two (or more) intersecting shapes and gets rid of all the polygons that are not in direct contact with the polygons of another shape. Figure 4.5 shows a Boolean intersection.

One other function that probably is not exactly a Boolean function but is often categorized as such is the idea of A Without B. Working with the understanding that 3D models are actually hollow shells, Figure 4.6 shows this concept in action. When you use a regular Boolean subtraction, the computer fills in the negative shape of the subtracted object. In A Without B, the 3D application chops out the subtracted shape but does not fill in its

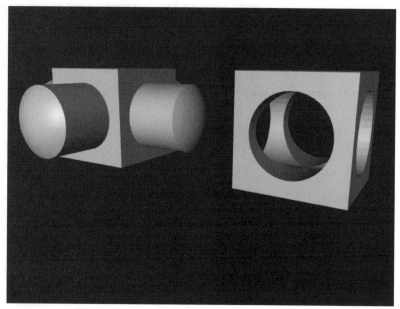

FIGURE *Boolean subtraction.*
4.4

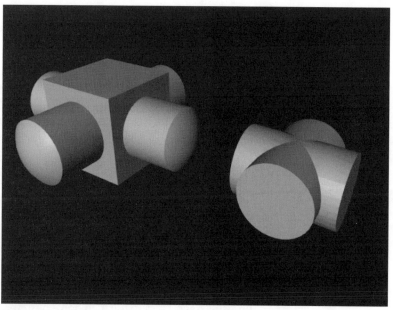

FIGURE *Boolean intersection.*
4.5

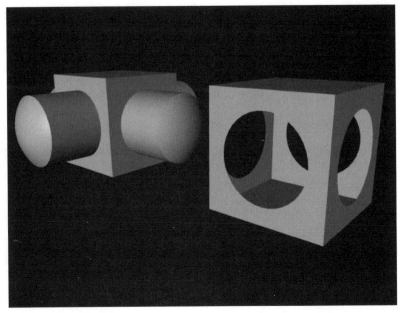

FIGURE *A Without B.*
4.6

negative space, leaving a hole in the remaining shape that exposes the empty shell.

SOME BOOLEAN CAVEATS

There are some tricks to working with Boolean modeling. Before we get to that, it is important to know that most programs will only do Boolean functions with polygon-based shapes. Some programs will act like they are using NURBS-based forms for Boolean functions, but in all actuality, they are sneaking in a NURBS-to-polygon conversion before they actually perform the Boolean function. As we discussed in previous chapters, higher polygon counts yield rounder surfaces. If you tell the computer, "Perform a Boolean subtraction on that sphere and cube," when the sphere and cube look like Figure 4.7, the computer does the math to subtract the polygon shape of the rough sphere on the cube, and the result ends up looking like Figure 4.8.

So, in order to get a good round hole (if that is the intended goal), it is probably a good idea to use high poly-count shapes or to *subdivide* the low-poly models that you have. *Subdivision* is the process of telling your 3D

FIGURE *Low-poly sphere and square.*
4.7

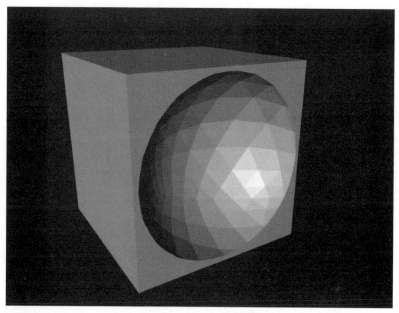

FIGURE *Result of low-poly Boolean subtraction.*
4.8

application to take the known polygons and divide them into smaller sections. This increases your poly-count and allows the shape to be smoother in appearance. Beware, though, this also causes very heavy models, thus slowing your machine and rendering. Each 3D application handles subdivision a little differently.

To further demonstrate Boolean, let's put a lid on our can and punch a hole in it. Begin by making a disc that is the appropriate size (Figure 4.9). Then create another solid shape in the shape that you want the hole to appear (Figure 4.10).

In Cinema4D, create a Boolean Object (Object>Modeling>Boolean) with the two shapes as children, and "A Subtract B" as the selected function. In Strata StudioPro, use the Subtract tool in the Extension palette to drag the hole to be cut to the shape to cut it from. In LightWave, use the Boolean tool (Tools>Boolean) and make sure you have the shape you're cutting from on the background layer. The result should resemble Figure 4.11.

FIGURE *Disc to become lid.*
4.9

FIGURE *Shape to become hole.*
4.10

FIGURE *Lid with cut hole.*
4.11

**Deformation
Lattices**

Imagine you have a ball of metal that is supple like clay. Now imagine a square mesh of magnetized wire surrounding that ball. As you grab the wire and pull at it, the supple metal ball will stretch and deform. Deformation lattices are the magnetic mesh surrounding your polygon of supplemental ball. Figure 4.12 shows a polygonal shape surrounded by a deformation lattice in Strata StudioPro. Figure 4.13 shows the lattice pulled and pushed, resulting in the deformed polygonal form.

"Big deal," you may say. "There must be an easier way to get that sort of deformed ball." Well, there are easier ways to get a deformed ball (see the discussion of mesh deformations later in the chapter); however, the power of these sorts of deformations is the ability to move shapes in and out of the deformation lattice. Figure 4.14 shows a shape outside the lattice, entering the lattice, and leaving the lattice in Studio Pro. Figure 4.15 shows a deformation lattice in Cinema4D moving over a shape, and the resultant distortion.

This method becomes tremendously powerful as you move into animation. It provides all sorts of comical effects of cars sliding down a dinosaur's

FIGURE *Deformation lattice unaltered.*
4.12

FIGURE *Deformed deformation lattice.*
4.13

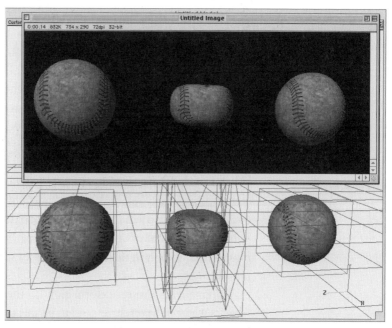

FIGURE *StudioPro deformation lattice and moving baseball.*
4.14

FIGURE *Cinema4D Free Form Deformation (FFD) region moving over pipe.*
4.15

throat or exaggerations of a big, bouncing marshmallow trying to enter a
straw, shrinking as it travels through the straw, and then squeezing out the
other end. Besides animation capabilities, FFDs can be a powerful tool to
create quite complex and organic shapes. Figure 4.16 shows a dynamically
shaped chest created by Frank Braade that was distorted using deformation
lattices.

Vertex Level

When I teach 3D classes and show how point-level deformations work, the
class enthusiastically responds with a chorus of ooohhs and aaahhs. That is
until they actually try to use it; then the ooohhs and aaahhs turn into wails
of frustration. Point or vertex-level deformation is theoretically one of the
most powerful tools in many 3D applications. However, it can also be the
most frustrating.

Working with a vertex deformation (in theory) is the ability to see the
vertexes where polygons meet, and to be able to pull and push those points.
It is supposed to be like some sort of virtual clay. The frustrating part stems

FIGURE *Frank Braade used FFDs to deform this chest.*
4.16

from the fact that when we are telling the computer what to do in 3D digital space, we can only effectively tell it in the two dimensions present on our screen. It is often hard to tell which parts of the model you are pushing or pulling. In addition, it is very easy to deform a polygon shape too much and end up with really awkwardly distorted shapes that are impossible to properly reassemble.

Many programs show the vertex points as beziér handles or spline points. This assists in creating smooth deformations so you can pull those points out to make a round face rather than one made of rock shards. As programs advance, they become increasingly adept at allowing users to manipulate polygons as they see in their mind. Virtual sculpting through virtual tools is becoming increasingly intuitive. Maya's Artisan (Figure 4.17) or Play's Amorphium (Figure 4.18) are making great strides in allowing for great mesh deformations. Watch for this theory to become a reality in most programs in the future.

FIGURE *Artisan screen shot.*
4.17

FIGURE *Amorphium screen shot.*
4.18

Standard Deformations

Some uniform sorts of distortions such as bending and twisting are currently included in many 3D packages. These allow for easy alterations of shapes in some nice structured ways. Figure 4.19 shows examples of shapes subjected to these sorts of treatments. Typically, this is a *nondestructive* form of altering an object. Nondestructive forms of modeling are those that allow you to go back to the original unaltered shape.

The table legs of our wooden man project are comprised of regular primitives and a taper deformation (Figure 4.20). See your user's manual to find out the specifics of deformations for your program of choice.

While we are talking about deformation, it is important to mention another very important way of deforming shapes: *bones*. Bones (which assist in Forward Kinematics (FK) and Inverse Kinematics (IK)) are perhaps the single most powerful deformation tool, especially in areas of character animation. Bones are so important in fact that all of Chapter 12, "Advanced Animation Ideas," is devoted to it, so there are many more deformations to look forward to.

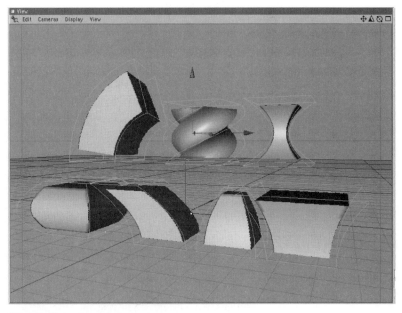

FIGURE *Twist, bend, bulge, twist, wrap.*
4.19

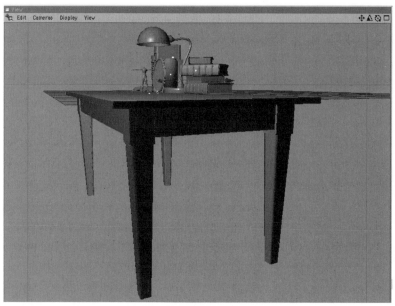

FIGURE *Table legs.*
4.20

Metaballs

Metaballs is a great method of creating organic shapes. Spheres and elongated spheres are very easy to make in 3D applications. A very complex shape like a nose can be roughed out by making many spheres and arranging them appropriately. Imagine that the figure shown in 4.21 is raw cookie-dough balls. If you were to put those balls in the oven, as they cooked they would spread and join with the balls around them. Figure 4.22 shows what form results from "metaballing" the spheres in Figure 4.21. Metaballs is also a great method of creating organic shapes (Figures 4.23 and 4.24).

Metaballs behave much like balls of mercury in a dish; as they get close together, they begin to influence each other. The closer they are, the more they influence each other until it becomes impossible to tell them apart (Figure 4.25). 3D applications that use metaballs go one step further by allowing you to designate how strong this attraction between spheres is. Figure 4.26 shows a series of spheres the same distance apart with differing levels of attraction.

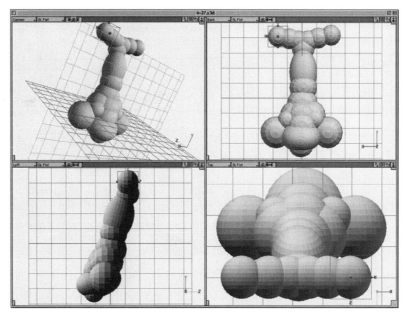

FIGURE *Nose from spheres.*
4.21

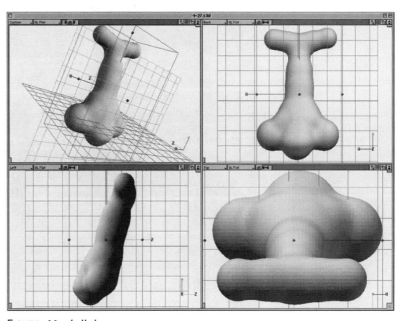

FIGURE *Metaballed nose.*
4.22

FIGURE
 Alec Syme's use of metaballs.
4.23

FIGURE *Brian Castleforte using metaballs for character modeling.*
4.24

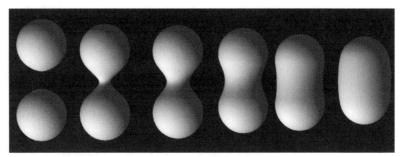

FIGURE *Spheres getting closer together with metaballs.*
4.25

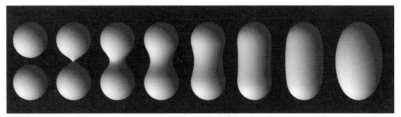

FIGURE *Metaballs with varying attraction properties.*
4.26

It is easy to see how powerful metaballs can be. The only problem is that in order to make nice, round, organic shapes, metaballs must make high poly-count objects. These high poly-count objects can quickly add up to be an extremely heavy model, so use metaballs with restraint.

We will use metaballs to create the head of our wooden star. First, create five spheres and organize them approximately like Figure 4.27. In Cinema4D, create a Metaball Object and then place the spheres within its hierarchy. In Strata StudioPro, select all the spheres and use the Metaball tool within the Extensions palette. In LightWave, you will want to blend HyperVoxels (see pages 11.13–11.14 of your manual).

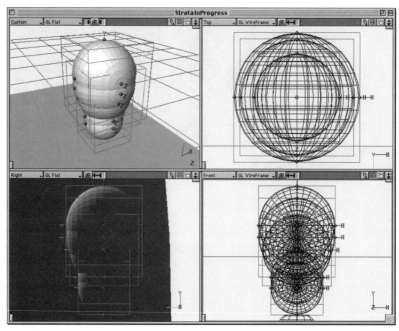

FIGURE *Spheres to become metaballed head.*
4.27

HyperNURBS or SubPatch

HyperNURBS, like all NURBS objects, are generator objects; that is, they create new shapes by using other shapes. Most NURBS objects use spline objects to generate shapes. HyperNURBS is the notable exception. Hyper-NURBS uses polygons or primitives to create new rounded shapes through a subdivision algorithm. Translated, this means that you can begin with a square and pull facets of faces of it in new directions into lots of new shapes, and then once placed in a HyperNURBS, the square edges become round (Figure 4.28).

Not all 3D applications have this powerful feature. Only recently has it been added to Cinema4D's arsenal. LightWave has had SubPatch, which is its term for creating objects in this way, for quite a few versions now. Strata StudioPro does not have a HyperNURBS functionality; therefore, if you're following the Strata StudioPro end of the tutorial, use the skinning method for the feet and hands that we are about to create using HyperNURBS.

Figure 4.29 shows the shape before HN or SubPatches. Notice that it is the general shape of the foot without worrying about any of the round edges. Figure 4.30 shows the rounded (HN'ed or SubPatched) final foot.

Repeat this process for the hand shapes (Figure 4.31).

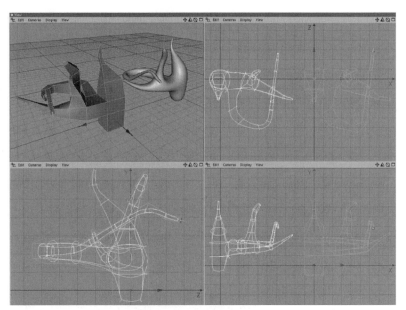

FIGURE *An object, and the effect of HyperNURBS on the same object.*
4.28

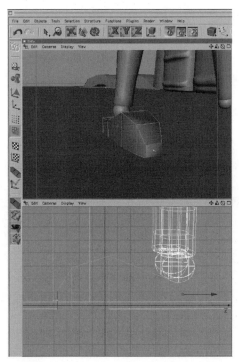

FIGURE *Square shape.*
4.29

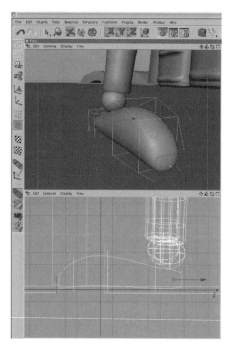

FIGURE *HyperNURBS rounded shape.*
4.30

FIGURE *HyperNURBS for hands.*
4.31

Terrain Modeling

Besides the chopping, adding, bending, twisting, and deforming of polygon shapes, there are also some other important ways to create very interesting shapes. Many of these have to do with modeling landscapes. Think of trying to model every mountain, hill, groundhog mound, and anthill in an extensive landscape. Besides the fact that it is quite difficult to model true to the form of Mother Nature, it would be an incredibly time-consuming attempt. Because of this, 3D applications often provide what are referred to as *fractal landscape generators.*

Fractal landscapes often contain an amazing amount of details in shapes that would take forever to model using any other method. The problem is, animators are not always skilled with fractal equations, so it can be difficult to control exactly what the fractal terrain will turn out to be. However, if the specifics of where the mountains and valleys happen to be are unimportant, fractal terrains are an excellent method (Figure 4.32).

Sometimes you need to be able to tell the 3D application exactly where the mountains and valleys are. Luckily, most provide for the generation of landscapes through grayscale figures. Using Photoshop or some other drawing program, or even using satellite photographs, you can create an image that designates valleys as black and mountain tops as white. The brighter

FIGURE *Fractal terrain rendering.*
4.32

the region, the taller it will appear in 3D form, and vice versa for dark regions. Upon import, the 3D application will take this two-dimensional color image and convert it into a three-dimensional polygon. This is essentially what a displacement map is in texture-land, which will be covered in more detail later.

There are other ways to build digital terrains. Some are very accurate, like DTM (Digital Terrain Map) or DTED (Digital Terrain Elevation Data) as provided by the USGS (United States Geological Survey). These are such specialized forms, the discussion of how to produce these sorts of terrains is probably best left to another forum. However, sometimes knowing that a method exists is half the battle, so it is worth mentioning.

Alternate Model Sources

Now that we have spent so much time discussing how to build models, remember there are always alternatives. You can purchase models through a variety of venues. They can be sent to you on CD, or can be purchased per piece online (see viewpoint.com, for example). Just do a search on 3D models with your favorite search engine, and a multitude of sites appears. Besides purchasing options, model exchanges exist where folks can contribute the models that they have created and download other models that others have made. Still other sites are simply model depositories where you can download the models at will (3dcafe.com). Each model site has its own set of rules and legal restrictions, so be sure to read the fine print. The key is, downloading a free model can save you hours of time. Some diehards insist on modeling everything from scratch, and when working on a commercial project, this is probably a good idea. However, if the point of an animation is the wooden dummy walking across the table and not the scissors in the background, it makes sense to spend your modeling time on the most important objects, and drop in the others like clip art.

Model Formats

When you begin modeling in a 3D application, the application stores the information in a special proprietary (special to that application) format. Usually, these proprietary formats are optimized for the application you are using, which helps the model remain flexible as you mold and change it within that application. However, this also means that you probably cannot open that proprietary model in other applications. Most applications allow you to import certain model formats that were created in other applications, but there are a few formats that are fairly universal.

.3DS files are 3D Studio files usually created by Kinetix's 3D StudioMax or some variation of that software. .3DS files are usually easily imported into most any 3D application. .DXF files are another format that is fairly universally accepted. So, as you are looking around for stock models, keep an eye out for the file format, or you will spend hours downloading a file that your application cannot understand.

T
U
T
O
R
I
A
L

4.1: CAGE MODELING NOSE CREATION

We have already looked at a rough example of organic creation of a nose shape in the Metaball section. This is a brief tutorial on how to create a nose shape using subdivision techniques of cage modeling. We will create the entire nose based on one simple cube from which we will extrude or pull away all the flat facets to create a blocky nose. Then, once the angular nose is placed within a smoothing object or Hyper-NURBS object, the shape will round out, presenting a well-rounded shape where once only harsh corners existed. The target shape is shown in Figure 4.33.

FIGURE *HyperNURBS nose.*
4.33

To begin, simply create a primitive cube. You may need to alter the state of this cube to make the polygons accessible to this method of polygon pulling. Once you can alter polygons, make a symmetry object so that when you alter one side, the other side alters as you go. Begin by selecting the front facet with the Polygon Selection tool. Using the Extrude tool of your chosen program, extrude the front facet, and resize it smaller to create a shape as shown in Figure 4.34. This will be the tip of the nose.

FIGURE *Tip of nose pulled out.*
4.34

Further define the general shape of the nose by extruding the top of the nose and shifting its position to match Figure 4.35. Before we continue, check out what the shape thus far rounds off to. To see what the nose looks like, subdivide it or place it in a HyperNURBS (HN) object (Figure 4.36). After seeing the rounded version, you may need to adjust the extrusions you have made so far. Simply select the offending facets again, and move, rotate, or resize to correct the problem.

Pull the beginnings of nostrils out by extruding the side facets of the original cube (Figure 4.37). Make sure to resize

FIGURE *Top of nose pulled out.*
4.35

FIGURE *Subdivided nose.*
4.36

FIGURE *Nostrils pulled out.*
4.37

and shift these newly extruded facets to match Figure 4.37. You may also wish to rotate these new faces, although you probably want to wait until more of the form emerges.

Now if we look at the nose shape from the bottom, the space between the nostrils is too large (Figure 4.38). To correct this, select the bottom facet and resize it along the x axis to be similar to Figure 4.39.

Now, for the nostrils, select the bottom face where the nostril should go, and do an inner extrude, or an extrude that creates a new facet that remains on the surface of the parent facet (Figure 4.40). Then, extrude this new face up into the nose (Figure 4.41).

Now, using the Points tool, adjust the cage that defines the nostrils until you get a shape that you want. Make sure that if you are not using symmetry functions, you adjust all changes on both sides of the nose. Spend some time in front of a mirror to better understand the form. A suggested shape is shown in Figure 4.42.

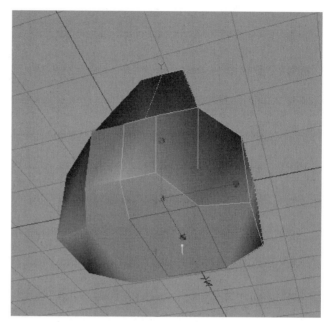

FIGURE *Bottom of nose before center adjustments.*
4.38

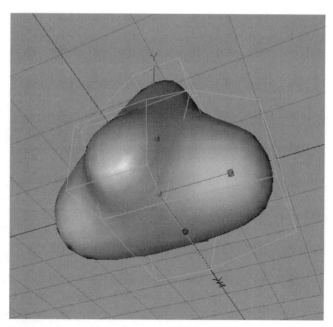

FIGURE *Bottom of nose after center adjustments.*
4.39

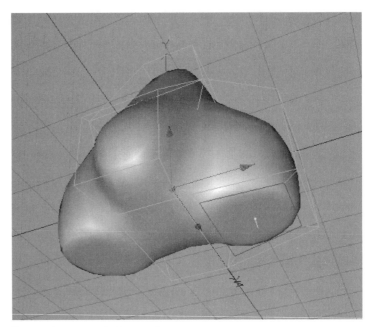

FIGURE *Inner extrude for nostril.*
4.40

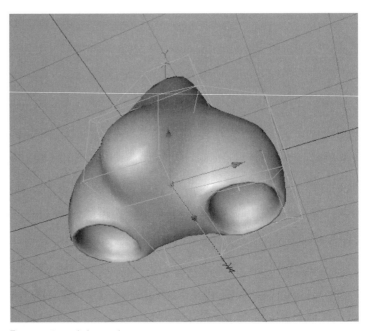

FIGURE *Extruded nostril.*
4.41

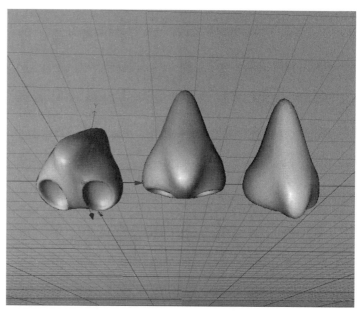

FIGURE *Finished HN nose.*
4.42

T
U
T
O
R
I
A
L

4.2: MODELING HANDS USING SUBDIVISION OR CAGE MODELING

For complex organic shapes like hands, cage modeling is a dream come true. However, it is a good idea to strategize a bit before tearing into the process. Begin by taking a sketch or photograph of the desired modeled object and "block it off." That is, decide where the cage or polygon subdivisions should occur. Figure 4.43 is just such a strategizing sketch.

From the sketch, we can see that there are four main sections (one for each of the fingers) and a section that breaks off early for the thumb. So, to begin with, create a cube with four segments and make it editable if necessary. Resize the cube so that it is thin and appropriate for a hand (Figure 4.44).

Now select the four polygons across the top of the shape and extrude them all up enough to give you a polygon facet on the side from which you can extrude the thumb (Figure 4.45).

Extrude these four facets again up to where the fingers are to start (Figure 4.46). At this point, we need to adjust the

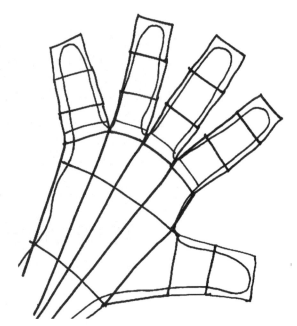

FIGURE *Hand strategizing sketch.*
4.43

FIGURE *Segmented polygon-based cube.*
4.44

FIGURE *Initial extrude done to leave facet for thumb extrusion.*
4.45

FIGURE *Finished palm extrusions.*
4.46

relative position of each of these facets, as the fingers do not all start at the same level. To do this, select each facet separately and arrange them to approximately match Figure 4.47

Now let's go back and create the thumb. Select the bottommost facet on the side of the hand and extrude it out. Reshape this new facet and rotate it to match Figure 4.48. Next, create the rest of the thumb by extruding this new facet out twice more to create an image similar to Figure 4.49.

Before we continue, check your progress by placing this shape within an HN object or rounding it off. The result should look something like Figure 4.50.

Back to the fingers. Previously, when extruding the faces, we did so as a group to maintain a solid shape. However, now the fingers need to separate from each other, so we need to extrude each finger out one at a time. Select the face of the index finger and extrude it out three times to create the finger with each joint (Figure 4.51). Do not be too concerned about the absolute size, rotation, or position of the fingers at this

FIGURE *Arranged finger bases.*
4.47

FIGURE *Start of thumb.*
4.48

FIGURE *Completed thumb.*
4.49

FIGURE *Subdivided hand.*
4.50

FIGURE *Index finger extruded.*
4.51

point; they can all be altered later once you can see all the fingers together.

Now repeat this process with the other fingers as shown in Figure 4.52.

Now comes the point of refinement. Using the Points tool, adjust the proportions of the hand until they match your own. Figure 4.53 shows a refined version of the hand.

Starting from the bottom end, extrude out a wrist (Figure 4.54). Further refine your hand as desired with the Points tool. Pull out points to make the top of the hand rounded. Push points in to collapse the palm a bit to give your hand all the details it needs. That is it, we have modeled the hand.

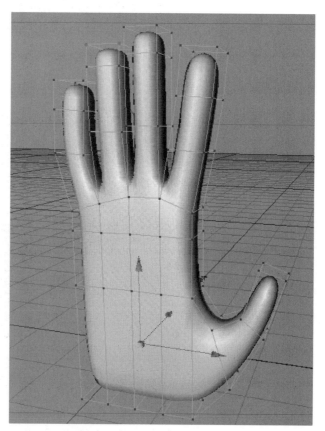

FIGURE *Extruded fingers.*
4.52

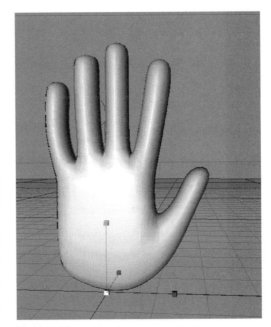

FIGURE *Adjusted hand.*
4.53

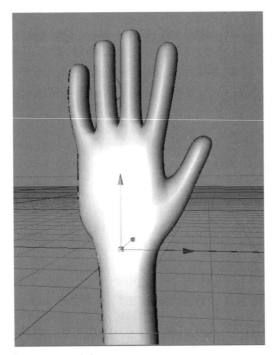

FIGURE *Extruded wrist.*
4.54

Exercises

1. Use Boolean modeling to add a window to one of the walls in the wooden man scene. Add another wall where the door would really be, and knock out the doorway.

2. Using the model of the amazing wooden man, use the simple tools of scale and distort to alter the sizes and proportions of the amazing wooden man to create some amazing wooden children.

3. From scratch, create an amazing wooden woman. Sketch her first and determine what anatomical differences are necessary to make her match her male counterpart stylistically.

4. To round out the wooden family, use all the modeling tools described to create an amazing wooden pet. Try using simple Booleans and deformations to create a dog. HyperNURBS or SubPatches would make a great fish. Try creating a snake with segmented primitives and Booleans.

5. Download some royalty-free models from Web sources that would look appropriate in the wooden man scene. You might start at www.3dcafe.com, or just search for 3D models. Make sure to download models that are compatible with your chosen software.

5

Texturing Surfaces

R ecently, I visited a painter friend of mine and noticed a "Peanuts" cartoon strip tacked to the wall. On the next visit, he had a banana peel tacked in the same spot. The visit after that he had a postcard of another artist tacked to the same place. Upon examining the postcard further, I realized it and all the other objects there had been painted on the wall in trompe l'oiel. Visiting a few weeks later, I noticed a smallish basketball sitting on the floor, but when I reached down to play with it, I realized that it was a bowling ball painted to look like a basketball.

This is how texturing works. When you model within a 3D application, the gray or white object that the application shows you is simply a collection of colorless polygons. Texturing is a sort of veneer that goes over the top of the polygons to make the polygons look like a recognizable object with a tactile surface. Some textures actually make changes to the polygons they are laid over (e.g., displacement maps), but more on that later.

Texturing will be how we make our wooden man look wooden and our lamp look like brushed metal. Before we get into the details of applying textures, it is important that we understand some terms and theories first. This chapter is almost all definition and theories. If you are familiar with the ideas and just want to get down to the practical details, skip to Chapter 6, "Advanced Texturing Techniques."

Types of Textures (Procedural and Bitmapped)

Before we dive into the different types of textures, it is important to note that there is a multiplicity of names for textures. Some programs call them "Materials," while others call them "Shaders." They are all the same beast with different names. There are two categories of textures available in most 3D applications: *procedural* and *bitmapped*. Procedural textures (often referred to as "Shaders") are a method of giving color to an object through mathematical formulas. Many take advantage of the idea of fractal geometry because of its accuracy in portraying natural phenomena such as trees, marble veins, clouds, and various other natural shapes. A big benefit of procedural textures is that they do not "break down"; that is, no matter how closely you look at an object with a procedural texture, it maintains its visual integrity. Figures 5.1 and 5.2 show various procedural textures viewed at various magnifications.

Besides being viewable from any magnification, procedural textures also have very little overhead. Since they rely on a formula to create appearance, they do not have to rely on any image, and thus save time in rendering. Many applications come with a variety of procedural textures built in, and

FIGURE
5.1
Procedural texture at a distance.

FIGURE
5.2
Procedural texture up close.

third-party procedural textures can also be purchased. The biggest drawbacks with procedural textures are that they work best with organic textures, and you are somewhat relegated to what the texture programmer had in mind. For the increase in rendering speed, you give up some control. Having said this, let it also be pointed out that often procedural textures do allow for some variation. For instance, Figure 5.3 shows an image by Matt Kleis in which he altered water and cloud procedural textures.

The second type of texture, and the type probably used most often, is a *bitmapped* texture (sometimes also called an *image map*, *texture map*, or *picture map*). The basic idea of a bitmapped texture is that you can use any created or altered bitmapped image (including photographs) in any

The Horde © Copyright Matt Kleis 1999

FIGURE *Matt Kleis' procedural mastery.*
5.3

application you like (Photoshop, Illustrator, Freehand, etc.), and project or place it on the surface of polygons. This is a popular form, as most anyone can create their own bitmapped textures. There are some drawbacks, however; bitmapped textures break down if the viewer gets too close, because the textures are based on bitmapped figures. Figures 5.4 and 5.5 show a bitmapped texture at a distance and up close. Notice the breakdown, and keep that in mind as you construct your maps.

In the hands of a master, bitmapped textures can be the most interesting and/or photorealistic options available. Figure 5.6 shows the results of Alec Syme's tackle box and some Photoshop wizardry.

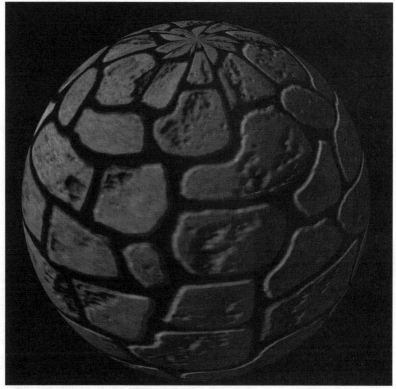

FIGURE *Bitmapped at a distance.*
5.4

FIGURE *Bitmapped up close.*
5.5

FIGURE *Alec Syme's bitmapped texture mastery.*
5.6

**Texture
Mapping**

Texture mapping is the way your texture is applied to the object. For instance, some textures are wrapped around an object like a blanket (Figure 5.7), while others appear as though they are being projected onto the object through a slide projector (Figure 5.8).

Texture mapping makes a huge difference in determining what your object finally looks like. Different programs sometimes offer different methods of texture mapping, although almost all have the same group of core techniques: spherical, cylindrical, flat, cubic, and UV.

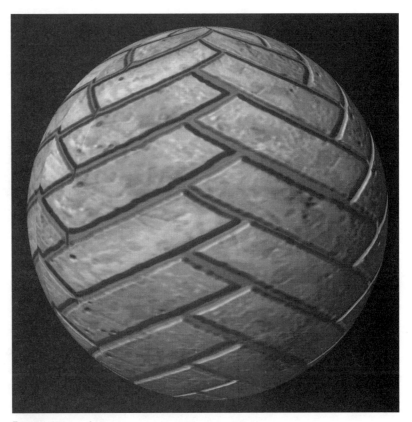

FIGURE *Wrapped texture.*
5.7

FIGURE *Projected texture.*
5.8

SPHERICAL MAPPING

Remember all those discussions in geography class about the difference be-
tween a map of the world and a globe of the world? The idea was that a map
of the world stretched and distorted the countries near the poles to make a
flat representation; thus, Antarctica and those northern European countries
seemed huge. Only after you examined a globe of the world did those land-
masses take on their actual size. A globe has "pinched" poles. This is how
spherical mapping works; the 3D application pinches the poles of the map
as it wraps around an object. Figure 5.9 is a map of the world and a sphere
using that map. Notice that spherical mapping can work effectively on
nonspherical objects.

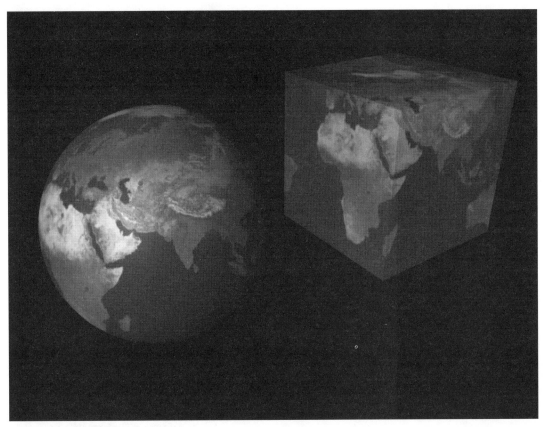

FIGURE *World map and textured globe and cube.*
5.9

CYLINDRICAL

Cylindrical mapping is wrapping the texture around an object in one direction. It is the blanket of those "pigs in a blanket" you used to make in Boy or Girl Scouts. This mapping technique works well with bottles or cans (Figure 5.10). It does not work very well with most complex forms, however, because of the lack of texturing on tops and bottoms.

FIGURE *This Coke bottle by Alec Syme uses cylindrical mapping.*
5.10

FLAT MAPPING

If you ever attended the popular *The Rocky Horror Picture Show* and saw all the folks dressed up as characters jump up on stage in front of the screen, you may have noticed how the movie fell across the forms of their bodies. Flat mapping (sometimes also called projection or planar mapping) works in the same way, except that when the fans were facing the projector, their backside was in shadow, while an object that is using flat mapping shows the texture as well. It is as if there is a texture gun that is shooting color that can pierce through objects as though they were blocks of glass. The texture on the opposite side is a mirror image of how the texture appears on the front of the object (Figure 5.11). This method works well with floors or walls, shapes that are essentially one plane.

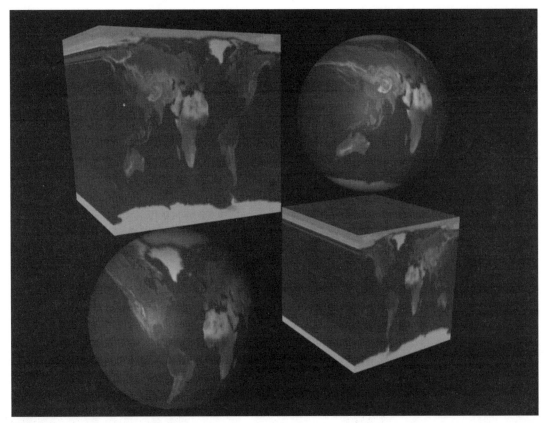

FIGURE *Flat mapping front and back.*
5.11

CUBIC

Cubic mapping is similar to flat mapping, except that (using the projector analogy) there are six projectors, one for each plane of a cube (Figure 5.12). This works very well for objects that are indeed squarish in shape—like a cube. This method does not work so well for round objects, as it makes the seams of where one projector's image ends and the next one begins too obvious.

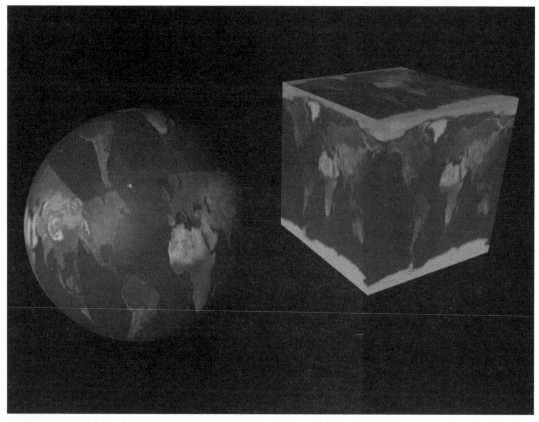

FIGURE *Cube and sphere with textures using cubic mapping.*
5.12

UV OR UVW MAPPING

Most textures have two-dimensional coordinates, *x* and *y*. These coordinates define the texture's horizontal and vertical positions. Many 3D applications use *U* and *V* instead of *x* and *y* to refer to textures when they are defining horizontal and vertical positions. In most cases, two coordinates would be sufficient, except that 3D has three dimensions and some textures have emerged that are 3D shaders. In order to fix a texture in three-dimensional space, a third coordinate *W* is added. Not long ago, only the crème de la crème of 3D applications included UV mapping; now almost every application has this powerful tool. The mapping methods we have looked at so far all treat the object as though it were a simple shape (a cube for cubic, cylinder for cylindrical, etc.); UV mapping recognizes more complex shapes and attempts to wrap itself around the various contours of the shape (Figures 5.13 and 5.14).

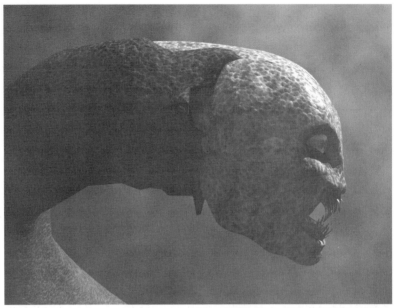

FIGURE *Good example of UV mapping by Stefan Eriksson.*
5.13

FIGURE *Zach Wilson's UVW mapping example.*
5.14

Another big advantage to UV mapping is the ability to stamp out "crawling" textures. Often, when using other mapping methods, the texture will appear to crawl along the surface of the object as it is animated through distortion methods (deformation lattices, IK, etc). UV mapped textures know where to stick as an object such as a character is animated.

Knowing which method to use and where is often a matter of experimentation. You can make educated guesses while analyzing the shapes you are attempting to texture. If the shapes are obviously cubes, cylinders, spheres, or planes, then it is very easy to know that cubical, cylindrical, spherical, and flat will work. Likewise, sometimes you will find that these methods work better with more complex shapes than UV mapping does. Luckily, it is very easy to change the mapping on an object. Often the key is to use several different texture mapping techniques on the same object. For example, see Figure 5.15 by Kim Oravecz in which a cylindrical mapping technique was used around the midsection, while a flat texture was used for the top.

Copyright 2000 Kim Oravecz

FIGURE *Kim Oravecz's multiple mapping technique.*
5.15

Being able to manage texture mapping can be one of the most important parts of texturing. For this reason, all of the different forms of texture mapping are covered in the next chapter.

Texture Channels

The real power of bitmapped textures is the ability to control different *channels*. Texture channels are synonymous with texture characteristics. That is, there is a channel for a texture's color, another for its reflectivity, another for its glow, transparency, bump, geometry, etc. In each channel of a given texture, you can place an image (called a "map") that tells the 3D application how that texture will appear. For instance, Figure 5.16 shows a ball with a texture with just a color map (that is, an image in the color channel) and the map used. Figure 5.17 shows the same object and texture with a bump map. Figures 5.18 and 5.19 again show the same object with a reflection map (making certain parts of the texture reflective and others not) and a transparency map (making sections of the texture transparent) applied, respectively. See the companion CD-ROM for color versions of these figures.

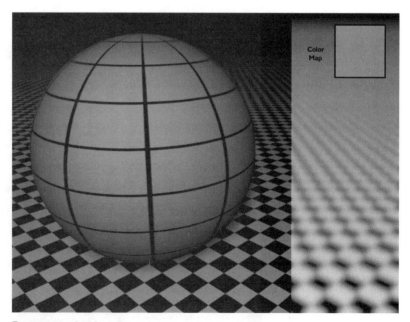

FIGURE *Simple color map.*
5.16

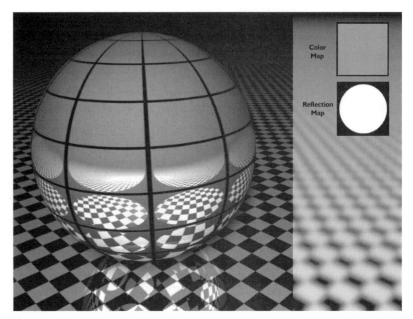

FIGURE *Color and reflection map.*
5.17

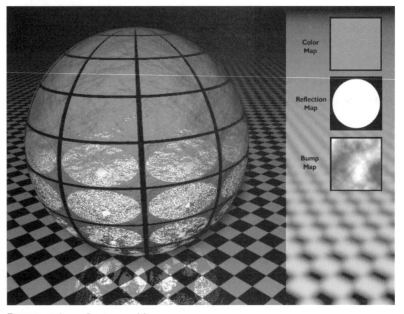

FIGURE *Color, reflection, and bump map.*
5.18

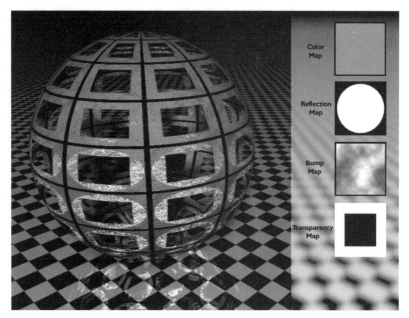

FIGURE *Color, reflection, bump, and transparency maps.*
5.19

There are a variety of channels for each given texture. Each program handles the nomenclature for these channels a little differently, but most include some variation of the channels listed in the next section.

A Note on Maps and the Color Paradigm

Maps are the actual figures placed within channels that tell the channel how to behave. Different channels have different protocols when it comes to interpreting maps. For instance, a color channel (also sometimes called *diffusion*) naturally works best when the map (which is just a bitmapped image) that is imported is in color. Other channels work on a grayscale paradigm. For instance, most bump channels interpret the entered map as a grayscale image in which the areas that are closest to white are raised while the areas closest to black are not (some programs actually recess black areas). Figure 5.20 shows an object with a low-contrast bump map applied. Figure 5.20 also shows the same object with the same map, only with a very high-contrast bump map.

Similarly, ideas such as transparency usually work on this same sort of black-and-white definition scale. Your 3D application interprets the map in

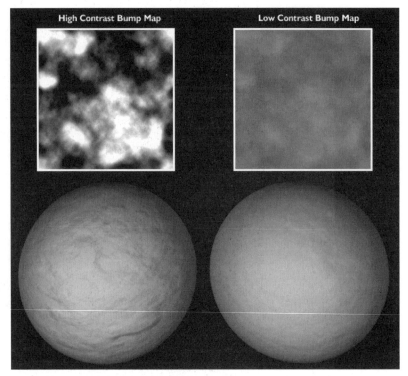

FIGURE *Low- and high-contrast bump map.*
5.20

the transparency channel and assigns all the black areas of your map to be transparent while all the whites are opaque (or vice versa, depending on your application). Many programs even deal with semitransparent areas that can be defined in grays (Figure 5.21).

Not all channels allow for the importing of maps. Some, like fog, are simple dialog boxes that allow for the definition of that channel's characteristics. See the different tutorials on the CD for more texture details on your specific program.

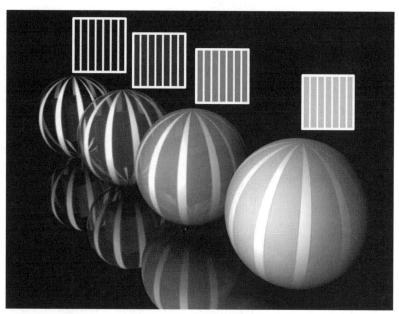

FIGURE *Transparent map 1, 2, and 3.*
5.21

Texture Channels

The characteristics of a given texture are defined through channels. Each channel represents a certain quality of the texture. The following list details some of the various channels in which you can import maps or simply alter the settings to create textures.

COLOR

This is the most straightforward channel. Color maps are perhaps the most descriptive of the channels, as they instantly let us know if we are looking at a slice of tofu or cheddar cheese. The idea behind a color map is that it tells the 3D application what color to place where. Sometimes, color maps are simple flat colors, while at other times, color maps are actual figures or photographs (Figure 5.22).

DIFFUSION

Diffusion deals with irregularities in surface color. For instance, if you are dealing with a metallic surface that has subtle changes over the face of the surface, you can map these changes out with a good diffusion map.

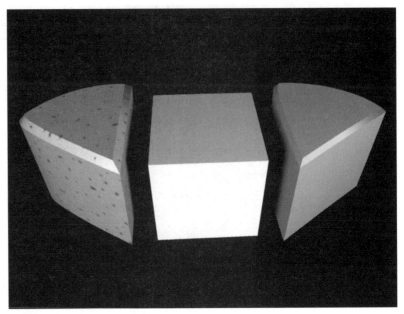

FIGURE *Blue cheese, tofu, cheddar cheese.*
5.22

LUMINANCE

Luminance is sometimes called "light-independent color," which basically means that an object has its own "inner-light." This differs from a glow texture in that the luminance color is strictly limited to the area the map defines and does not spill out—except in Strata StudioPro. Strata StudioPro calls its luminance qualities "Glow." Likewise, a luminance map does not actually cast any light on the objects around it (Figure 5.23).

TRANSPARENCY

There are two heavy uses for this type of channel. These channels are incredibly powerful, but require a new way of thinking. Transparency maps can act sort of like a cape of invisibility; or even better, a cape of semi-invisibility. A transparency map can turn an orange into a crystal ball, or change a baseball into a wicker ball (Figure 5.24). In Figure 5.24, the last sphere shows how transparency maps can also exhibit the light-bending (re-

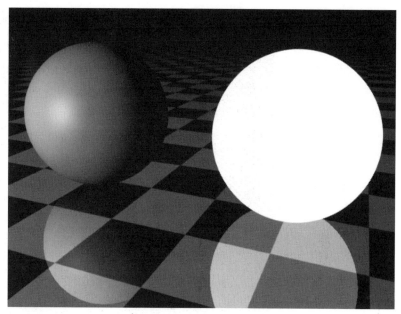

FIGURE *Object with a luminance map.*
5.23

fractive) qualities of light. *Refraction* refers to the way light is bent as it passes through objects. Different objects in nature use different refractive qualities; the refraction as light passes through water is different than as it passes through glass. Most 3D applications allow you to determine if and how much refractive qualities are to be assigned to a certain texture. Texture maps can be semitransparent in the sense of simply letting light pass through them as in the ears shown in Figure 5.25.

Besides the refractive ideas of transparency maps, there are tremendous faux modeling capabilities in transparency channels and mapping. Sometimes programs separate these ideas of turning a solid object in to one with certain sections being completely see through, into other channels called *genlocking* or *alpha maps*. The idea of creating a map to essentially designate new geometry is incredibly powerful, but more on that later.

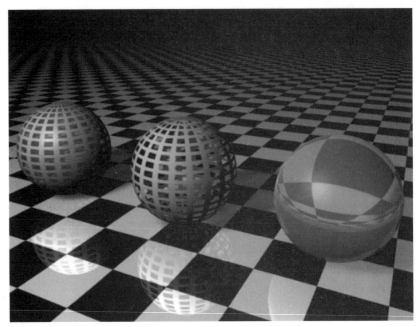

FIGURE **5.24** *Crystal ball and wicker ball.*

FIGURE **5.25** *Switch A. Roo by Kim Oravecz.*

REFLECTION

This channel allows an object to reflect other objects or environments around it. Reflection maps allow you to define which parts of an object will be reflective, and which areas will be matte. For instance, in Figure 5.26, the ball on the left has reflection enabled, but no map. The second ball has a reflection map that causes the blemishes to be nonreflective. One warning about reflection, though: It increases the time needed to render fairly dramatically, and so should be used only when needed (besides the fact that the world at large is tired of seeing reflective chrome balls on checkered floors; but that is a whole other soapbox).

FIGURE *Reflection mapping illustrations.*
5.26

ENVIRONMENT

This channel allows you to create a faux reflection. It actually paints an environment (defined by the map you give it) on the face of the texture as though the object were actually sitting in the environment depicted in your map. Figure 5.27 shows an excellent use of an environment map. It looks like that eyeball is sitting in the middle of the forest, when in reality, the artist had no need to actually model any trees or surroundings; just use the environment map shown below the rendering.

FIGURE *Dragon eyeball and environment map by Stefan Eriksson.*
5.27

FOG

Pretty self-explanatory idea that allows for semitransparent shapes. This is handy when trying to create figures of smoke (Figure 5.28).

BUMP

This channel allows for *virtual* bumps across the surface of an object. It does not actually change the geometry of your polygons at all. The 3D application just understands that you want it to render shadows within the object as though there was the geometry present to define raised and lowered areas of the surface (Figure 5.29). This is a very powerful tool in that it can save hours of modeling little bumps and divots in a shape by simply defining it with a bump map (Figure 5.30). Since bump maps can depict complex surfaces without adding extra polygons, it can save a lot of time when it comes time to render the objects. Beware, though; since bump maps do not actually alter the geometry of a given shape, the profiles of bump-mapped shapes are not accurate. Notice in Figure 5.30 that that edge of the circle is smooth—no bumps, even though the bumps are clearly seen along the face

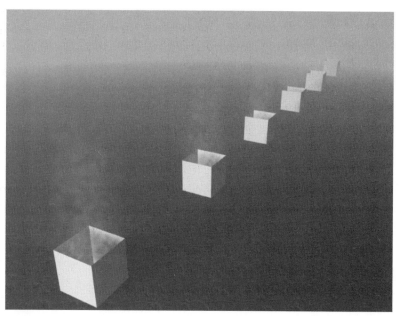

FIGURE *Fog and smoke.*
5.28

FIGURE *Thorsten Ulbricht's cathedral is a good example of effective bump mapping.*
5.29

FIGURE *Bump map example with cutaway profile close up.*
5.30

of the object. If the profiles will actually be seen, consider using the displacement channel.

SPECULAR

This channel defines whether an object has highlights. Usually, the specular channel allows you to define how large the highlight is, how bright it is, and often what color the highlight is. Figure 5.31 shows a variety of objects with all channels the same, except for alterations in the specular (and specular color) channels.

GLOW

If you are into neon lights, photon fire, or any other glowing apparatus, this is the channel for you. Glow channels allow you to make an object appear with an inner or outer halo, or both (Figure 5.32). Glow maps can be used to make parts of objects glow while others do not. You can choose what color and intensity to make an object's glow. One drawback of glow channels in most programs is that they are a post-rendering effect; that is, only

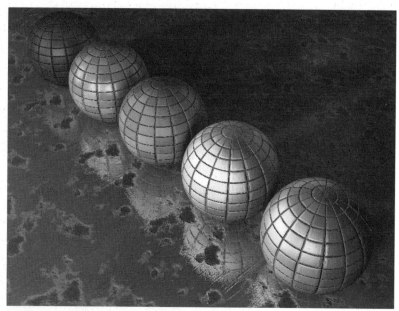

FIGURE
5.31
Specular channel illustrations.

FIGURE
5.32
Peder Akesson's neon sign is a great example of effective glow.

after the scene is completely rendered and all the reflections and light sources have been calculated does the 3D application go back in and add the glow effect. This means that glows do not appear in reflective surfaces and they do not actually emit any light (Figure 5.33). Strata StudioPro users should note that you must use the Aura setting to achieve a glow effect.

FIGURE *Glow effect not reflecting.*
5.33

DISPLACEMENT

Not too long ago, displacement channels were only available in very high-end programs. Now, most 3D applications allow you to define geometry by using grayscale figures. This is different from the bump maps discussed earlier in that displacement maps actually deform the geometry they are placed on (Figure 5.34). A drawback of displacement maps is that to make the displacement map work, there needs to be a significant amount of polygons for

it to work with. If a plane is made of only a few polygons, there is not enough material for the map to work with, and the results are unpredictable. Therefore, for displacement maps to work correctly, the geometry they are placed upon has to be very heavy or have a fairly large poly-count (Figure 5.34). Even though computers are faster and processing power is speedier, many objects with extremely high poly-counts for displacement maps can slow your machine enough to make anyone impatient.

FIGURE *Displacement map and profile.*
5.34

With the right selection of maps and channels activated, you can produce some truly amazing results. Richard Dziendzielowski's desert scene in all its photorealistic glory is a tribute to such mapping choices (Figure 5.35). Likewise, the seemingly dense modeling of Peder Akesson's zeppelin image (5.36) is an example of smart mapping through transparency and genlocking (alpha) channels. Figure 5.37 shows a Brian Castleforte image that uses displacement to save on hours of modeling time.

FIGURE *Richard Dziendzielowski's desert mapping mastery.*
5.35

FIGURE *Peder Akesson's clever mapping reduces hours of modeling time.*
5.36

FIGURE *Brian Castleforte's smart use of displacement maps.*
5.37

T
U
T
O
R
I
A
L

5.1: CREATING A CHAIN-LINK FENCE USING TEXTURES

As mentioned earlier, textures can be an incredibly powerful modeling tool. This may seem a little weird, but consider the rendering shown in Figure 5.38. It is the rendering of a chain-link fence created almost entirely from textures. To model the chain links intertwining would be a large task in itself; to model hundreds and thousands of these intertwining links would be a nightmare.

To begin, look at what the geometry of the model actually entails. Figure 5.39 is the untextured model. Notice that everything in the scene is a simple primitive, including the flat

FIGURE *Chain-link fence render.*
5.38

plane that will become the chain link. The polygon count is low and the model interaction is snappy.

To create the chain-link texture that defines more about geometry than anything else, begin with a photograph or an image of chain link. The photograph shown in Figure 5.40 was carefully framed so that I had one square of the chain link against a solid blue sky, making it easy to "knock" the sky out. Be sure that when building textures that will define visual geometry to make the photograph as straight on as possible. You do not want to have to fight perspective when attempting to create the texture. The perspective will be handled by the 3D application, so keep your textures as orthographic as possible.

Break down the texture to its most fundamental building block by copying one section (Figure 5.41) from the original image and pasting it into its own file. By breaking it down to its simplest shape, we can begin to make the shape a pattern and make it seamless, so that as it repeats across the surface of the model, we will not be able to tell where one copy of the texture ends and the next one begins.

The next thing to do is begin to make the shape seamless. To do this, we need to make sure that each part of the chain-link square is seen only once. Crop the image so that each part

FIGURE *Untextured chain-link model.*
5.39

FIGURE *Starting photograph of chain link.*
5.40

of the pattern is only visible one time. Figure 5.42 shows the chain link cropped so that we only see two of the links. Since this shape will be repeated and the link on each side of the square is just a repeat of the link opposite it, we only need to show two.

FIGURE *Simplest form of chain link.*
5.41

FIGURE *Preparation for seamless texture.*
5.42

To make sure the texture is seamless, use the Offset filter in Photoshop to wrap the texture around so you can see the seams in the middle of the image (Figure 5.43). For a complex form such as the chain link, begin by offsetting the image in only one direction, working out the seams along that axis and then offsetting in the other direction.

FIGURE *Wrap-around result of the Offset filter.*
5.43

Now comes the tricky part: Seams as shown in Figure 5.43 cause big problems for filters, so the trick is to work those seams out. Sometimes the trick is to take selections of the image and move them (Figure 5.44). Make sure that if you move any part of the image, that you apply the Offset filter again to make sure that the movement has not disrupted the flow in other parts of the image. Often, moving part of an image creates the need for some other adjustments elsewhere to keep the image seamless.

FIGURE *Adjusted offset image.*
5.44

Once you are satisfied that the image is seamless in one direction, apply the Offset filter in the other (Figure 5.45). If you have been moving chunks of the image around, you may find holes or shears in your image as can be seen in Figure 5.45. Use the Rubber Stamp tool, the Smudge tool, or simply use the Paintbrush to paint in the missing chunks of information (Figure 5.46). Again, remember to offset the image several times to make sure that your efforts to remove seams have not caused new ones to appear.

Upon completion of Offsetting and working out the seams, you have a good start for the color map of the chain-link fence. Select the background (in this case, the sky) and delete it so you have a clean, seamless image that can define the color of the texture as shown in Figure 5.47.

In the case of a chain-link fence, we want parts of the texture to be transparent. To do this, take your original color map and make all the color information (in this case, the chain link) black (Figure 5.48). This tells your 3D application what parts are to be opaque (the chain link), and which parts of the texture are to be transparent (the space between the links).

FIGURE *Newly offset texture in new direction.*
5.45

FIGURE *Texture altered to cover shears and Offset filter reapplied.*
5.46

FIGURE
5.47 *Color map for chain-link fence.*

FIGURE
5.48 *Transparency or alpha channel map.*

The paradigm of whether black is opaque or transparent is different for different applications, so you may need to inverse out the image.

Now, it is just a matter of importing the color and transparency or alpha channel maps into your application of choice and then scaling them to visually match. In Figure 5.49, the texture is applied using flat projects at a scale of 8% along the x axis, and 12% along the y—your proportions may vary.

Notice that even though the shape that contains the chain-link texture is a solid polygon, the transparency map allows light through parts of the shape so that it casts appropriate shadows.

FIGURE *Close-up of a chain-link fence.*
5.49

5.2: PLANT LEAVES THROUGH TEXTURES

Organic shapes are perhaps the most difficult of all to do in 3D. As free flowing as they seem to be, our eyes can always pick out when the seeming randomness of organic shapes just is not right. Often, 3D animators try to model the complex shapes of nature, but are left with unbelievable and uninteresting shapes. To combat this problem, one of the best methods is to steal directly from Mother Nature by scanning her natural textures and using them to define geometry.

Through the careful use of the power of transparency or alpha channels, you can achieve a look that is at once organic and complex in appearance, but very elegant and simple at its base geometry level. In the case of trees or any leafy plant, consider creating all leaves through this method of careful texture creation. Let the inspiration of Mother Nature be the ultimate guide and control.

Figure 5.50 shows a collection of leaves created with simple planes, primitive capsules, and a whole lot of texture work. The leaves, although apparently painstakingly modeled, are all textures.

To begin, create a simple collection of shapes that include a cylinder for the stem and an altered plane (in this case, a beziér plane) that has a bit of curve to it (Figure 5.51).

FIGURE *Finished leaf rendering.*
5.50

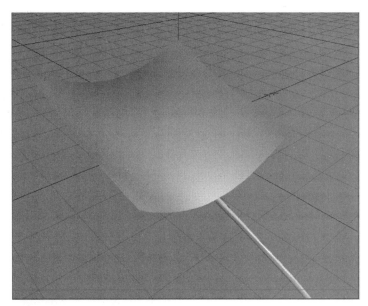

FIGURE *Base nontextured model.*
5.51

To create the texture work that will become so important to this scene, find a leaf you like and scan it (Figure 5.52). The size and resolution of the scanned leaf is arbitrary, but do not go overboard. The image shown in Figure 5.52 is 800x600 pixels, which is more than sufficient for any final output including print. If your final output is animation, do not go over 320x320, as it is unlikely that you will ever be so close to the image that you can only see one leaf filling the entire screen.

Now the trick is finding ways to extract and create the desired maps from this source image. In Photoshop, begin by knocking out any unnecessary color information (Figure 5.53). Even though eventually we will be creating a transparency map that will knock the unwanted areas of the image out anyway, it is nice to have a clean color map from which to build the other maps to be used. Make sure to save a copy of the image thus far as something like "Leafcolor.tif."

Once this color map is created, it will be easy to create a transparency map that will tell the plane upon which this texture will ultimately be applied, what part to "drop-out" and what parts to leave in. To create this transparency map, select the white of the color map with the Magic Wand tool. Then, go to pull-down menus Select>Inverse to select the leaf. Mak-

FIGURE *Scanned leaf.*
5.52

FIGURE *Base color map.*
5.53

ing sure that the background color is black, delete the leaf from the image, which will leave you with a simple black-and-white silhouetted version of the leaf.

This is the beginning of the transparency map. The black section in the shape of the leaf will signal to the 3D application that this section is to be opaque—we should be able to see the color from the color map. The white section tells the appli-

cation that these areas of the color map are not to be rendered—they are to be seen as transparent and not stop any light rays traveling by. One note here: The black-and-white paradigm of whether the black or white is transparent may be different in your chosen application. See your manual for the details.

One common problem with transparency maps is that they are not defined tightly enough, and the resulting render leaves a small white outline. To ensure that the transparency map does not allow any of the white from the color map to render, we will adjust the transparency map to be a little tighter. With the leaf still selected, go to the Select>Modify>Contract pull-down menu. At the resultant dialog box, enter "2" pixels. This collapses the leaf selection in all directions by two pixels. Now go to Select>Inverse again to select the white of the image and the new contracted leaf. Use the Edit>Fill>Foreground Color pull-down menus to fill with white. The resultant image should look something like Figure 5.54. If your program defines opaque and transparent images differently from what is shown in Figure 5.54, use the Image>Adust>Invert pull-down menu to invert the entire image. Save this file as something like "LeafTrans.tif."

To further refine this leaf texture, create a bump map and a displacement map. To create the bump map, open the color map (LeafColor.tif) and convert the image to grayscale by going to Image>Mode>Grayscale (Figure 5.55). With this grayscale image, the 3D application can render certain regions as raised—in this case, the white veins that run through the leaf. You may wish to further augment this map by increasing the contrast of the grayscale with the Image>Adjust>Brightness/Contrast or Image>Adjust>Levels pull-down menus. The result should look something like Figure 5.55. Save the file as "LeafBump.tif."

For the displacement map (the map that will actually affect the geometry of the object), we need to be a little more selective, or else the leaf will be so displaced from the information given it that it will look like it has been run over by a truck. To do this, create a new layer over your bump map. Carefully draw the areas you really wish to rise or recede off the face of the leaf by using the Paintbrush tool with a high-feathered brush. Once you have traced the areas you wish to displace (the veins, in the case of Figure 5.56), discard the underlying

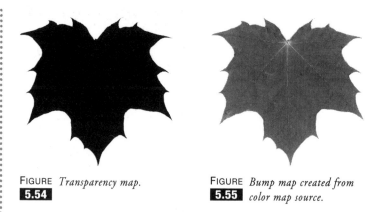

FIGURE **5.54** *Transparency map.* FIGURE **5.55** *Bump map created from color map source.*

layers so that you have a simple map similar to that shown in Figure 5.56. Notice that in this example, the black areas are to recede, and since the black lines were drawn with a feathered brush, the rise will be gradual. Save this map as "LeafDisplacement.tif."

FIGURE **5.56** *Displacement map to define receded leaf veins.*

Now, with the potent combination of maps prepared, open the 3D application where you modeled your plane and capsule primitive and create a new material or texture. Import each of the LeafColor, LeafTrans, LeafBump, and LeafDisplacement files into their appropriate channels within the texture. Upon application, you should have a leaf that looks much like Figure 5.57. You may need to alter the mapping of the leaf texture on the surface of the plane.

FIGURE *Leaf with applied leaf textures with transparency.*
5.57

Notice that with the transparency map applied and the transparency channel activated, the previously uninteresting plane has become an interesting leaf. Meanwhile, this simple act of scanning the leaf has made sure to keep accurate color and shape to the leaf.

For the stem of the leaf, create a new file that is 320x320 pixels large, and use the Eye Dropper tool to lift the color of the leaf color map. Fill the new image with this color, and then select a brown color for the foreground color. Use the Paint Brush tool to paint in some brown spots to rough the texture up. Be sure to not paint up to any of the edges so that you do not create unnecessary seams. You may even want to copy and paste sections of the leaf color map into this new image to give a little tactile quality to it (Figure 5.58). Save this new stem texture as something like "StemColor.tif."

Create a new material or texture within your 3D application and import this map into the color channel. Make sure to also activate the bump channel and import this same image, or create a mild turbulence with built-in procedural textures so the resultant texture does not look like plastic. The resultant render should look like Figure 5.59.

FIGURE *Stem texture with painted brown areas.*
5.58

FIGURE *Leaf with textured stem.*
5.59

Group this newly textured stem and the leaf, and then copy and paste to your heart's content to create clusters of leaves.

An interesting variation of this technique is to take the original color map and using the Image>Adjust>Color Balance pull-down menu alter the color of the leaves to fall colors (Figures 5.60, 5.61, and 5.62). Do the same thing to the color map "StemColor.tif" (Figure 5.63).

By applying these new color maps to copies of the original leaf texture that uses the same transparency, bump, and displacement maps, you can quickly create a variety of fall-

FIGURE *Fall-colored leaf texture from original color map.*
5.60

FIGURE *Fall-colored leaf texture from original color map.*
5.61

FIGURE *Fall-colored leaf texture from original color map.*
5.62

colored leaves. You may want to increase the bump and dis-
placement amplitudes to give these leaves a more coarse tac-
tile appearance. The result of such a variance is shown in
Figure 5.64.

FIGURE *Fall-colored stem texture from original stem color map.*
5.63

FIGURE *Fall-colored leaves.*
5.64

Exercises

1. Using the techniques described in tutorial 5.2 make palm tree leaves. You may need to track down a photograph in a book or on the web for reference.

2. Use high bump and displacement maps to texture the trunk of the palm tree. Explore the difference between UVW and cylindrical mapping on the trunk.

3. Make a picket fence from one large flattened cube in which each of the pickets are created simply with alpha/transparency maps.

4. Add bump maps to the picket fence to rough it up. Then add another layered color map of dirt.

CHAPTER

6

Advanced Texturing Techniques

Creating Textures from Scratch

Most 3D applications come with a fairly good collection of different maps or textures. These textures are great because they are available, they are usually optimized for the software you are using, and they are ready to be dropped on your models. These stock textures allow you to quickly create textured models—you and the other 20,000 people who own the same software. "Canned" textures are nice to start with and can give you some fun results, but professionals and employers are rarely impressed by models that use canned textures—it either means the artist is too lazy to create his own, or does not know how to. Either way, canned textures are not the healthiest thing for a portfolio, so learning how to create your own textures becomes a fairly important aspect of digital art. Creating procedural textures is a bit more complex than the scope of this book allows, so we will concentrate on how to create bitmapped-based textures.

As discussed earlier, textures are made up of several channels that contain maps that define how different characteristics of the texture are to behave. These maps are figures whose source is fairly unimportant. Some artists enjoy creating these figures through some sort of drawing program like Photoshop, Painter, Illustrator, or Freehand. When you are aiming for a very stylized image, drawn textures are an excellent way to keep control of the style. The other method is to create textures from photographs, but sometimes photographs simply contain too much visual noise, and a drawn representation of a photograph is sometimes needed to simplify a map to make it usable. The actual process of drawing textures is a book in itself so we will not spend much time here, but if you can't find a stock photo of the texture you need, keep in mind the option of creating maps from scratch.

Probably the most widely used method of texture map creation is done from photographs or other stock figures. The Web runneth over with collections of textures of every genre imaginable. Most of these figures are royalty free and can be used however you see fit. Most of these Web-retrieved figures are simple color maps, but these color maps can often be altered to create other maps such as bump, diffusion, and specularity, by simply converting a copy of the color map file to grayscale and altering the image as needed. Although not necessary, it is wise to build most maps from one common source map. This allows for the bump map to align correctly with the color map, the specular map to align with the glow map and the color map, and so on.

My favorite way to build textures is from photographs of surfaces that I

have taken myself. This helps me get the most realistic-looking textures. To become familiar with all the terms just covered in Chapter 5, let's create a texture from scratch. Since textures are perhaps the most standardized school of thinking in the 3D world, we will not delve into the specifics of each of the programs we have been covering thus far. The instructions will stay general; adapt them to your program of choice.

Figure 6.1 is a photograph of a street. This will be the basis for an asphalt texture. This particular image is saved as a tiff file that most 3D applications work with quite well. However, depending on your tool of choice, there are other file format options allowable; check your documentation.

Before going any further, it is important to talk about the problem with seams. When a 3D application places a texture on an object, it takes the maps you have entered and places them on the object. If the maps are

FIGURE *Original asphalt photograph.*
6.1

smaller than the shape, then it sets another copy of the map next to the first in a patchwork fashion. The problem is that this patchwork fashion is not so fashionable in 3D—it makes for figures like Figure 6.2.

FIGURE *Seamed texture.*
6.2

 The key is to make a seamless texture. Most textures that you can purchase are already seamless, and most built in to your 3D application of choice are also seamless. Unfortunately, nature is rarely that kind when working from your own scans or photographs.

 A powerful method of removing seams is to use Photoshop and its Offset functions. To create a seamless texture from the original shown in Figure 6.2, open the file in Photoshop. Go to Filters>Other>Offset (Figure 6.3). In the resulting dialog box, make sure that "Wrap Around" is selected and

FIGURE *Filter>Other>Offset pull-down screen shot.*
6.3

enter 300 for the Horizontal and 300 for the Vertical settings (for an image that is 600x600 pixels). Notice the result in the original image (Figure 6.4).

The benefit of doing this is that you can now see the seams in the middle of your image where you can work with them. Since the image was wrapped around, you know that the right side of your image matches seamlessly with the left side, and the same for the top and bottom.

Now that you can get at the seams, it just becomes a matter of using the Rubber Stamp (Figure 6.5) tool or CNTRL-click a source location of your image that is similar in value to the seamed areas, and then click and drag over your seams to copy the pattern of the image over the seams. Once the seams are no longer visible, repeat the process of offsetting to make sure that you did not inadvertently create any new seams as you were erasing the old ones. When you run the Offset filter and see no flaws in the center of the image, you then have a good seamless image from which to build the rest of your maps. If we were to use this new seamless image on an object, the result would look like Figure 6.6.

FIGURE *Result of Offset filter.*
6.4

FIGURE *The Rubber Stamp tool.*
6.5

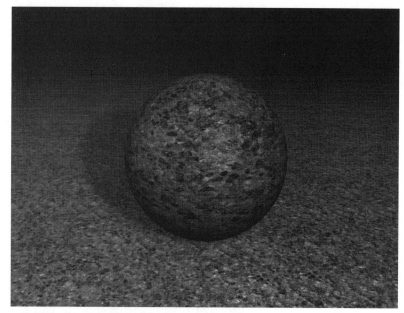

FIGURE *Resulting seamless texture rendering.*
6.6

Several textures that we will be using for our Amazing Wooden Man will require seamless textures. On the CD included with this book are the raw source photos for the table wood, the wooden man wood, the brushed metal, and the leather textures. Also included are seamless versions of the textures. If you know how to work seams out already, then just use the seamless textures. If ironing seams out is a new idea, experiment with the raw files and compare them to the seamless versions.

Expanding the Maps

The most natural thing to do with this newly created seamless map is to use it as the color. To keep track of the various maps being created, save this file as "asphaltcolor.tif." The rendering in 6.6 is a nice start, but the shapes still look like painted plastic. To remedy this, we can create a bump map from the original color map. Convert the image asphaltcolor.tif to grayscale, and simplify the equation, since bump maps usually work most effectively from grayscale figures. To emphasize the rises and falls in the road, adjust the contrast through Image>Adjust>Levels so that the darks get darker and the lights get lighter. Remember that the lighter the area, the higher it will

appear. Since many of the rocks are actually darker than the tar, Inverse (Command/CNTL-I) this bump image to make the dark rocks light and the light-colored tar dark; this way, the rocks will appear to rise (Figure 6.7). Save the image as asphaltbump.tif.

Once this bump map is placed in the bump channel of the texture (that already has asphaltcolor.tif in the color channel), the result looks like Figure 6.8.

To refine the texture a bit, alter the specular (or highlight) channel so the width of the highlight is very narrow, which will give us a small dot at the height of each pebble in the texture (Figure 6.9).

The biggest problem now is that the shape profiles are still too smooth. This is because we used a bump map, so it is drawing faux bumps on the

FIGURE *Heightened contrast.*
6.7

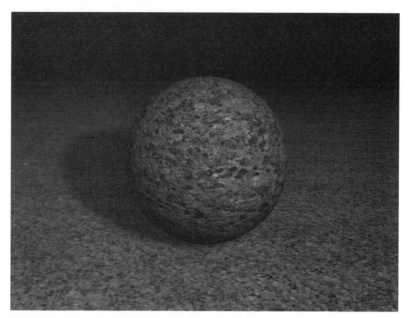

FIGURE *Rendering with new bump map.*
6.8

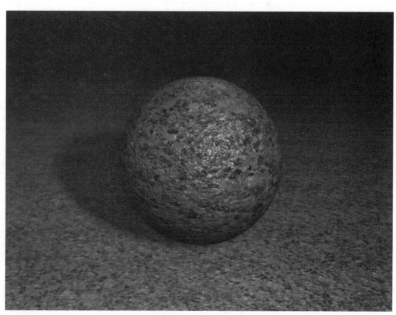

FIGURE *Texture with highlight.*
6.9

surface rather than creating actual bumps. Since a profile is never seen on the road, leave the texture as is, but for the rounded shapes above it, make a copy of the texture to give this new version more information without affecting the texture on the road.

Figure 6.10 is a wireframe look at the model we have been texturing thus far. Notice that the rounded shapes sitting on the road have a very high poly-count. Because the poly-count is high, a displacement map will work well.

For the displacement map, simply use the same asphaltbump.tif map so that the actual geometrical alterations match the rendered bump map. The resulting render, which includes a nice bumpy edge, is shown in Figure 6.11.

Now for the fun of it, let us create extra geometry and some extra maps just to see the effects of various channels. Create a cube around the sphere with the displacement map, and another sphere around that new cube. Let us make the outermost sphere a crystal ball. To do this, simply create a new material (texture) with a little bit of blue for color, and then activate the transparency channel and allow it refractive qualities (sometimes called *fresnel*). Give it a refraction index of about 1.2. The ball should look something like Figure 6.12.

FIGURE *Wireframe render of asphalt scene.*
6.10

FIGURE *Asphalt scene with displacement map.*
6.11

FIGURE *Asphalt scene with ball around displacement map sphere.*
6.12

Now to allow us to see the sphere within the cube, let us make another transparency map (or alpha map) that will be placed on the cube. The transparency map to use is shown in Figure 6.13. It will allow for large round holes in the sides of the cube.

Now, by creating a new texture, making the color red, and adding the map shown in Figure 6.13 to the transparency channel, we can cubic map the new texture to the cube and get a rendering like Figure 6.14.

Now, on to our wooden man project. Let us begin with our wooden man. WoodenMan.tif is the image used for the dummy, and the biggest trick (with a seamless texture) is finding the best way to map the texture on the various body parts.

Let us start with the hips. This shape lends itself well to spherical mapping. Begin by creating a new texture and bringing WoodenMan.tif into your color channel. To give the surface a little sheen, use a bit of the Specular. Because this wooden dummy would probably be fairly smooth, and we

FIGURE *Alpha map for cube.*
6.13

FIGURE *Final rendering.*
6.14

are never going to have too close of a shot, do not use any of the other chan-
nels—only use channels for details that will be noticed or seen. Then, apply
this new texture to the hips by dragging the texture from the Materials,
Source, or Textures palettes to the hips in the editor window. Upon place-
ment, Cinema4D will ask what type of mapping you wish to use. Strata
StudioPro will require you to adjust the mapping in the extended Object
Properties palette, and LightWave allows for mapping alterations in the
Layer Type section of the Texture Editor. In any case, select "Spherical"
mapping. Repeat this process with the other objects of the body using
spherical texturing for the joints, hips, torso, chest, and head, and cylindri-
cal texturing for the legs, hands, and feet. Texture each separately, as each of
these wooden body parts would indeed have been crafted separately and
thus would have a unique texture scheme. You may wish to alter the size of
the texture on the object if the default is not to your liking. The result
should look like Figure 6.15.

 For the lamp, we will use BrushedMetalLampBump.tif. This is a grayscale
image created with Photoshop by creating noise (Filter>Noise>Add Noise)

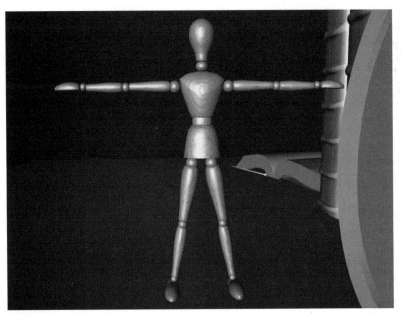

FIGURE *Textured wooden man.*
6.15

(Figure 6.16a) and then motion blurring (Filter>Blur>Motion Blur) it by 15 pixels at 0 degrees (Figure 6.16b). Then, after working the seams out, increase the contrast by about 70% (Figure 6.16c). No need to worry about creating a color map, since the color you wish to use can be defined well enough in the color channel.

Create a new material/texture and bring BrushedMetalLampBump.tif into the bump channel. Increase the amount until the preview texture box shows a bump you like. Making sure the color channel is activated, give the texture a little bit of a blue tint. Use the same BrushedMetalLampBump.tif map in the reflection channel and give it a strength of about 30%. This makes the grooves of the brushed metal nonreflective. Make sure the specular channel is activated.

Application of this texture to the lamp is also a matter of mapping the texture differently to each part of the lamp. The shade, of course, should by spherically mapped. Map the base cubically, and each end of the neck cylindrically. Map the neck with UV (or UVW). The result appears like Figure 6.17.

While we are working with the lamp, let us put a glowing bulb inside of it. This object that we are going to create will not actually light the scene,

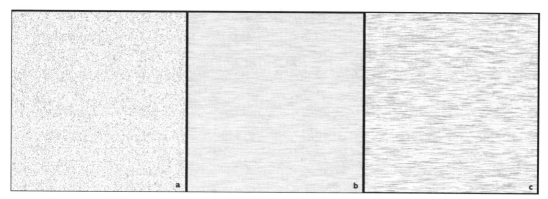

FIGURE *Brushed metal bump map creation series.*
6.16

FIGURE *Textured lamp.*
6.17

but it will look as though there is a bulb within the lamp. In the next chapter, we will put an actual light source where the bulb will be.

Create a sphere (the glow will completely cover any shape that is actually there) or a lathed shape, and place it where a light bulb would be. Then create a new texture that has no color channel, but uses luminance and a heavy glow. Use a yellow glow as the color of glow selected. Play with the settings

of the glow until you get the result desired. In Strata StudioPro, you may want to add an Aura from within the Resource palette, as the Glow settings in the Surface Texture Editor, are actually the equivalent of Luminescence settings in other programs. The glowing bulb should appear something like Figure 6.18.

Before we move on to the books and can (which are probably the most challenging to correctly texture and map), let's look at the mirror for a second. The rim of the mirror is very easy to texture; simply use a color channel and select a color that you like. Activate the specular channel so the mirror will appear to have a plastic rim. The mapping is unimportant since there is no pattern to deal with. Simply place the new colored texture on the rim, and you are finished. The actual mirror part is also fairly easy. Create a new texture and only activate the reflection channel. Again, the mapping on the reflective part of the mirror is unimportant. There is a lot of fine-tuning that can be done to mirrors. A little imperfection of the surface can be portrayed by placing a bump map on it, or perhaps some smudges or nicks could be created with a color map; adjust as you see fit. The result looks something like Figure 6.19.

FIGURE *Glowing bulb.*
6.18

FIGURE *Mirror.*
6.19

You will notice that the reflection in the mirror will probably be very dark. This is because we have not set up the lighting appropriately yet. More on that in the next chapter.

The table uses a simple set of maps. TableWoodColor.tif is the color map placed in the color channel. TableWoodBump.tif is a grayscale version of the same map that will be placed within the bump channel to give the table a little bit of extra tactile texture. Again, specular is activated to make the table look like it has been glossed. Apply the texture to the table top using flat mapping, and use cubical mapping for the rest of the parts. The resultant table is shown in Figure 6.20.

While we are talking about flat mapping, create two planes and set them as walls behind the table. Since we will never see the floor in the animation this tutorial will be covering, we will not worry about creating any other room details. Create a new texture, place WallBump.tif in the bump map, and add a little bit of gray to the color channel. Apply the texture to each wall separately using flat mapping (Figure 6.21).

Now for the books. The book covers all use the same source texture as a bump map (LeatherBump.tif). In addition, they all have identical specular

FIGURE *Textured table.*
6.20

FIGURE *Scene with textured walls.*
6.21

channels. The only difference is the color channel; one uses a dark red, one a dark blue, and one a brown. Apply each of these textures in either UVW or cubic mappings. The pages use the BrushedMetalLampBump.tif as a bump, a yellow color for the color map, and a high reflection value. The result provides a gold-leafed edge effect. The results are shown in Figure 6.22.

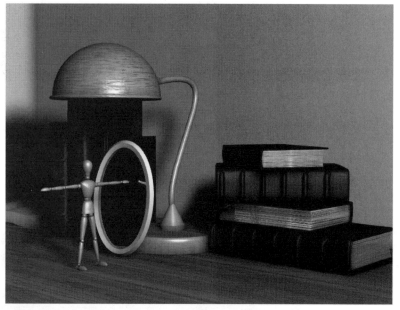

FIGURE *Textured books.*
6.22

The can uses a color map and a reflection map. We only want certain parts of the can to be reflective. To do this, create a color map from scratch in Photoshop (Figure 6.23). Then, convert this file to grayscale, increase the contrast until it is a black-and-white image, and paint the text out (Figure 6.24). The white areas will be reflective, and the black areas will not. Place the new texture on the can using cylindrical mapping and, voilá—Figure 6.25.

And with that, you are all modeled and textured for the Amazing Wooden Man. The scene should look something like Figure 6.26. You might notice that it looks quite flat at this point; this is mainly because of the lighting. Read on to find out how to make your scene glow with energy.

FIGURE *Can color scale image.*
6.23

FIGURE *Can reflection map image.*
6.24

FIGURE *Rendered can.*
6.25

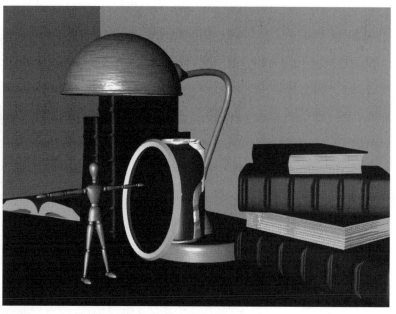

FIGURE *Final modeled and textured scene,*
6.26

T
U
T
O
R
I
A
L

6.1: DIRTYING THE SCENE DOWN

Computers do several things well, one of which is creating smooth, perfect surfaces. These smooth surfaces would be hard to achieve manually, but a computer seems to be able to effortlessly create glass like surfaces over which the light glides and the reflections roll. For instance, the image shown in Figure 6.27 is a simple plane textured with only built-in color maps with the reflection and specular channels turned on. The sleek nose and the smooth body have a polished look.Unfortunately, almost every computer-generated surface has just such a look. One of the new trends rapidly emerging in 3D is the challenge to find ways to make computer-generated imagery look not quite so computer generated. People are tired of the smooth surfaces and the easy-to-create reflections, and viewers long ago ceased to be impressed by the standard reflective metal surfaces.

In order to make your work really stand out, an important key is to create imagery that is imperfect, dirty, and all-around scummy. This may seem odd, but it is true. For this exercise, we will use a simple place created with HyperNURBS. Before

FIGURE *Metal surfaced plane.*
6.27

you dive into the rest of this tutorial, take a little time to model a simple shape over which you can place some rusty, grimy textures.

In order to get the desired grimy look, we need to look at ways to find good scum with which to work. Figure 6.28 is a photograph of the back of a rusting truck. The rust and dripping rust are perfect candidates for scumming up the perfect little place shown in Figure 6.27.

FIGURE *Photograph of a rusty truck.*
6.28

To begin, isolate the areas of interest within the image. Use the Crop tool to cut out everything but the rusty part of the truck (Figure 6.29).

The next key is to create a seamless texture map that will work well when tiled across a surface. To do this, use the Offset filter to pull the seams to the middle of the image (Figure 6.30). Then, using the Smudge tool and the Rubber Stamp tool, work the seams out (Figure 6.31). Be sure to use the Offset filter again to check for any newly created seams.

After you are satisfied with the look of the texture map and have made sure that it is seamless, save it as "RustColor.tif." Create a new texture and place this new seamless map into the color channel. If you want to have the texture a different

FIGURE *Cropped back of truck.*
6.29

FIGURE *Offset texture map.*
6.30

FIGURE *Rubber Stamped seamless texture map.*
6.31

color, make sure you adjust the color balance in Photoshop before saving. The result should look something like Figure 6.32.

FIGURE *Rust color map applied.*
6.32

The result shown in Figure 6.33 isn't a bad start, but it still looks like plastic, and with the reflection channel activated, there exists unnatural reflections even on the rusty parts of the metal where there should be none. Open the RustColor.tif file again in Photoshop and convert the image to grayscale (Image>Mode>Grayscale). This new grayscale image will serve as the basis for many maps that will help define the texture (Figure 6.34).

Save a copy of this new grayscale image as "RustBump.tif," and import this new map into the bump channel of the rust texture within your 3D application. Because this image was not altered to provide a high contrast, we will want to set the amount of bump quite high within the 3D application. The rendering shown in Figure 6.34 has a value set to 500%.

Not a bad start. With the high bump map applied, the nose of the plane begins to have a much more tactile feel. The rust is still reflecting; thus, even though there appear to be indents

FIGURE *Grayscale version of RustColor.tif.*
6.33

FIGURE *High bump map applied.*
6.34

where the rust is on the surface of the nose, it looks smooth within the rust spots. The trick here is to make the rust spots more matte, less glossy, so that there is a difference in specular and reflective qualities across the surface of the nose.

Although there will be areas that are semireflective on this surface, we want to have a very well-defined map that makes sure there is absolutely no reflection at the center of the rust. To do this, open RustBump.tif in Photoshop again and adjust

the contrast up. By increasing the contrast, dark areas become darker and light areas become lighter within the map. This makes sure that the originally dark spots of the rust go near black while the gray parts of unrusted metal go near white. The amount of contrast adjustment is largely a matter of personal choice, but be careful to leave areas of gray, as this is the only way to ensure areas that are neither completely glossy nor completely matte. A suggested adjustment is shown in Figure 6.35. This will become the reflection map that will allow certain parts of the surface to reflect all around it while others are completely matte.

FIGURE *Adjusted bump map for reflection map.*
6.35

Save the file as "RustReflection.tif" and import this map into the reflection channel of your 3D application of choice. Once activated, this reflection channel now defines the area of reflectivity. Figures 6.36 and 6.37 show the texture with this new reflectivity map activated and the resulting matte and reflective areas.

We can further heighten the feel of rusted metal by augmenting the specular map so that parts of the nose have high specular areas of gloss, while the rust section is very flat. To do this, use the same texture map that was used for the reflective map, and place it within your specular channel. In the same way that the black areas show nonreflective surfaces in the reflective channel, these black spots show nonspecular or flat matte areas when placed within the specular channel. Make

FIGURE *Rendering with reflective map activated.*
6.36

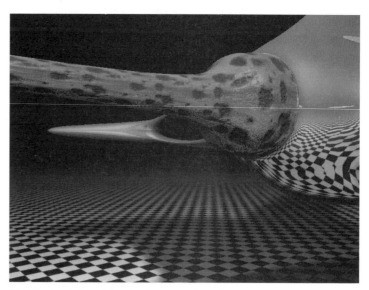

FIGURE *Rendering with reflective map activated.*
6.37

sure to have the specular settings set to a high value so the difference in glossy and matte areas is clear. The result is shown in Figure 6.38.

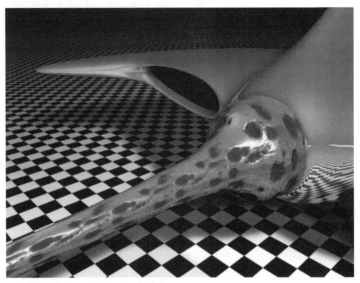

FIGURE *Specular channel with new map.*
6.38

Now the nose looks pretty good. More touch-up could be done, but were are going to move on to the body of the plane. For the body of the plane, we want to make it appear as though there is some deterioration around the front edge of the wing where it strikes the wind. The real trick is to get the grime to match up to the edge of the wing.

There are several different methods for attempting to get this wind-blown grime where we want it, but one of the simplest is to get a good image of what the shape of the wing is, and create the texture maps in that shape. To do this, first make a quick rendering of the plane from a top view, making sure to do it in a flat orthographic format (Figure 6.39). This rendering will be used to learn the outline shape of the wing so we can create one large texture that can be mapped using a flat projection over the top of the plane. The result will be perfectly aligned wind streaks and rust.

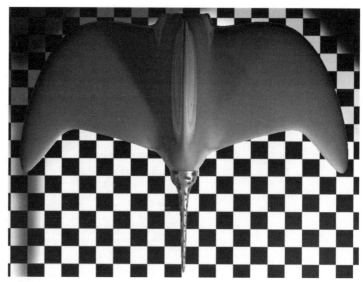

FIGURE
6.39 *Top orthographic view to use for texture map template.*

We will want to be able to find the edge of the plane quickly within Photoshop, which will allow us to quickly place the texture over the surface. Using the Magic Wand and Lasso tools, we could probably carefully find all the necessary edges; however, your 3D application already knows where they are—you just have to make it tell you.

To do this, render an alpha channel. This is usually a setting within your rendering dialogs that has the 3D application render a channel that can be accessed in Photoshop that defines the edge of the rendered model. To make this rendering cleared, delete the floor. Even though the rendering shown in Figure 6.39 does not show any marked difference, there will be a considerable difference in Photoshop.

There are areas of detail to which we will want to pay particular attention. In the case of the plane shown in this exercise, the air intakes will be an area of increased grime. To make sure that we understand where these intakes are, create an editor rendering using wireframe (Figure 6.40). This wireframe gives us the structural information to know where geometric detail is.

The final desired look is a painted metal surface with various nicks and scratches that has been worn away by lots of flying

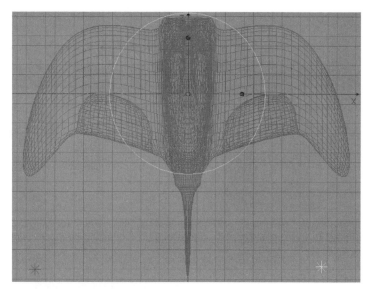

FIGURE *Wireframe rendering.*
6.40

acid rain. To create this texture, start with a texture of some beat-up metal. Figure 6.41 is the side of a trash dumpster outside of my studio. The great tactile features of this photograph will provide enough information for bump maps as well.

FIGURE *Trash dumpster photograph.*
6.41

Even though we are going to build the entire texture for the plane as one tile, we will need to make this stock photograph seamless so that we can copy and paste more than one copy of it over the face of the plane. Use the Offset filter and the Rubber Stamp tool to create a seamless texture similar to Figure 6.42.

FIGURE *Seamless version of dumpster texture.*
6.42

Now, open the rendering done earlier (the one with the alpha channel—Figure 6.39). Make sure that the Channels palette is open within Photoshop (Windows>Show Channels). The Channels palette should appear something like Figure 6.43. This shows us several things, but the most important is the last channel: the alpha channel that is not visible.

We want to select just the area of the image that is the plane itself. To do this, click on the alpha channel within the Channels palette (Figure 6.44). Immediately, the other channels will be hidden as the alpha channel is activated. The image of the plane suddenly appears like Figure 6.45, allowing for simple selection of the plane space by using the Magic Wand tool.

After you have used the Magic Wand tool to select the white that is the shape of the plane, activate the other channels again by clicking on any one of them within the Channels

FIGURE *Channels palette with the all-important alpha channel.*
6.43

FIGURE *Alpha channel activated.*
6.44

FIGURE *Resultant plane rendering.*
6.45

palette. The result will appear like Figure 6.46 where the plane is neatly selected, allowing us to conveniently paint or alter within the shape of the plane.

Now we want to place new information over the shape of the plane to give it the desired grimed-down look. However, the texture we have prepared (the seamless trash dumpster photo) is horizontally oriented. Since the rust streaks should be running vertically, rotate the dumpster photo 90 degrees (Image>Rotate Canvas>90 CW) so that the rust stripes are now running vertically (Figure 6.47).

Make sure that both the seamless texture and the image of the plane are open. Use the Rubber Stamp tool to copy the texture from the seamless texture image to the overhead shot of the plane. Do this by first making sure you have a large brush with very soft edges within the Brush palette. The soft edges will ensure that you do not create any seams as you work. Then Option-Click (Cntrl-click) on the texture image, then click and hold on the plane image to copy the texture over (Figure 6.48).

Continue the process until the texture fills the entire body of the plane. The image should look something like Figure 6.49.

FIGURE *Plane selected.*
6.46

FIGURE *Rotated photo.*
6.47

FIGURE *Transferred texture process.*
6.48

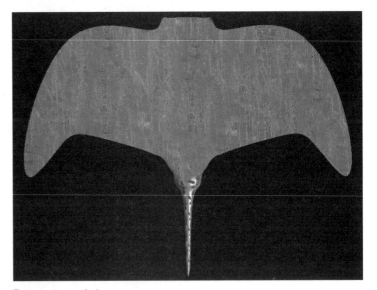

FIGURE *Painted plane.*
6.49

 To create the smudges of windswept grime, create a new
layer so that we can maintain the integrity of this first painted
layer. Now select the Airbrush tool and set the pressure to
about 5% within its Options dialog box. Using the Airbrush
tool, paint in some rough black streaks making sure to use the
SHIFT key to maintain straight lines. After working the plane

over with black, change the foreground color to other shades of gray or browns and repeat the process. The image thus far should appear something like Figure 6.50. Notice in this figure the areas around the air intakes are relatively untouched. These areas deserve special attention.

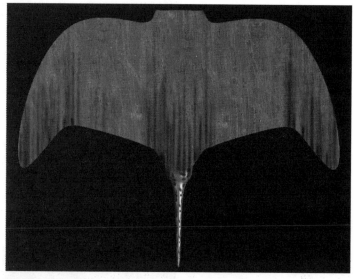

FIGURE *Dirtied-down plane.*
6.50

In order to work with the air intakes, it becomes important to integrate the information gained through the wireframe rendering. Copy and paste the wireframe rendering into the file we have been working with so far. Now, reduce the opacity of this layer to 50% and place it beneath the painted grime layer but above the color layer (Figure 6.51). This allows us to see what the grime looks like and see where it is placed.

Now, with the air intakes clearly defined, add a lot of black buildup around them. In addition, create a lot of black soot around the tail end of the plane. The look thus far is depicted in Figure 6.52. Save this image as something like "BodyRaw," as we will need to refer to this layered version of the texture to extract additional texture maps.

Discard the wireframe layer to be left with an image similar to Figure 6.53. Save this image as "BodyColor.tif."

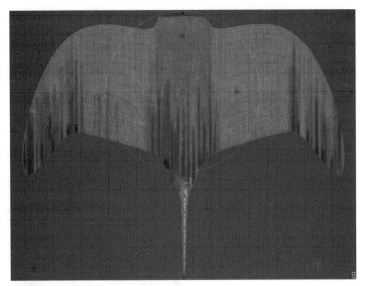

FIGURE *Wireframe information.*
6.51

FIGURE *Painted grime with wireframe.*
6.52

FIGURE *Finished color map.*
6.53

Now we will want to backtrack a little to extract some other texture maps. Hide the grime layer and convert the image of just the color rusty metal beneath to grayscale (Figure 6.54). We will use this grayscale image as the bump map. Hiding the grime layer makes sure that the grime does not also show up as bumpy material. Adjust the contrast on this image slightly higher and save the image as "BodyBump.tif" (Figure 6.55).

Open "BodyRaw," and this time, discard all layers but the grime layer. This layer will be used to designate which parts of the texture are allowed to have a gloss and reflection. Flatten the image and save it as "BodySpecReflect.tif."

Finally, open "BodyRaw" one more time, go to the Channels palette, and select the alpha channel. Save this simple black-and-white image as "BodyAlpha.tif." This image will act as the transparency map that will only allow the colored information and grime to show on the texture (Figure 6.56).

All that remains to be done now is to place all these newly created maps in their appropriate channels. Make sure to place "BodySpecReflect.tif" in both the specular channel and reflection channel. Once all the maps are placed within their appropriate channels, apply the texture to the body of the plane using a flat projection, since that is how we put the

FIGURE **6.54** *BodyBump.tif.*

FIGURE **6.55** *BodySpecReflect.tif.*

texture together. Be certain that the projection used in the flat projection is from the top. The final plane appears in Figures 6.57 and 6.58.

FIGURE *BodyAlpha.tif.*
6.56

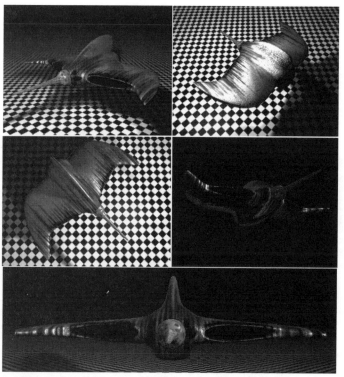

FIGURE *Final plane with new scuffed-up, grimed-down textures.*
6.57

FIGURE *Plane with added lighting effects in new environment.*
6.58

T
U
T
O
R
I
A
L

6.2: CREATING MAPS FOR ORGANIC SHAPES THROUGH GRIDS

Texturing like the plane exercise works fine for fairly simple shapes. The straight-on method is easy and offers a great deal of control. However, sometimes the forms to be textured are much more complex with many more variations across the face of the surface. Creating a texture from scratch for complex shapes can be a daunting task unless you know where your texture will finally lay.

Figure 6.59 shows a model created by Nate Tufts. The way the model is constructed lays out the hair, teeth, and tongue as separate objects. The rest of the face, however, is one solid mesh. Since the hair, teeth, and tongue are separate objects, they are easy to texture, and because of the cartoonish nature of the model, cartoony flat textures are easy and appropriate to create and apply (Figure 6.60).

The tough area is the face. The color across the forehead and the color on the cheeks is different on the face. Further, the tactile qualities of the neck are different from those of the

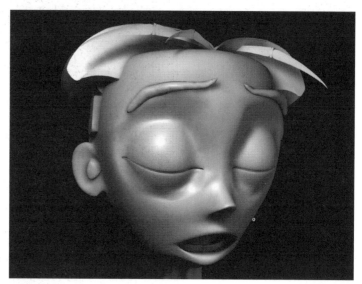

FIGURE *Nate Tufts' model.*
6.59

FIGURE *Textured hair, teeth, and tongue.*
6.60

eyelids. One way to have different texture qualities in different regions of the face is to layer textures; that is, to create several different materials or textures and apply different layers patched at different places across the face. This is a viable solution; however, it can get tricky making sure that the edges of each of these textures are soft and placed symmetrically on the other side.

A better method is to create one texture that wraps across the entire face. The trick then is to decide where on the maps you create for the face to tint red for the cheeks, brown for the 5 o'clock shadow, and shiny for the forehead. To find this out, first create a mock-up texture that will allow you to have a reference point. Figure 6.61 is a grid of simple numbers about 800x800 pixels large. It was created in Photoshop, although where you create is unimportant as long as you are able to save it in a file format your 3D application will be able to read.

1	2	3	4	5	6	7	8	9	10	11	12	13	14	15	16	17	18	19	20
11	12	13	14	15	16	17	18	19	20	21	22	23	24	25	26	27	28	29	30
31	32	33	34	35	36	37	38	39	40	41	42	43	44	45	46	47	48	49	50
51	52	53	54	55	56	57	58	59	60	61	62	63	64	65	66	67	68	69	70
71	72	73	74	75	76	77	78	79	80	81	82	83	84	85	86	87	88	89	90
91	92	93	94	95	96	97	98	99	100	101	102	103	104	105	106	107	108	109	110
111	112	113	114	115	116	117	118	119	120	121	122	123	124	125	126	127	128	129	130
131	132	133	134	135	136	137	138	139	140	141	142	143	144	145	146	147	148	149	150
151	152	153	154	155	156	157	158	159	160	161	162	163	164	165	166	167	168	169	170
171	172	173	174	175	176	177	178	179	180	181	182	183	184	185	186	187	188	189	190
191	192	193	194	195	196	197	198	199	200	201	202	203	204	205	206	207	208	209	210
211	212	213	214	215	216	217	218	219	220	221	222	223	224	225	226	227	228	229	230
231	232	233	234	235	236	237	238	239	240	241	242	243	244	245	246	247	248	249	250
251	252	253	254	255	256	257	258	259	260	261	262	263	264	265	266	267	268	269	270
271	272	273	274	275	276	277	278	279	280	281	282	283	284	285	286	287	288	289	290
291	292	293	294	295	296	297	298	299	300	301	302	303	304	305	306	307	308	309	310
311	312	313	314	315	316	317	318	319	320	321	322	323	324	325	326	327	328	329	330
331	332	333	334	335	336	337	338	339	340	341	342	343	344	345	346	347	348	349	350
351	352	353	354	355	356	357	358	359	360	361	362	363	364	365	366	367	368	369	370
371	372	373	374	375	376	377	378	379	380	381	382	383	384	385	386	387	388	389	390

FIGURE *Grid texture.*
6.61

Once you have this grid map created, import it into your 3D application into a new texture within the color channel. Then apply the new grid texture to the desired shape (in this case, the face). You may need to adjust the mapping to one that will allow you to clearly see the numbers and grid as it lays across the face. Now render the face with this new grid applied to it from a variety of different angles so you have a reference of where exactly each number of the grid falls (Figures 6.62, 6.63, 6.64, and 6.65). Make sure to take plenty of renderings, taking special care to focus on problem areas like the areas around the eyes and ears.

Now the idea is to take these renderings and use them as a reference. Open the grid in Photoshop, create a new layer so that you preserve the original grid and so that you can delete it later, and using the finished renderings as reference, begin to paint in areas of the face with color matching color variations to corresponding squares of the grid. Be sure to periodically check your progress. Save the grid. Figures 6.66 and 6.67 are works in progress and the resultant render. Figure 6.67 is simply an experiment to see what he would look like with a beard—not good.

FIGURE *Perspective views of the face.*
6.62

FIGURE *Side views of the gridded face.*
6.63

FIGURE *Close-up side views.*
6.64

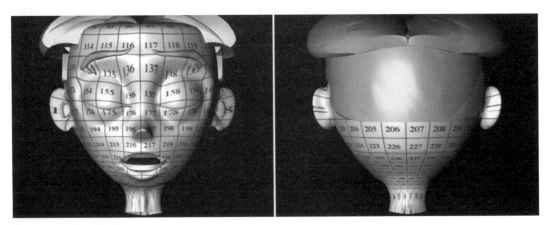

FIGURE *Front and back views.*
6.65

Color Plate 1: *Not all character modeling needs high-end modeling tools. This girl (modeled and textured by Chad Griffiths) was done using an old version of Strata StudioPro using nothing but primitives and metaballs.*

Color Plate 2: *Ryan Crippen's fascinating fly image was created with Bryce. Although the modeling was done with simple tools and Boolean functions, it remains a sophisticated image.*

Color Plate 3: *NURBS and other high-end tools can be used to create seamless single mesh characters like this one by Chad Griffiths.*

Color Plate 4: *Frank Braade used a free form deformation to twist and bend this chest into the organic shape you see here.*

Color Plate 5: *Metaballs can be a powerful effect for everything from water, to globby monsters to great illustrative effects. Alec Syme uses such a tool in this fantastic illustration to portray moving or liquid money.*

Color Plate 6: *Besides great lighting, Zach Wilson masterfully uses textures to create fantastic scenes with objects of incredible depth and organic visual quality.*

Color Plate 7: *Richard Dziendzielowski shows us a beautiful and interesting scene that feels organic and free from the computer 'feel.' Careful texturing in the water, lake bed, and tree create a visually enticing image.*

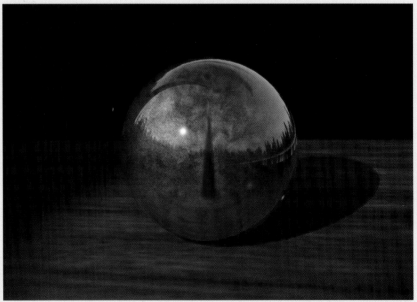

Color Plate 8: *With the clever use of an Environment Channel, Stefan Eriksson creates the illusion of an intense surrounding without having to actually model it. This gives an otherwise simple scene incredible visual depth.*

Color Plate 9; LEFT: *This model by Nate Tufts was textured using the grid system. The texture map in the top right corner is the final color map and the image on the top left serves as the bump. The grid system allows for accurate placement of color or other textural details.*

Color Plate 10; RIGHT: *The much seen work of Alec Syme demonstrates a mastery of textures. This image gives a fantastic quasi-photorealistic feel with details like bubbles, sweat on the bottle, and swirling liquid.*

Color Plate 11: *Particle emitters for bubbles and a gentle depth of field creates visual interest and depth. Image by the Author.*

Color Plate 12: *Particle emitters, when frozen in time, can create spectacular visual effects as seen here in this image by Jeff Carns.*

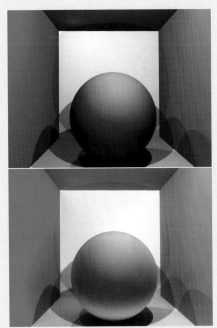

Color Plate 13; LEFT: *Alec Syme's masterful use of particle emitters makes for a not-of-this-world image that, with interesting lighting and composition, creates an image that is hard to look away from.*

Color Plate 14; RIGHT: *A comparison of raytracing (top image) and radiosity (bottom image). Notice the blush on the ball in the radiosity rendered image.*

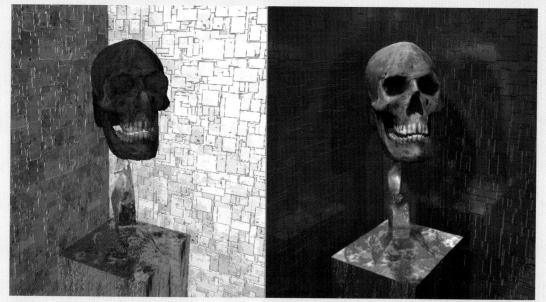

Color Plate 15: *Before and after lighting. Image on left uses the "standard" lighting that comes with most 3D packages. The image on the right uses the key light, back light, fill light strategy to model the form and pull it out from the background.*

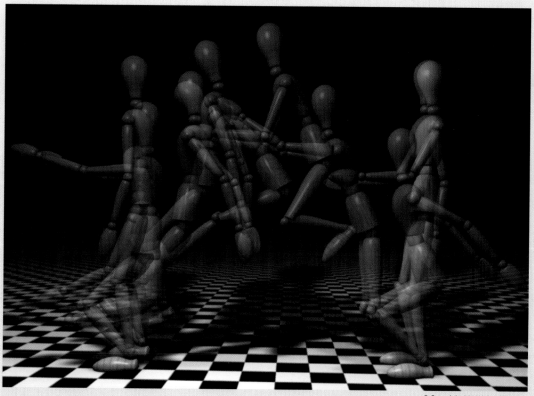

Color Plate 16: *Jumping wooden man based upon Muybridge photographs.*

Color Plate 17: *Proving he really is "Captain 3D," Phil McNally creates stereo 3D images that when viewed through blue/red glasses produce a truly 3D experience.*

Color Plate 18: *Another example of Phil McNally's stereo 3D technique.*

FIGURE *Grid method to establish areas of color.*
6.66

FIGURE *Bearded boy.*
6.67

After you are pleased with general spots of color, apply general color washes in a layer of its own to completely cover the grid. Be sure to keep layered versions of these maps with an intact grid system, so if you choose to make adjustments later, you still have the original files to work with (Figure 6.68).

FIGURE *Added color wash for skin tone.*
6.68

All sorts of details can be added to this color map. For instance, Figure 6.69 shows some red blemishes for pimples.

Other maps can be built using the grid map. For instance, Figure 6.70 shows the same pimply boy, only this time it includes an altered color map and a bump map. The bump map was created directly from the layered color map by hiding all layers but the pimples, converting it to grayscale, increasing the contrast, and saving it as a new map.

FIGURE *Pimpled boy.*
6.69

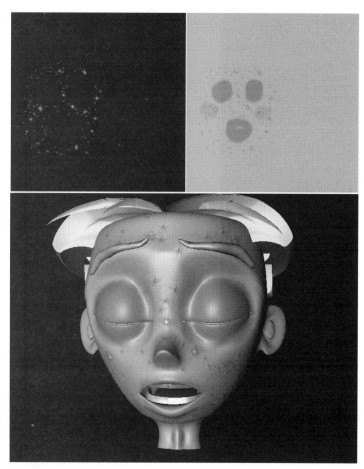

FIGURE *Pimply boy with bumps.*
6.70

Further alterations that could be made are maps that define an oily T-zone (across the brow, forehead, and nose) and a matte face. This could be placed in the specular map to give the boy a shiny nose. Also, a great technique for skin pores is to take an extreme close-up photo of your own skin, or even scan your face. After doing this, convert the image to grayscale and find a good section that shows pores. Make the pored section seamless and Rubber Stamp several areas of pore work into the map, making sure to exclude areas like the eyelids and ears.

Be sure that when working with this method, you keep numerous versions of each map and save layered versions within Photoshop. If you end up completely covering up the grid, the game is over. Also, when working with skin tones and adding color to things like the cheeks and eyelids, make sure to use a very soft brush with very soft edges. Too hard an edge or too dramatic a color shift and your character will end up looking like a clown. Be sure to take many test renders along the way; this sort of texture work takes a lot of refining, although theoretically, you know exactly where everything goes.

Exercises

1. If you have a digital camera, take a picture of a small section of your wall. Make a seamless texture from it and create the appropriate bump and other maps that will give the wall a more tactile feel. Apply this to the walls of the wooden man scene.
2. Create a new texture for your soda can choice. Either create it from scratch within a painting application, or scan a flattened can. Be sure to create an extra reflection map to make certain parts of the can's paint job reflective and other parts matte.

Shedding Light on 3D Illumination Systems

Without lighting systems, animations cease to be a visual art form. Lighting is often the last thing thought of by many animators, and consequently, bad lighting has ruined many clever projects. It is not an afterthought; rather, lighting itself can become a character within your animation. But, before we get down to the nitty-gritty of how the virtual lighting systems work within 3D, let's talk a bit about some rough definitions of lighting systems, and the theory behind light and color.

3D applications usually use four different light sources: *ambient, global lights, point lights,* and *spotlights*. Ambient light is light that attempts to emulate the bounce that occurs with all light. When we turn a light bulb on, the light streams from the bulb and bounces off walls, tables, chairs, tile, etc. As this light bounces, it illuminates other objects around it. If a 3D application attempted to keep track of where all these bouncing particles or light went in a scene, it would take it years to render, so ambient light is provided to "fake" this idea of sourceless light bounce. Ambient light makes the entire scene brighter without affecting the shadows. The problem is, this gives you no control over any sort of selective focus. Figure 7.1 shows a rendering of a

FIGURE *High ambient light render.*
7.1

scene with no lighting instrument sources but high ambient light. Notice, no shadows, no form—no good. Usually, the first thing to do in any scene is to completely dispose of any ambient light.

Global lights are like the sun; the source is somewhere far away, but it is directional. A global light affects everything in the scene; thus, everything is illuminated or casts shadows from it. Different applications handle global lights differently. For instance, Strata StudioPro gives a small light palette that allows you to add global lights and then determine where they originate by moving the head of the "tack" into position. Other applications like Cinema4D place this feature within an environment and actually call it the sun. You then designate what latitude and longitude the scene is at, and what time of day it is.

Global lights are a quick fix to lighting, and are often useful for some outdoor scenes; but again, you lose the control of helping your audience know where to look in the scene. Delete all global lights as well. The resultant scene (without any ambient or global lighting) is, of course, a complete void—black; however, it is then a clean lighting palette on which you can paint with light.

Point lights act like light bulbs; they originate from one location and emit light in all directions. Figure 7.2 shows a point light in the middle of a group of primitives and the resultant render.

You can control both how bright the point light is and how far the light from a point light emits. This is usually represented by a pair of circles displayed around the point light in the window of your 3D application (Figure 7.3). Most 3D applications allow you to simply click and drag these circles to increase or decrease the range of your light (Figure 7.4). The inner circle represents the radius at which the light is at full force, while the outer circle represents the point at which the light falls off completely. An important thing to notice about point lights is that the render shows the result of the point light, but does not actually render the source. That is, you can see the result of the light bulb, but not the light bulb. It is important to remember that if all the light is supposed to be coming from a visible hanging light bulb, you actually need to model a light bulb and place it in the same location as your point light.

Probably the most potent tool in lighting is the spotlight. Spotlights give you ultimate control of everything from brightness to direction to color to volumetric effects. Spotlights are usually represented in 3D applications in several parts (Figure 7.5): the source, direction, full-intensity radius, fall-off radius, full-intensity distance, and fall-off distance.

FIGURE *Primitives around a point light.*
7.2

FIGURE *Sample point light with close range.*
7.3

FIGURE *Sample point light with increased range.*
7.4

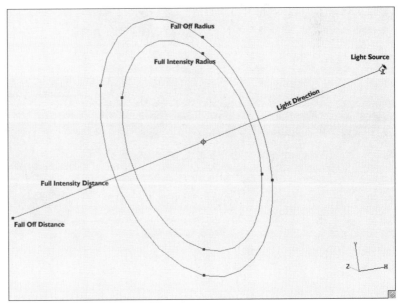

FIGURE *Diagram of spotlight parts.*
7.5

To click and drag the source icon is the equivalent of moving the lighting fixture. To click and drag the direction icon is like keeping the fixture in one place but pointing it in a new direction. The full-intensity radius shows how wide the light spreads at full intensity, while the fall-off radius shows the outermost point at which any light from the spotlight can be seen. If there is a significant difference between these two circles, the light is very soft. If there is little difference between the full-intensity and fall-off radii, the light has a much harder edge (Figure 7.6).

Full-intensity distance and fall-off distance work much the same way, but deal with the straight distance from the source. Figure 7.7 shows two lights with differing full-intensity distances and the resultant renders.

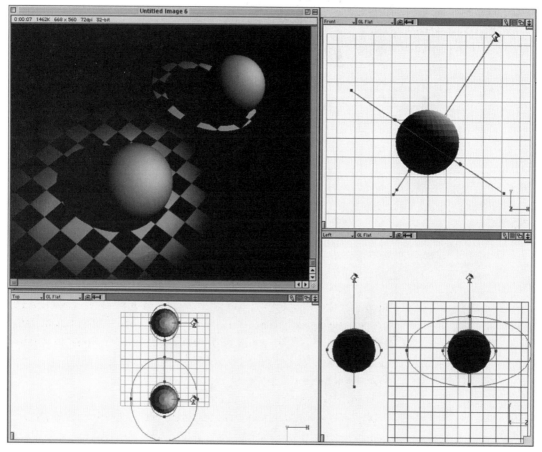

FIGURE *Hard- and soft-edged spotlights.*
7.6

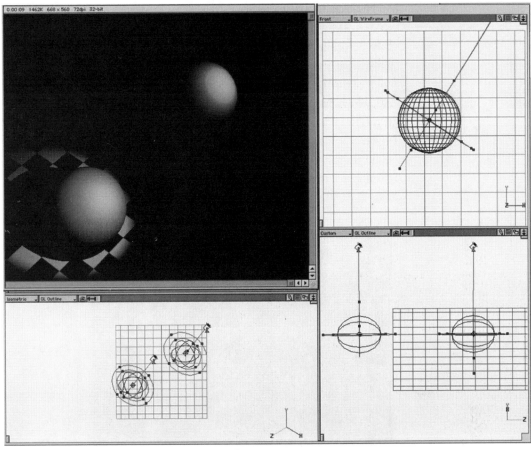

FIGURE *Different full-intensity distances.*
7.7

**The Theory
of Light**

As a theatre undergraduate, I had a lighting design teacher who would start his beginning lighting design class by bringing in a sealed can of paint with dried streaks of blue paint running down the side of it. He would hold it up and ask, "What color is the paint inside this sealed can?"

We would of course make the logical guess of "Blue!"

"Nope." He would say, "I said *inside* the can."

"Well how are we supposed to know that?" we'd cry, "Open the can and we'll tell you."

"If I open the can, it'll change the color, or rather give it color . . . " he would hint.

His point was that without light, the paint inside the can actually had no color. Color is a result of light bouncing off surfaces. As a beam of white light (which in light actually contains all colors) strikes a surface, the surface absorbs certain parts of the color spectrum contained within the beam. The color of the light that it does not absorb bounces off the surface and hits our eye, which passes the information to our brain, which interprets it as a color. If you shoot a red light on a red apple, then the apple appears red. However, if you shoot a green light (a light without any red in it) on a red apple, the result is a gray apple (Figure 7.8), as there is no red within the light to reflect to our eye. Further, without light, there is no color to be seen. So, to under-

FIGURE *Red apple with red and green lights.*
7.8

stand good lighting, we must first understand light itself. First we will study the controllable qualities of light, and then we will look at the functions. Once we understand the qualities and functions of light, we will look at how to use those controllable qualities to fulfill the functions. Without this understanding, our beautifully constructed objects can appear flat and dull.

Controllable Qualities of Light

In his book, *Designing with Light*, J. Michael Gillette outlines qualities of light relevant to good lighting design.

> **Distribution.** This is a fairly broad characteristic that encompasses many ideas. One idea is that of the hardness or softness of the edge of the light as it strikes a surface. A low-diffusion light makes for a hard edge, while a high-diffusion light leaves a soft edge (Figure 7.9).

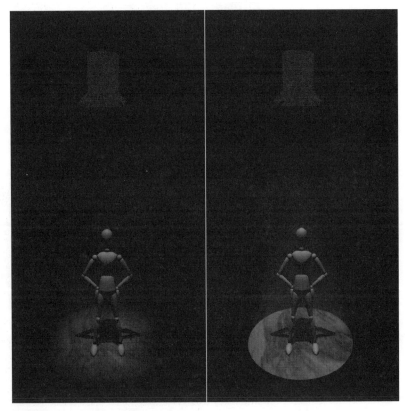

FIGURE *High- and low-diffusion edges.*
7.9

Diffusion also refers to how the shape of the light appears. When working with volumetric light (or light in which you can see the beam), a low-diffusion beam looks like the figure on the right in Figure 7.10, while a high-diffusion beam appears like the figure on the left.

Low diffusion in the form of volumetric light can be a powerful ally in establishing ambiance. See Figure 7.11 for an example of low-diffusion sun rays (spotlights) establishing a great setting. Figure 7.13 shows hard-edged (low diffusion) spotlights assisting in creating a feel totally different from that of Figure 7.11, but just as effective. Visible light in the form of point lights can also be effective in either high- or low-diffusion forms. Figure 7.12 shows Jeff Carns' haunting image with a high-diffusion point light in the middle of the egg.

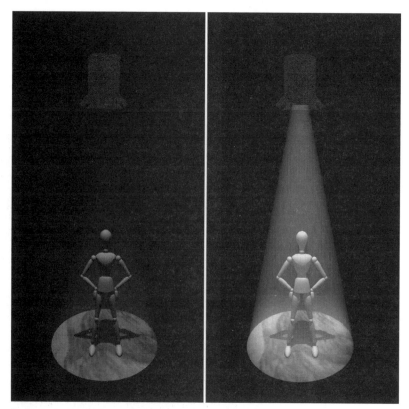

FIGURE *High- and low-diffusion beams.*
7.10

FIGURE *Alec Syme's effective use of volumetric lighting.*
7.11

FIGURE *Jeff Carns' egg and high-diffusion point light.*
7.12

FIGURE *Ryan Crippen's "Power Room" makes great use of low-diffusion volumetric lighting.*
7.13

Intensity. Intensity refers to how bright the light is. It can be zero for a light that emits no light, or it can be incredibly, even painfully, bright.

Movement. In the world of 3D, movement has several meanings. In theatre, the lighting instruments that light the stage actually rarely move, but they can indeed move quite a bit in virtual space. Besides the lights that light a scene but have an invisible source, movement also can refer to the movement of a visible light source; for example, a lantern being carried across the scene. Finally, movement also refers to the length of time it takes a light to increase or decrease in intensity.

Color. Tinted light is an amazingly powerful psychological tool. Different-colored lights can convey a great deal of information, including emotion. We will talk much more about color later.

Functions of Light

It is nice to understand the characteristics of the tools at hand, but it is also necessary to have a grasp on their use and functions. The functions of light are visibility, modeling, and mood.

Visibility. The most obvious function of light, visibility can be determined by the number of lights, the intensity of those lights, and how they are focused. Focus is an important idea in visibility. It is easy to turn up the *ambient light* (light with no particular source that penetrates every corner of a scene) so that everything is clearly lit, but that does not help the audience understand the scene or the narrative as well as *selective focus*. Selective focus is based on people's instinctive reaction to be drawn to the brightest area of a scene. Since in the 3D environment, the artist has complete control over the lights, it makes sense to exploit this power to show the audience where to look, as well as where not to look when hiding shortcomings in the scene (Figure 7.14). The audience will never notice problems in the scene if they are not well lit.

Modeling. When we speak of modeling in a lighting sense, we are talking about the visual definition of geometric form—visual modeling. Good visual modeling creates shadows on the objects in the necessary places to allow an object's form to be understood, yet still provides enough general light for the object to be seen. Too much light is not a good thing; it destroys shadows necessary to define a shape (Figure 7.15). Figure 7.16 is a figure by Jeff Carns that uses light to delicately model architectural details.

Mood. Over-the-top mood lighting is very easy to establish. Just throw a bunch of heavy blue lights on top of objects and voilá, instant melancholy. Throw a bunch of red lights on a character and bang!, instant angry scene. However, most scenes are in need of more subtle mood descriptors, and these are often very hard to achieve. We will talk more of mood later, but it is very important to understand that subtle mood lighting is usually what separates a mediocre scene from one with real emotional impact.

FIGURE
7.14
Cleopatra and focus illustration.

FIGURE
7.15
Venus and light modeling.

FIGURE *Jeff Carns' fine use of modeling light.*
7.16

Fulfilling the Functions of Light

A standard concept in both photography and theatrical lighting design is that of *key* and *fill lights*. Key lights are the brightest light in the scene and are aimed at the most important object or character. Fill lights are usually much dimmer and are usually present to assist in illumination and to soften the shadows caused by the key light. You can also use fill lights to add subtle color and depth to a scene.

In theatre, we often make rough sketches, known as *key plots*, to plan how the key and fill lights are going to work to achieve a design. Key plots are often divided into three parts (top, front, and side) to show the angle of

key and fill lights in relationship to the target object. Figure 7.17 shows an example of a key plot. Each arrow on the plot represents a different light.

There are no real rules to key plots. Usually, no one but the lighting designer ever sees them in the theatre world, and no one but the digital artists see their own key plots. The important thing is to use this planning tool as an impetus to organize and plan ideas in lighting. By creating key plots for each scene or mood change of a scene, you can actually save an amazing amount of time when it comes to actually placing lights in your scene.

Most programs have a default lighting setup. Sometimes this setup consists of lots of ambient light and a global light or two originating from the camera. This sort of setup is great to model with, but has the emotional impact of a cheap doorknob. To create models that are interesting to look at and make the audience feel something, it is necessary to plan beforehand

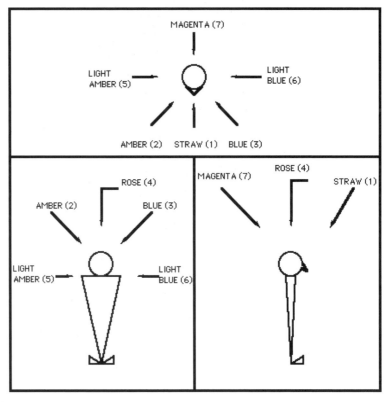

FIGURE *Key plot example.*
7.17

and then implement ideas such as elements of angle, multiplicity of light sources, and color enhancements.

A professor of lighting at Yale University name Stanley MacCandless wrote an influential book called *A Method of Lighting the Stage*. In this publication, MacCandless outlines many of the ideas of key and fill lights discussed earlier, as well as the idea behind angle. MacCandless argues that dynamic use of angle can be one of the most effective ways to communicate mood, time of day, and a variety of other ideas. Global lights, if angled appropriately, can give a good feel for angle in outdoor scenes. However, in interior scenes where lighting fixtures always have a limited range, global lights are rarely appropriate. Good use of spotlights is a far better choice.

We have talked a bit about ambient light and how it attempts to give the effect of light bounce. The problem arises in the loss of control that results in ambient light use. A far more effective method is to manually control multiple light sources.

When we walk outside on a sunny day, we may think that there is one light source: the sun. However, every building, car, window, sidewalk, and street is reflecting some of that sunlight at all sorts of angles. Similarly, when indoors, all those glossy table tops, metal chairs, Coke bottles, and white sheets of paper are bouncing the light emitted from a light bulb of some type. In both of these scenarios, there is a clear key light: outdoors, the key light is the sun; inside, it is the light bulb. All the surfaces that are bouncing the light are essentially fill lights, even though they have no intrinsic light-emitting power of their own. For this reason, it is important to have many lights in almost every scene.

Stanley MacCandless calls for at least five separate light sources: A top light, back light, two side lights, and a combination of angled front lights can give an object a more realistic sense. Notice the difference between Figures 7.18 and 7.19. Figure 7.18 uses one light source that faces straight at the character, while 7.19 uses a variety of light sources. In Figure 7.19, there is a strong key light that helps to create the shadows necessary for good visual modeling around the chin and nose, while the fill lights soften those shadows and allow us to still understand what is happening below the chin and nose.

Hardly any light is actually white. Sunlight perhaps comes the closest to it, but as soon as it hits a surface and the light is reflected, the color of that bounced light changes as the surface absorbs parts of the spectrum of colors. The same goes for inside, only most artificial light sources are often very yellow or blue to begin with. In both situations, the bounced light is really a

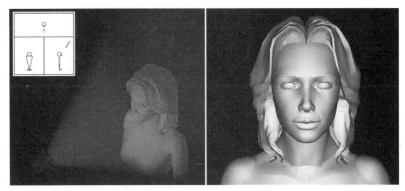

FIGURE *Single light source illumination and modeling.*
7.18

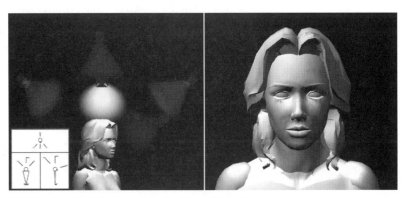

FIGURE *Multiple light source illumination and modeling.*
7.19

rainbow of fruit flavors. Lighting in 3D should be no different; usually the key light (the strongest light) has a strong color in order to affect the mood of the scene, while the other fill lights will assist in illuminating the scene and complementing or contrasting the colors.

Obviously, the choice of color for the key light is extremely important. Remember the apple in Figure 7.8? The same thing can happen to any surface or texture you have created in your model. There is nothing like modeling an immaculate engenue with rosy cheeks and a clean complexion and then throwing a greenish light on her. All of a sudden, she looks more like the Wicked Witch of the West than Dorothy. Often times, you can use colored fill lights to pull out important colors. A dash of rose-colored fill lights

can do wonders for that pallid complexion, and a shot of light green on a forest scene can make those green leaves sing. The point is, picking a color for the fill light to assist in mood is just the beginning of color choices in a scene. Look carefully at the colors present and which ones you want to bring out, then light them appropriately with the necessary fill lights.

Lighting What You Know

After looking at my work, my undergraduate drawing professor would tell me, "You need to draw more of what you *know* and less of what you *see*." That comment always irritated me, since I had spent a large amount of time recording the model in front of me. The problem was, even though I was accurately recording what I was seeing, it was not communicating the model to someone viewing my drawing. Virtual lighting is the same way. We *see* that at night it is dark; there is not much light—sometimes no light. However, showing a night scene with little or no light does not make for a very interesting scene.

As an audience, we have been trained to accept certain colors to represent different situations. For instance, Figure 7.20 shows a set design I did for the

FIGURE *Daylight scene.*
7.20

show *Pools Paradise*. This figure shows the set lit as though it were midday. Figure 7.21 shows the set lit as though it were the middle of the night. We can see everything on the stage and all the characters that may wander in or out, and we will even believe that they cannot see each other across the room, even though we can see both of them. The trick is that I lit the scene with a heavy purple key light that deadens the yellow of the set and makes it "feel" dark, even though it is very well lit. The scene is not lit realistically, it is lit to communicate.

There is one other overused ability of light within 3D applications: lens flares. Lens flares are the effects bright lights have on camera lenses. 3D applications are able to duplicate these effects. Unfortunately, because they have become so easy to do, they are everywhere. If you wish to use a lens flare, do so sparingly in situations where it adds to the effect, as in Figure 7.22.

Our wooden man scene actually has an overall simple lighting scheme. The idea is that the scene takes place in a room, at night after everyone has gone to bed. Because of this, there is only one main light source, the lamp on the desk. We'll also add a little bit of directional light as though it were

FIGURE *Nighttime scene.*
7.21

FIGURE *Lens flares can be useful, as in this tasteful example by Jeff Carns.*
7.22

coming from the hallway bathroom, just so the scene stays well-enough lit to make for a good animation. Also, along with lighting we know, there will be a third light source—a purple light—that will color the scene and light it a little, but maintain the feeling of night.

So, to begin with, if there is ambient light as a default (Strata StudioPro), remove it all. Cinema4D and LightWave act as though there is a floodlight affixed to whatever viewpoint you may be looking through. This obligatory floodlight disappears as soon as you place a light within the scene.

Begin by placing a point light within the light bulb object. If you rendered it now, Cinema4D would create a bizarre site with no shadows, including no shadows from the lamp shade (Figure 7.23). If you are using Cinema4D, be sure to activate the shadows for this new point light. Strata StudioPro has shadows set by default, so you would have a black scene with nothing visible because the point light is inside the bulb. LightWave, similar to Cinema4D, needs to have the shadows activated for the new point light.

At this point, all three programs would render a scene with nothing visible, because the light source is inside the bulb object. Select the bulb object

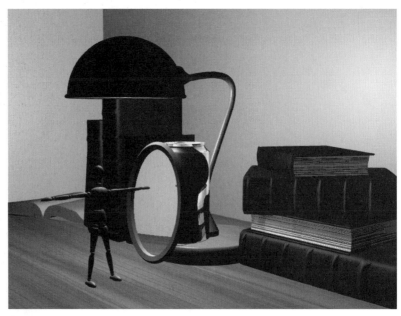

FIGURE *Cinema4D newly placed light source.*
7.23

and disable its shadow-casting abilities so that the point light's rays will pass
through the boundaries of the bulb (Figure 7.24).

The image may be closer to reality, but it is a bit too dark and does not
lend itself to helping to tell a story. Let's do some fine-tuning. First, in a room
that dark, we often have some volumetric lighting apparent—or light rays
that we can see. Add volumetric light to this new point light and adjust the
range of the rays so that they barely touch the top of the table (Figure 7.25).

Now let's adjust the color of the light so that it has a little bit of a yellow
tint to it; much like light bulbs do (Figure 7.26).

Now, let's put a little more illumination on the scene in general. We'll do
this by placing a very gentle wash on the scene. We still want this scene to
appear as though it were happening at night, so we'll put a bit of blue/pur-
ple tint to this light. Create another point light and then alter the light color
to a deep purple. We want this to be a very gentle wash to change the bright-
ness to only about 2%. Since this point light is just to give the scene a feel-
ing of night, we don't want it to cast shadows or make the scene look like it
has some sort of purple light bulb off to the side, so leave the shadows off.

To further illuminate the scene, let's add a spotlight that will act as light
coming in through the doorway from the bathroom down the hall. This

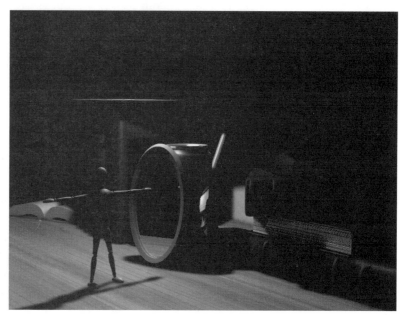

FIGURE *Cinema4D renderings with cast shadows.*
7.24

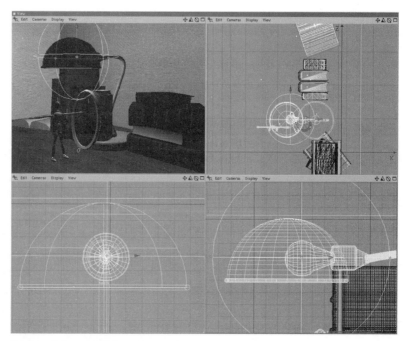

FIGURE *Volumetric light radius.*
7.25

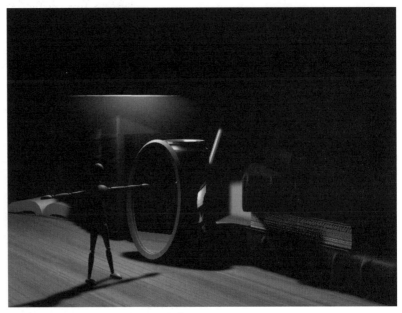

FIGURE *Rendering with volumetric light.*
7.26

light, too, would be very soft and diffused, but it would indeed cast shadows. To do this, we'll create a spotlight. Create a spotlight and change the Brightness to 30%. Give the light soft shadows (Cinema4D and LightWave only) (Figure 7.27).

We'll talk much more about rendering later, but this scene shows a real drawback to raytracing rendering. In real-life, if a light bulb was directly above a tilted mirror as it is in our scene, there would be some reflected light on the table and on the dummy—there is none in Figure 7.28. This is because ray tracing doesn't calculate bounced or reflected light. If you are using LightWave or Strata StudioPro, you could always choose to use their renditions of radiosity rendering, but radiosity (in all its flavors) is usually so time intensive that it should only be used in very selective situations. This scene is probably not one of them, since the plan is to animate it.

So what is to be done? Well, we need to place additional lights that will light the scene in the way that the reflected light would have. In Cinema4D and LightWave, place an area light slightly above the surface of the mirror, turn soft shadows on, and reduce the brightness to 50%. In Strata StudioPro, you'll need to use a point light with an intensity of only about 30%—also placed just a little above the mirror. This will do two important things:

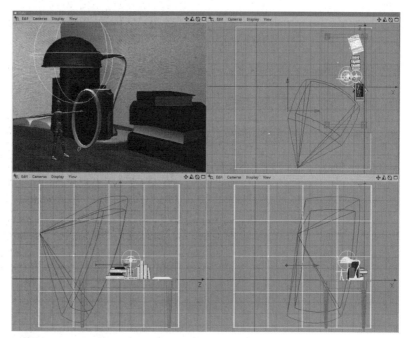

FIGURE *Rotated spotlight and purple light.*
7.27

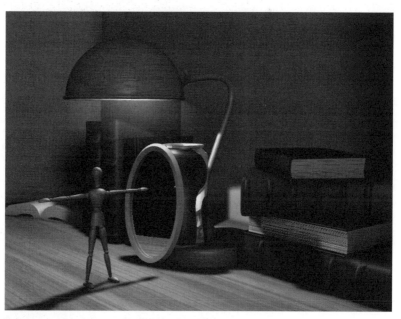

FIGURE *Rendered scene with all lights but mirror.*
7.28

1) It will make figures reflected in the mirror light and bright, and 2) It will give a spill to the table and other surrounding objects. The final lit scene should appear something like Figure 7.29.

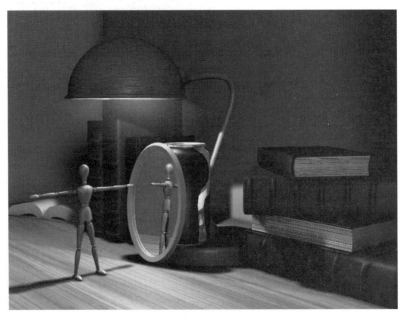

FIGURE *Final lit scene.*
7.29

T
U
T
O
R
I
A
L

7.1: LIGHTING TO SHOW FORM—A CASE STUDY

People often leave the lighting to the last step in an animation—almost as if it were an afterthought. Unfortunately, the lighting can make or break the look of a model. It doesn't matter if you have spent the last six months creating a perfectly anatomically correct rendition of a character you have designed; if it is lit wrong, it will look flat and destroy all the modeling work you invested. One of the most important functions of lighting is to be able to effectively illuminate your model to show off the geometry contained within.

Most 3D applications have some sort of default lighting setup. Usually, this default lighting is either a high amount of ambient light (Figure 7.30) or the equivalent of a floodlight

FIGURE *Ambiently lit skull.*
7.30

mounted to the top of the camera (Figure 7.31). Both of these scenarios allow for simple illumination; that is, we can see (more or less) the objects in the scene, but the results are always flat and don't show the contours of the model.

For this case study, we are using a simple skull model downloaded from 3D Café (www.3dcafe.com). Notice in Figures 7.30 and 7.31 that although we can clearly see what it is we are looking at, the sockets of the eyes and nose are flat, almost as though there is no indention at all. The definition of holes or imprints occurs through the existence of shadows. Both Figures 7.30 and 7.31 have a conspicuous lack of defining shadows, both on the wall behind the skull and on the surface of the skull itself.

To help define these shadows, the first thing we need to do is place a light source at an angle to the model so that the shadows will be visible. In this case, we will begin by placing a

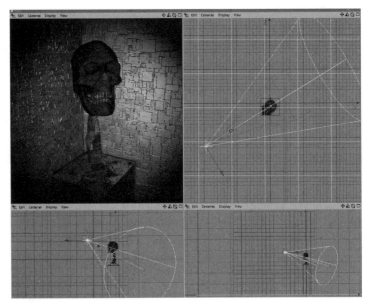

FIGURE *Front-lit skull.*
7.31

key light just offset of the camera. A key light is simply the brightest light and will give the model its strongest light source (Figure 7.32). Make certain that if your 3D application places lights as shadowless (or nonshadow-casting) light sources, that you activate the shadows. Also, to have complete control of all light on the scene, make sure to use some sort of directional light (spot or parallel) so you have spotlights that can be pointed and angled rather than bleeding light bulbs.

You will notice that in Figure 7.32, a nice shadow is cast upon the wall behind the skull. This gives the viewer a second perspective from which to understand the form of the model. Although the viewer's point of view has not changed, he suddenly understands the profile of the model.

Similarly, notice the strong shadow that appears on the side of the skull's nose and right under the brow. This is because the light is angled above and to the side of the skull, allowing those descriptive shadows to emerge. Unless you're looking for the deer-in-headlights look, most lights should be placed at angles from the model or viewing plane.

Now the problem is that the skull is hit hard from one side, and sections of the skull are completely obscured because of the lack of light. The entire right side of the skull is impossible

FIGURE *Offset key light.*
7.32

to make out. To solve this, we will place fill lights or lights with less intensity whose job is to softly illuminate shadowed areas without destroying the modeling those shadows provide.

Figure 7.33 shows the same model, only with two angled fill lights. There are several important things about these fill lights. The first is their intensity. The intensity of these two fills is about 15%. Compared to the 100% intensity of the key light, they do not provide a noticeable change in overall light intensity; however, they do provide illumination on areas previously obscured by shadow. Since these fill lights' purpose is to illuminate previously obscured areas of the model, the angle at which they are placed is extremely important. Notice in Figure 7.33 that the angle of the fill lights is considerably lower than the key light. This way, they have an opportunity to hit the underside of model outcroppings and thus soften the shadows and illuminate the areas that were once dark.

A really nice trick in dealing with key lights that adds nice visual depth to a scene is to color them. The key light, as the most intense, provides the majority of the color information of the scene and defines the mood (if the key light was red, the feeling of the scene thus far would be much more sinister).

FIGURE *Two key lights.*
7.33

However, the fill lights can often have a wide variety of colors that assist in bringing out colors extant in the model while not changing the overall mood. By changing the fill lights' colors (one to blue and one to red), the depth is increased and the shadows remain intact (Figure 7.34). Part of the beauty of colored fill lights is that colors like dark blue can illuminate a scene but the human mind still reads the color as dark. In theatre, often a scene will be presented in which the audience is to believe the lights are off. As the two characters on stage creep across the stage oblivious to each other's company even though they are both in full view of the audience, the audience understands (because the scene is lit dimly with a blue color) that the scene is dark, even though they can plainly see all that is transpiring.

Thus far, all the lighting we have done has been front or side lighting. This has worked well to establish shadows that help to define some of the form across the surface of the model. However, in doing so, the overall model begins to fade into the background. To make the model pop out again, we can use a variety of "kicker" lights to highlight the edges of the model. One of the best examples of this is to create a top light, or a light that is directly above the model (Figure 7.35).

FIGURE *Colored fill lights.*
7.34

FIGURE *Top light.*
7.35

Look at the top of the skull. All of a sudden, there is a thin highlight, almost like a delicate halo, that immediately provides a surface that separates itself from the surface behind it. The intensity of this light varies from situation to situation. In this case, the intensity is about 70%, since the color of the background and the color of the skull are very similar. However, you may find situations that have a higher contrast between foreground and background where a much lower intensity would be more appropriate.

To further augment the edges of the model, Figure 7.36 has a back light added. To place a light behind a model seems rather gratuitous at first, since the back will not be seen. However, upon closer examination you will notice that it helps to create highlights along the outer surface of the model that provide further definition from the background. In many cases, this back light can also provide shadows on the floor in front of the model that help determine the overall profile of the form.

Figure 7.36 can be further refined to add to the form. In Figure 7.37, there are two more fill lights (both dark blue at

FIGURE *Added back light.*
7.36

FIGURE *Added fill lights.*
7.37

about 15%) that illuminate the bottom right-hand corner of the jaw. Notice, however, that even though there are eight separate lights coming at this model from all sides, there is still a clear shadowed and lit side. Because of this, the form is still clear and we visually understand the form. The key is to never let the fill lights become too strong. If they are too intense, the model is washed out, shadows disappear, and form is visually destroyed.

Having spent all of this time using lights to define geometry, remember that sometimes textures can aid greatly in defining the visual form. Figure 7.38 is the same model and lighting setup as Figure 7.37, only with a darkened background texture and black textures in the eyes and nose sockets. These black textures read as very dark shadows make the recess appear very deep. This is a good reason to get started with lighting very early in the process. With lighting setups created early, you can find places to apply texture alterations to create better form definition.

FIGURE *Altered textures.*
7.38

T
U
T
O
R
I
A
L

7.2: CASE STUDIES IN LIGHTING HUMANS
FOR MOOD

Now that we have looked at some real-life lighting situations, let's examine different ways to establish mood and feel through lighting using the Zygote model included in Cinema4D. Through the course of these case studies, we will look at how angle and color can take the same scene and radically alter the feel and emotional impact.

Figure 7.39 shows our brave boy with the typical default lighting—one light source striking him straight on. Notice the flatness of the image across the nose and the flat, uninteresting feel overall.

Before we begin to establish mood, let's use the techniques described earlier in this chapter to light the boy to better show the necessary geometry. Figure 7.40 shows the same scene only using the standard key light, two fill lights, top light, and back light setup. Notice that once again, with the correct lighting set up, the shadows that define the bridge of the nose, the eye sockets, and the chin silhouette appear, allowing

FIGURE *Flatly lit boy.*
7.39

us the visual information needed to understand the form. This is a good setup for a daylight scene; the face is strongly lit with a directional light (key light) that provides powerful shadows on one side of the face as really appears when someone is standing in the sun. However, by using the blue fill light, the shadowed side of the face is still illuminated, while maintaining the feel of shadow.

To create a night scene, a simple shift in color balance can maintain the modeling functions of the lighting setup while giving the scene a distinct nighttime feel. There are two main visual clues that alert us to a nighttime feel: 1) At night, shadows are often harder to distinguish unless there is a very strong moon. Thus, by lessening the impact of shadows by either turning them off in the lighting instrument or softening them, we can make shadows less intrusive and less descriptive of a strong light source such as the sun. 2) At night, colors are unsaturated. Without the strong full spectrum light of the sun, colors at night gray out and do not have much vibrancy. Unsaturated colors speak volumes as to the time of day even if there is no change in light intensity.

In Figure 7.40, the key light was a light-cream color to assist in bringing out the skin tones and to give the scene a daytime feel. By shifting the color of the key light to a dark gray-blue, the skin tones become more gray, less saturated, and more like skin appears at night or under low lighting conditions. All the fill lights were changed to an amber color to make sure the boy did not look dead, but were kept at an extremely low intensity to just give the skin enough color for blush. The back light was changed to yellow to simulate a light touch of moonlight across the shoulders, while the top light was changed to the same blue as the key light. The trick to this sort of scene is making sure that the character is still visible. In Figure 7.41, we can still see the boy and clearly understand his features (good shadows on nose, eyes, and chin), yet he feels like he is under low light. Remember, the feeling of low light does not necessarily mean less light; rather, it often just requires a more clever use of color.

The real power of lighting comes by making strong choices in lighting. One of the most powerful ways to make radical changes in style or mood is to leave parts of the face com-

FIGURE *Standard proper lighting.*
7.40

FIGURE *Nighttime lit scene.*
7.41

pletely obscured by shadow. By removing all but the back light and top light, and adding another top light at a slight angle to act as a fill light, we can create a truly mysterious image even though we know it is simply a little boy (Figure 7.42). The top light and back light are at 100% and a light cream color. The newly created top light that is acting as a fill light is blue to deaden the colors a little bit, but gives a little added illumination on the tops of the cheeks and chin. It is important to be able to see some of the facial features or we simply will not understand what we are looking at. With the blue fill light and the strong top and back lights that provide silhouettes and highlight to the top of the head, ears, and shoulders, we know the overall shape of the object approaching. Because we cannot see the eyes, we do not know where the figure is looking; we even have a hard time telling if he is smiling, laughing, frowning, or grimacing. All of these unknowns add up to mystery, and thus to a frightening image.

To create brooding or mysterious scenes, direct light that hides certain anatomical features cannot be beat. However,

FIGURE **7.42** *Scary scene lit with strong, limited lights.*

sometimes the scariest scenes are scenes in which all the features are visual and somehow lit in unusual ways. In almost every situation, we expect shadows to be cast below outcropping features such as the nose, eyebrows, cheekbones, and lips. When the highlighted regions of the face become those usually in shadow, the result is a disconcerting image that is independent of simple geometry. Figure 7.43 is the same boy with the same expression, only this time the top light that we used to highlight the image before was rotated to below the boy. The top and back lights are still intense and cream, but the high-intensity blue light that is shooting up at the boys face places all the highlights where the shadows should be. Think of every campfire scary story you have heard, and every movie gag with a flashlight held at someone's chin. Inevitably, this effect is used and most viewers can relate to this piece of visual communication.

Throughout these lighting exercises thus far, the main focus has been the use of angle to define mood. However, color can have a tremendous impact. Using the originally correctly lit setup (Figure 7.40) and shifting the colors of the fill

FIGURE *Spooky scene uplit.*
7.43

lights from blue to reds and pink, the skin tones of the boy come alive and a very youthful-looking figure emerges. Further, by altering the key light from a yellow to a beige, the skin tones further glow to create youthfulness and activity (Figure 7.44).

By altering these pinks, oranges, and ambers to greens and blues, the skin becomes ashen, unnatural, and aged. In Figure 7.45, the same lights with the same intensity are used; however, the colors of the lights have all been changed to dark greens and blue. The gray skin is no longer the face of a youthful child, but rather one much older and much more sickly.

Using our frightening setup, but changing the blue light coming up at the face to red, and altering the cream-colored top and back lights to orange, we suddenly have the campfire scenario discussed earlier (Figure 7.46). Even without any other geometry in the scene, we suddenly have a character placed within a believable location. Leave the back light as blue to give the nighttime visual descriptive highlights on the T-shirt.

FIGURE *Youth defined through color choices.*
7.44

FIGURE *Age defined through color choices.*
7.45

FIGURE *Campfire lighting.*
7.46

One further illustration is the use of volumetric lighting. We typically relate volumetric lighting to very intense light sources like the sun or a theatre spotlight; the idea being that the light is so intense that it actually illuminates the dust in the air. When volumetric qualities are activated in a light and the shadows are set to "hard," the result is the look of an actor on the stage. Figure 7.47 shows such a situation where the fill lights have been reduced in intensity and the key light has high-intensity volumetric light. The washed-out face displays the look of a young man on stage. Again, the location is defined strictly through lighting conventions—no added geometry needed.

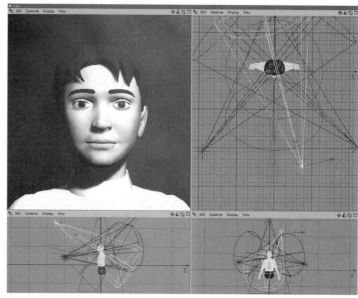

FIGURE *Stage lighting through volumetrics.*
7.47

Exercises

1. Create a new light source that will act as moonlight to stream in through the hole you made for the window in earlier chapters. Play with the color. Observe the moon. Experiment with volumetric and visible light to find the effect you want.

2. Recreate the entire lighting setup for the wooden man to show a day-light scene with heavy sunlight coming through the window. Create another scene at night, but using the light that would be on the ceil-ing of the room. Experiment with the colors of both the sunlight and the fluorescent light from above.

CHAPTER 8

Seeing the Power of Rendering

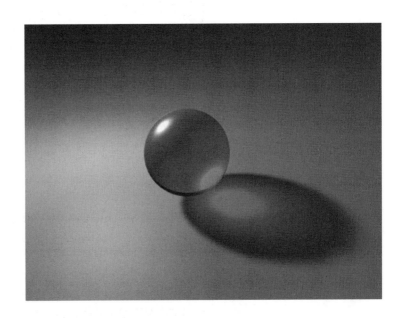

What Is Rendering?

After the scene has been modeled, textured, lit, and animated, it comes time to decide how we, the audience, are finally supposed to see the project. The computer process of taking the three-dimensional model with its accompanying textures and lights and turning that into a two-dimensional image is called *rendering*. In simplest terms, to tell a computer to "render" is telling the computer to "draw the information I've given you so far." Projects, whether still or animations, are not complete until they have been rendered. Rendering is the final front end and the product of the 3D process.

In general terms, your 3D application is rendering all throughout the work process. The wireframe or shaded OpenGL view of your model that you work with is a sort of rendering. However, most "feedback –based" renderings do not incorporate some very important specifics like reflections, shadows, and true transparency. The big rendering engines most commonly used today are *phong, gouraud, raytracing, radiosity, toon,* and other stylized rendering engines.

Phong and gouraud shading are some of the first rendering engines available, and are typically very fast rendering processes. They are so fast, in fact, that some applications like Cinema4D use gouraud shading as their feedback rendering engine; that is, they render fast enough to be interactive. A big drawback of these engines is that they typically use a scaled-back form of rendering transparency and never take into account any sort of refraction. Further, most phong and gouraud shading shows effects of light, but not their shadows (there are some forms of phong shading that are exceptions to this rule) (Figure 8.1). Some applications such as ElectricImage use a very fast form of phong shading that will calculate refraction, shadows, and, with some tweaking, reflection (Figure 8.2).

Raytracing is by far the most commonly used rendering engine. The theory behind raytracing is that the rendering engine creates imaginary rays between objects within the scene and the viewer (or camera lens). This line is direct, but can take long detours if it hits objects that have been deemed reflective. This is an excellent way to show reflective objects, refractive objects, and transparent surfaces (Figure 8.3). As the industry matures, raytracers are becoming increasingly speedy. So speedy, in fact, that some 3D apps only offer raytracing.

Raytracing does have a drawback, though; it does not calculate any light that may be bouncing between objects. For instance, Figure 8.4 shows a white ball inside a room with multicolored walls. With even a matte finish, the ball would be showing the results of the brightly colored walls on its sur-

FIGURE *Gouraud shading without shadows.*
8.1

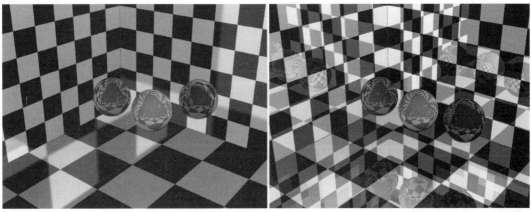

FIGURE *Anson Call's ElectricImage rendering.*
8.2

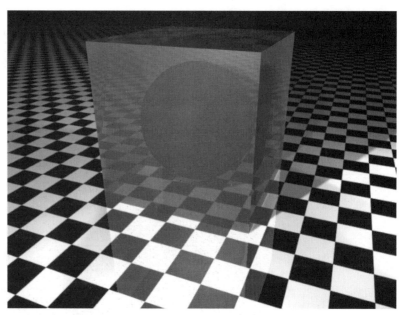

FIGURE *Raytracing rendering showing reflection and refraction.*
8.3

face in real life, but raytracing does not calculate these. The result is renderings that perhaps do not show the effects of surroundings on an object quite as well as something that uses radiosity.

Radiosity is probably the single most powerful and photorealistic rendering engine available. Radiosity analyzes a scene and treats every object and surface as a potential light source. This allows incoming light to bounce off surfaces and change characteristics as it goes. This detailed manner of handling light makes radiosity a very sophisticated rendering method. Figure 8.5 shows the same setting portrayed in Figure 8.4, but notice the softer shadows and gentle color blushes on the surface of the ball.

The biggest drawback is that although powerful, calculating all those extra bounces of light is extremely time intensive. It is not unusual for a radiosity rendering to take from 4 to 100 times the time to render as a raytracing render. Be selective about radiosity renderings, or if you know that you need an effect that radiosity will provide (e.g., the colored blushes on the side of the ball), consider "faking it" with raytracing. For instance, the blushes on the side of the ball could be done with colored lights that cast no shadows. Faking radiosity sometimes takes a little longer, but it usually saves you time over what you would spend waiting for a true radiosity render.

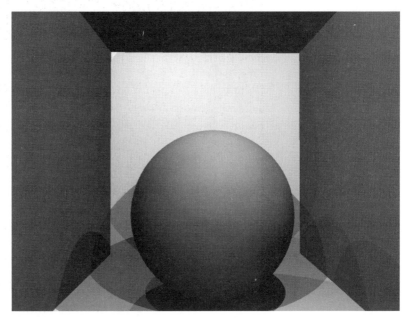

FIGURE
8.4
White ball in colored room with raytracing.

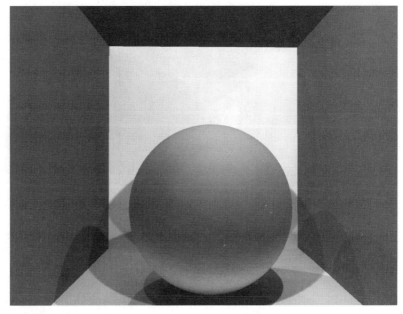

FIGURE
8.5
Radiosity rendering of white ball in a colored room.

Post-Rendering Effects

There are a number of interesting effects that rendering engines can perform after the image is finished rendering. These "post-rendering effects" are essential effects drawn on the final render after the render has been calculated. For instance, glow (as discussed in Chapter 6, "Advanced Texturing Techniques") is a post-rendering effect. That is why a glowing light bulb does not show up in a reflection. By the time the 3D application applies the post-rendering effect, all reflections and lighting concerns have already been addressed. Despite their limitations, post-rendering effects add some very nice touches to figures or animations. The following are some post-rendering effects and examples of their use.

> **Depth of field.** We may not consciously notice it, but our eyes are not able to have everything within our site in focus all the time. You can focus on the rubber ducky sitting atop your monitor, but the wall 10 feet behind it is actually out of focus. Cameras (both still and video) work the same way. We can have a focal point, but there can be objects in front and behind that focal point that we can see but are out of focus. Figure 8.6 shows an example of depth of field.

FIGURE *Depth of field illustration.*
8.6

Applications allow you to control the depth of field in different ways. Usually, they handle it through a camera object. The camera object, besides having range of view pyramids to adjust, will also have various planes defining where the view is in focus and where it is out of focus (Figure 8.7). In still renderings, depth of field is an effective touch of realism.

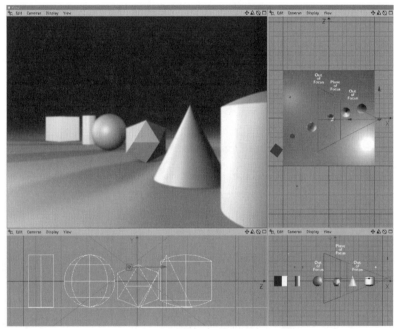

FIGURE *Cinema4D's depth of field camera functions.*
8.7

Motion blur. Have you ever tried to figure out how he does it by pausing your favorite Jackie Chan film in the midst of one of his acrobatic feats? The result is inevitably a blurred mess. This happens because the shutter of a camera (still or video) opens and closes too slowly to capture pristine shots of fast movement. When the shutter is open, fast-moving objects cover too much ground, leaving a smeared or blurred image. 3D applications do not have that problem since they record each frame as though motion were frozen in time, but you can tell 3D applications to pretend that they are a real camera and create motion blur. They do this by taking a given frame

and rendering the movement within that frame for that frame, and then shifting the movement a bit before and a bit after and render those frames. They then composite the frames before and after the original frame into a blurred image (Figure 8.8).

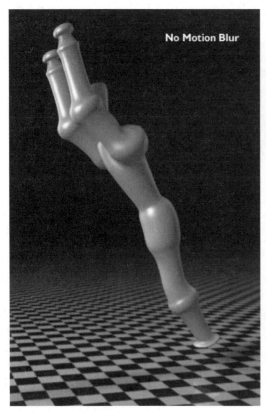 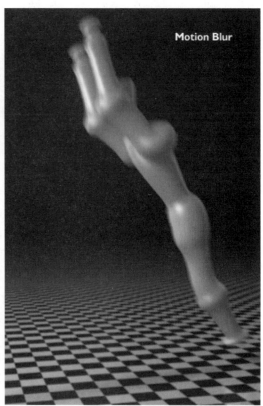

FIGURE *Movement with and without motion blur.*
8.8

This gives a nice illusion of blur due to slow camera shutter speed. This is a great effect and helps make 3D animations look much less sterile than they tend to be by default. However, the drawback is that to achieve motion blur, the 3D application must render the same scene many times. Usually, you can tell your 3D application how many times you wish it to render and offset the scene for a motion-blurred frame. The more times it rerenders an offset frame, the deeper the blur (Figure 8.9), but the longer the rendering takes. If "5 Times" is selected, the 3D application must render the

same frame five times for each finished frame, 16 times for "16 Times," etc. (Figure 8.9).

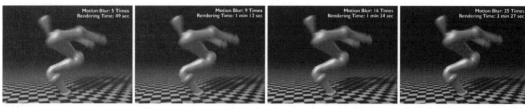

FIGURE *Various blur settings and resultant rendering time.*
8.9

Lens effects. We talked a little bit about this in the lighting section, but another fun yet overused post-rendering effect is lens flares. Lens flares attempt to emulate the effect lights have as they are bent through a camera lens. The flares and artifacts that result are typically viewed as gratuitous unless used very judiciously (Figure 8.10).

FIGURE *Lens flare example.*
8.10

Rendering DPI

DPI stands for "dots per inch" and refers to how dense the bits of color information are in an image. Computer monitors typically display figures at 72 dpi. The 72 dots of colored information within each inch visually blend enough by the time they hit our eye that 72 dpi figures look clean and crisp on a computer. However, print a 72 dpi image on a printer and you end up with a blocky mess. Print resolutions tend to be much higher in order to remain crisp (usually 200–800 dpi). The problem is, the more dots per inch, the more information a file must contain, and therefore the bigger the file. This is why Web images are always 72–75 dpi—these are small files but they look good on a screen. Similarly, animation, since it will be viewed on a monitor or a television, need not be any higher than 72 dpi. Therefore, when rendering stills, you want to understand how large the image is ultimately to be displayed and on what medium. If you are doing a 4″ × 4″ image for a magazine, you want the resolution to be 500 dpi; therefore, you need to render an image that is 2000 × 2000 pixels large (4*500 × 4*500). Remember that the higher the resolution, the longer it will take your computer to render an image, so be sure to carefully determine what is needed before rendering to save time (Figures 8.11 and 8.12).

FIGURE *4″ × 4″ image at 72 dpi in print.*
8.11

FIGURE *4″ × 4″ image at 300 dpi in print.*
8.12

The trick is understanding how many inches there are on the surface of a monitor or screen. DPI becomes a fairly confusing and irrelevant term when it comes to working with television-targeted figures. For instance, if you have a 40″ TV, you do not see any more of an image than you would on a 12″ TV—you just see it larger. Although there are other standards for new emerging technologies like HDTV, 640 × 480 (640 pixels wide by 480 pixels tall) is the standard size of pixels that TVs display. 640 × 480 is called NTSC, which refers to the National Television Systems Committee and the standard they established for color television (the details actually include 525 lines of information played back at 30 (actually, 29.97) frames per second). What this means is that animations rendered at 640 × 480 will play as crisp and as clear as color televisions in the United States will display. Many folks choose to work in 320 × 240 (half NTSC) because the files are smaller, play faster on slower computers, and actually transfer to TV *almost* acceptably. However, if your machine will handle 640 × 480, do it.

**Rendering
Settings**

After resolutions are determined, the textures are optimized, the model and textures are ready to go, and it actually becomes time to render, you will be presented with a variety of settings choices to wade through. Although most programs use different nomenclature, most have the ability to adjust the following concepts:

> **Anti-aliasing.** Bitmapped figures are figures comprised of small squares of color called *pixels*. Take any image in Photoshop, zoom in close enough, and you can actually see the blocks of color information. When a 3D application renders an image, it creates such a bitmap and sometimes, on close examination, "steps" become visible in the shape where the edge of the shape is being displayed by pixels (Figure 8.13). Anti-aliasing is the way 3D applications try to smooth these trouble edges. Figure 8.14 shows the same edge of the object shown in Figure 8.13, only this time, the rendering was done with anti-aliasing.

Anti-aliasing is often unnecessary if figures are small enough, because the viewer will never be able to look close enough to see the "jaggies." However,

FIGURE *Jagged-edged pixels.*
8.13

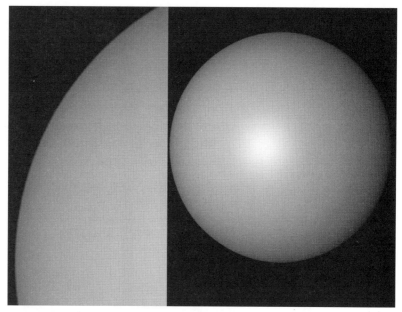

FIGURE *Anti-aliasing activated.*
8.14

in animation, anti-aliasing is often desirable because it keeps the edges of objects smooth so they do not "flicker" as the animation moves from frame to frame. Beware, though, anti-aliasing will indeed add to rendering time.

Oversampling. When your computer renders, it essentially takes colored bits of information and arranges them so that the whole looks like a cohesive image. As seen earlier, figures are comprised of small pixels that can be thought of as tiles. In this way, bitmapped figures are a bit like the Byzantine mosaics. The computer is the artisan placing mosaic tiles together to make the image you created. Oversampling determines how large the tiles are in your mosaic. The larger the tiles, the faster your artisan computer can fill in the spaces. The smaller the tiles, the tighter the detail, but it takes your artisan longer to fill the spaces. Use oversampling when close-up detail is important, but use it sparingly over all—it is a time hole and can take unnecessarily long to render.

Transparency recursion. Also sometimes called *ray depth*, transparency recursion has to do with how many times a computer will "see"

through a transparent object. For instance, Figure 8.15a shows five windowpanes lined up in front of each other. The transparency recursion is set for 4; thus, the fifth windowpane appears opaque. Figure 8.15b shows the same windowpanes, but with the transparency recursion increased to 5. Low transparency recursions keep rendering times low, so this setting is often by default set to a low value. Usually this need not be altered, but if you have many transparent objects, you may want to selectively alter this.

FIGURE *Windowpanes and transparency recursion effects.*
8.15

Reflection recursion. Sometimes called *reflection depth,* this setting also determines how many times an object is reflected. If two mirrors were placed facing each other, in theory, the reflections would reflect forever. 3D applications attempt to keep rendering times low by limiting the number of times the render attempts to draw the reflected image. Figure 8.16a shows a reflection recursion set to 4, and Figure 8.16b shows a setting of 20.

FIGURE *Reflection recursion effects.*
8.16

Alpha channel. We have already discussed this a little in previous tutorials. The idea behind alpha channels is that a channel is created within a rendered image that is purely black and white (Figures 8.17 and 8.18). These black-and-white pixels designate where in the rendering objects exist; if the alpha channel shows white, the object is present. If black, there is no object. You can access the alpha channel from the Channels palette of Photoshop when the image is opened (Figure 8.19). In the case of animations, Adobe's AfterEffects and Premiere, and Apple's Final Cut Pro will recognize embedded alpha channels.

Alpha channels can be tremendously powerful when dealing with complex scenes or special effects. For instance, Figure 8.20 shows the image rendering in Figure 8.17 placed in front of a blurred background of a forest scene. The forest is one layer in Photoshop that has had the Gaussian Blur filter (Filter>Blur>Gaussian Blur) applied to it. The woman was "picked out" of her original rendering by using the Magic Wand tool to select the white pixels of the alpha channel, copy the colored pixels within that selection, and then paste them in a new layer over the forest. By simply using the

FIGURE *Rendering image of Zygote model.*
8.17

FIGURE *Alpha channel.*
8.18

FIGURE *Channels palette in Adobe's Photoshop.*
8.19

FIGURE *Alpha channel composited image.*
8.20

alpha channel to pick the woman out of the rendering, there was no need
for time-intensive Photoshop work. In the case of an animation where you
are working with 30 frames per second, alpha channels are necessary when
compositing computer-generated elements with other computer-generated
clips or real-life footage.

Some important caveats about alpha channels to remember:

- Alpha channels create an alpha outline around everything in the
 scene. Therefore, if you have floors or skies in the rendering, the
 alpha channel will include those, making it impossible to superim-
 pose any characters over another scene. If you plan to use compositing
 techniques to blend objects into other backgrounds, leave all "scenic"
 items (floors, skies, etc.) out of the scene.
- Most alpha channels are pre-multiplied. The basic gist of the problem
 here is that if you are anti-aliasing your render, you may end up with
 a black outline around the alpha-channeled image. This is caused by
 both the color and alpha channels being multiplied previously, and

their addition leaves a black line. If this occurs, use a *straight alpha*. Straight alphas rid you of those annoying black halos. But beware, if you are not going to composite a straight alpha-ed rendering, it is completely useless.

| **Rendering Time Concerns** | Several factors determine how long a rendering will take. One, of course, is which rendering engine you choose to use. |

Other variables include:

- How many polygons are in a scene (more polygons = more rendering time)
- How many light sources you have within a scene (more light sources = more light rays to calculate = more rendering time)
- The shadow characteristics of those light sources (more lights casting shadows = more rendering time)
- Characteristics like reflection and transparency (more places for the light to reflect or bend = more rendering time)
- The size of your bitmapped figures used in textures (larger bitmapped files = more information to deal with = more rendering time)
- What dpi (higher dpi = more rendering time)

An image with 12 lights all casting shadows that illuminate 400 objects of high poly-count that have large 2MB bitmaps for textures including high reflection settings, laying on top of water with high reflection, and refraction settings with a recursion of over 100, that is rendered at 8000 × 6000 pixels with anti-aliasing and 12 times oversampling will take quite a while, no matter what machine and program you are using.

Take time to optimize. If certain objects are always going to be in the background, do not render them as high poly-count objects. Likewise, keep their image maps small. If a light source is not needed to illuminate the scene or highlight an object, take it out. Think of the final render process when modeling and texturing; it will save you hours when the deadline is looming.

Also remember that the bigger the processor and the more RAM available, the faster the rendering. 3D is a RAM hog anyway, so if you have the funds to bump up the RAM your machine has, buy it.

Compression Whether working with stills or animations, 3D applications give you the chance to compress your finished renderings. Compression is a computer's way of making the file smaller and easier to handle. Tiff, jpg, gif, Sorenson, Cinepak, Indeo, and Real format are all forms of compression. Compression allows a computer to load an image faster or play an animation smoother. The problem is, compression makes files smaller by dropping out information from the file. Too high a compression can leave a file looking poor and messy. Further, with most compressions, once a file is compressed, the dropped information is gone—there's no way (other than rendering again) to get it back. Generally, if you are working with stills, keep your images in either pict or tiff format as long as possible. If the final target is the Web, convert the file (and keep a backup) right before it is to placed within the Web page. If the project is an animation, render the frames with no compression. In animation, there is usually some added compression in the editing process—and compressing already compressed animation clips is not a pretty sight. This keeps the file's integrity high for as long as possible, giving you the opportunity to fine-tune or make adjustments throughout the process, and makes the final project more professional and cleaner.

T
U
T
O
R
I
A
L

8.1: FAKING RADIOSITY THROUGH RAYTRACING

Radiosity creates some truly beautiful renderings; however, the time involved often makes true radiosity rendered images hardly worth the wait. To further complicate the radiosity dilemma, some programs do not have any radiosity capabilities (Cinema4D, for example). So, how do you get around the limitation of lack of radiosity capabilities in software, or lack of time to wait for radiosity renderings?

To solve this problem, let's look at the three main benefits and effects that radiosity presents. 1) Radiosity calculates caustics. *Caustics* refers to the way light is bent and focused as it passes through objects such as crystal. Figure 8.21 shows an example of caustics. See the light spot in the shadow where the light focuses similar to light through a magnifying glass? Standard raytracing will not do this (Figure 8.22)

2) Radiosity is a master at rendering light and color bounce. That is, it can calculate the change in light as it bounces off a colored surface. In Figure 8.23, a metallic ball is placed in the

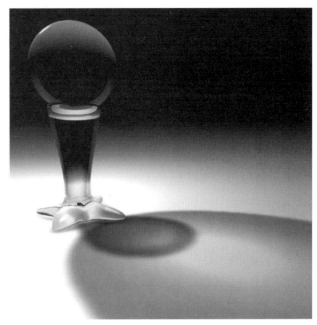

FIGURE *Real caustics effects.*
8.21

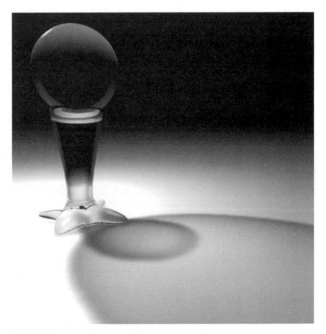

FIGURE *Raytraced scene without caustics.*
8.22

corner of a room with white walls. In real life, as the light hits colored metallic surfaces like the one shown in Figure 8.23, the walls around it would show the red blush. Unfortunately, raytracing does not calculate this effect (Figure 8.24).

The last big advantage of radiosity is really related to the problem just discussed. When shining light at highly reflective surfaces such as mirrors, there is light bounce. Usually, the integrity of the bounced light stays fairly true if the surface is extremely polished (Figure 8.25). However, when a high-

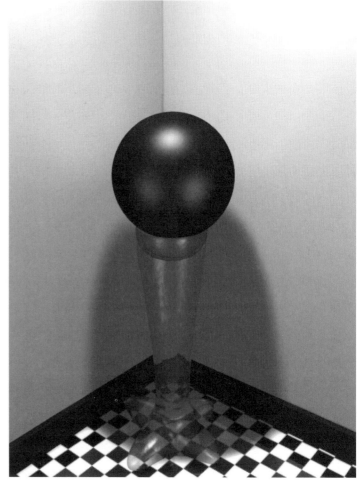

FIGURE *Ball in corner and resultant bounced light.*
8.23

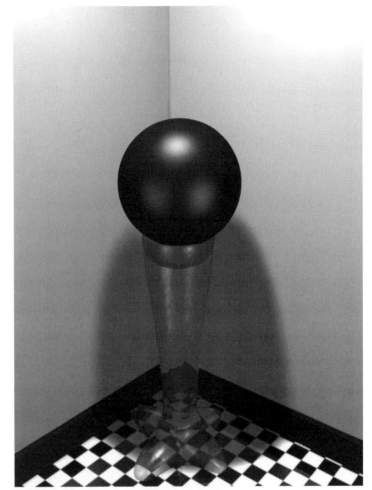

FIGURE *Raytraced version of the same scene—notice, no blush on walls.*
8.24

definition light is pointed at a highly reflective surface and rendered with raytracing, the rays stop right there (Figure 8.26).

Now that the problem has been defined, let's begin working on the solutions. Even though raytracing has its limitations, all of these radiosity powers can be faked through some creative strategies within raytracing engines.

Caustics are caused by the way light passes through certain materials. In order to fake caustics, we need to alter the way

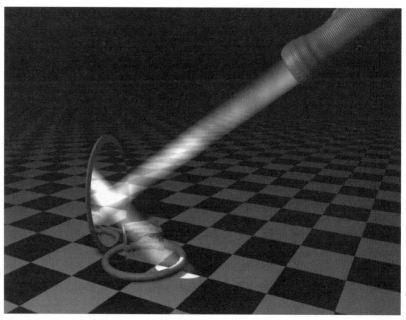

FIGURE *Bounced flashlight.*
8.25

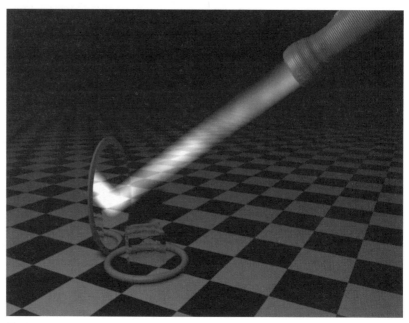

FIGURE *Raytracing equivalent in which the light ray dies.*
8.26

that light passes through an object within raytracing. Let's take the example of the crystal ball in Figure 8.27. In this example, the color, transparency, and specular channels are activated. The transparency is set to a light-blue color and has a transparency setting of about 75%. Using raytracing, the shadow is solid and filled.

FIGURE *Raytraced ball.*
8.27

Since the desired effect is a ball that appears to have a bright spot in the middle of the shadow, we simply need to create a transparency map that blocks out light differently as it passes through the ball. To do this, create a new empty document within Photoshop that is about 400 x 400 pixels big. Make sure that your foreground color is white and your background color is black. Using the Radial Gradient tool (Figure 8.28), click on the middle of the canvas and drag to the edge of the canvas to create an image similar to Figure 8.29. Save this image as "CausticsTrans.tif."

In this case, we want to make sure that the center is accentuated to clearly see the caustics effects. Therefore, make a circular selection in the middle of the canvas and then feather

FIGURE *Radial Gradient tool.*
8.28

FIGURE *CausticsTrans.tif.*
8.29

the selection by 5 pixels (Select>Feather). Fill this feathered selection (Edit>Fill) with white to get Figure 8.30. Save the changes.

FIGURE *New caustic transparency map.*
8.30

Working within your 3D application, we now need to create a shape to take advantage of this new transparency map. To create the round shadow that we are aiming for, create a flat disc that is the same diameter as the sphere. Create a new texture and turn off all channels except for the transparency. Import CausticsTrans.tif as the transparency map, and apply this new map to the newly created disc. The rendered result should appear similar to Figure 8.31.

Notice that although the shape of the disc is unsightly, the shadow is fairly close to the desired effect. The trick now is to let the shadow cast by the disc appear as though it is being cast by the sphere. To do this, we need to first make sure that the sphere is not casting any shadow of its own. Most 3D applications allow you to turn this feature on or off for each object. See the documentation for the details on your program (Figure 8.32).

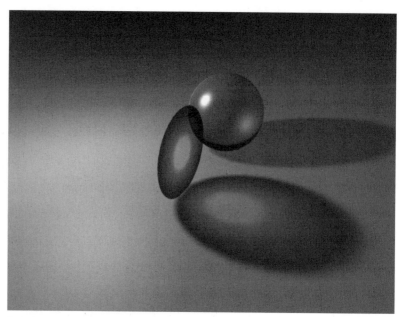

FIGURE *Correct shadow-casting disc.*
8.31

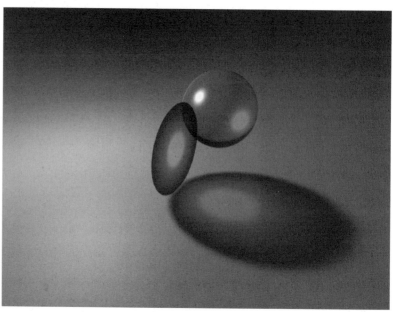

FIGURE *Sphere with no shadow.*
8.32

Now we want to make the disc object so that the shadow remains but the disc itself disappears. Again, this can be altered on a per-object basis within your application. The result thus far should look similar to Figure 8.33.

FIGURE *Invisible disc with visible shadow.*
8.33

Now we have the interesting situation of an invisible object (the disc) casting a shadow, and a visible object with no shadow. To merge the two, simply place the disc inside the sphere and group the two. The resulting render should appear as Figure 8.34.

There are some restrictions to this type of cheating, though. The first is that the disc casting the caustic-looking shadow is flat, so it only works when the main light source is perpendicular to it. Therefore, if the object is moving in relation to the light or vice versa, the disc must be animated to turn according to the light source. The second restriction is that if you are creating an object that is colored and you want the light passing through it to be colored, you must change the color of the white within the CausticTrans.tif image. Similarly, the image

FIGURE *Fixed ball and disc.*
8.34

we built to simulate caustics only works for spheres; you will need to create custom caustic-faking transparency maps for each object.

On to the next radiosity faking technique. Back in Figure 8.23, the red blush on the walls around the ball is understood to be light reflecting off the surface of the red ball. In a sense, the surface of the ball becomes almost like another light source. So, to fake this radiosity effect, we simply need to create additional light sources.

Previously in this exercise, we used the ability to make certain objects cast (or not cast) shadows. Similarly, in the wooden man tutorial, we looked at ways to ensure that the light bulb object would appear to be emitting light, even though the actual light source was a separate light within the bulb. In the case of the red ball, we simply need to place light sources within the bulb to emit light outward onto the appropriate objects in the appropriate directions.

Figure 8.35 shows a blue ball in the corner of a room. Using standard lighting and raytracing, there is now a blue hue on the walls.

FIGURE *Blue ball in corner with raytracing.*
8.35

Let's begin by placing a spotlight inside of the ball to cast a light-blue hue on the left wall. The placement is very important. The blush is supposedly coming from reflected light off the surface of the ball. Therefore, there would be no blush on the floor in front of the ball, which is why we cannot place a point light in the middle of the ball and call it done. Notice the placement and rotation of the spotlight within the ball in Figure 8.36.

The trick to these hue-casting lights is that they must be of relatively low intensity and have a very soft edge (high diffusion). Make the inner angle of the light very small (even 0 degrees) and the outside angle quite wide (110 degrees or more). Be sure to make the light an appropriate color. Usually, the blush should be lighter and less saturated on the objects surrounding the bounced-light object. Also make sure that this new light casts no shadows; if it did, the light would never penetrate the inside of the ball (Figure 8.36).

This isn't a bad start. However, to make this visual trickery work, there needs to be many more such lights. Figure 8.37 has four lights all with the same color and intensity to create the nice soft blush on the walls. The key to effective radiosity

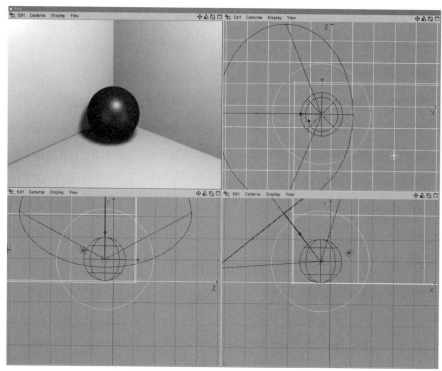

FIGURE
8.36
Soft-edged spotlight (nonshadow casting) within ball.

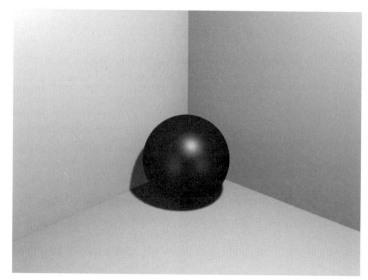

FIGURE
8.37
Completed radiosity blush effect.

blush is to make sure that the lights creating the blush have no edge so it is impossible to tell where one light ends and the next one begins.

This entire technique belies an important concept of 3D. Too often, 3D animators assume that the 3D application is going to do all the work for them. "If I set it up like it is in real life, it will look like it does in real life," they cry. Unfortunately, this usually is not the case. Look at what needs to appear in order to portray a given situation, and be prepared to make alterations that go beyond what would normally be present in real life.

The last radiosity faking trick takes advantage of the fact that light emitters within 3D applications actually have invisible sources.

Figure 8.38 shows a setup in which a flashlight is shining a beam of light at a mirror that is positioned to bounce the beam off two other mirrors and back to the ground. Figure 8.39 shows the unfortunate raytracing result of such a setup.

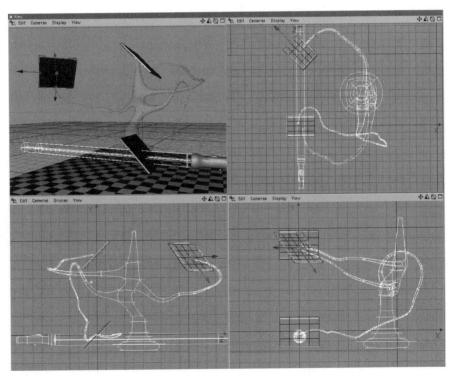

FIGURE *Mirrored setup.*
8.38

FIGURE *Raytracing result.*
8.39

If radiosity were rendering this scene, it would calculate how the beam bounced from one surface to the next and how the light would slightly dissipate. To solve this problem, it is important to think of what we would be viewing in real life. In real life, it would appear as though there was a beam joining each of the surfaces. As the visible beam struck the first mirror, a new reflected beam would shoot up to the next surface. This new beam would again be replicated upon hitting the second mirror to a new beam heading for the third mirror. The last mirror would reflect this beam (or replicate it) to the floor.

Remember that the light beam emerging from the flashlight is an independent beam. All we need to do is copy and paste this beam and orient it into place to represent the bounced beams. Figure 8.40 shows the wireframe layout of all four beams (one flashlight and three "reflected" beams), and Figure 8.41 shows the resultant render.

FIGURE *Duplicated beams to emulate reflected beams.*
8.40

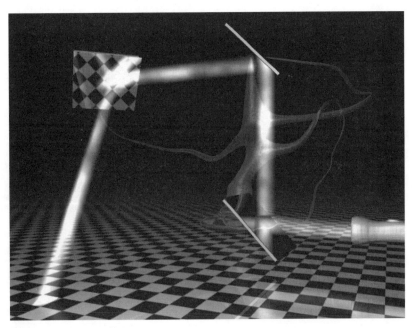

FIGURE *Resultant render.*
8.41

Radiosity is incredibly powerful; perhaps the nicest output in all of renderdom. However, it is not the end of the world if you do not have the software or the time for it. Think in artistic problem-solving ways, and even the lowly yet speedy raytracing can produce radiosity-like effects.

T
U
T
O
R
I
A
L

8.2: MULTIPASS RENDERING

3D renderings tend to be clean—very clean. Crisp edges, sharp drop-offs, and crystal-clear materials are the trademarks of computer-generated imagery. Unfortunately, this is not always the way a scene would play out in real life, and often is not the most beautiful or aesthetically pleasing. Part of this is due to the lack of a *fresnel* effect.

The fresnel effect is a fancy way of referring to edge fall-off. Figure 8.42 is a rendering of a highly reflective chrome ball using a standard rendering setup and algorithm. Figure 8.43 is the same scene with the fresnel effect.

This fresnel effect is not easily accomplished within the standard 3D application alone. In fact, no matter how great a render engine your 3D application of choice uses, there can

FIGURE *Regular raytracing rendering. Notice the hard, crisp reflection that goes*
8.42 *forever.*

FIGURE *Fresnel effect rendering with soft, gentler reflection.*
8.43

always be some fine-tuning and added control through multi-pass rendering.

Multipass rendering is a way of rendering a final scene as a group of separate movies or images. Each of these individual images only contains one part of the visual information needed for the scene. One may contain all the specular highlights, others may just include reflections, and so on. The power of this lies in the ability to composite them all together in Photoshop or AfterEffects while still allowing you full control over each of these characteristic clips.

Besides the fresnel effect illustrated earlier, consider this example: A client wants a 10-second movie (that's 300 frames) of two high-specular objects sitting beside each other on the floor (Figure 8.44). Rendering these 300 frames at a high resolution with lots of anti-aliasing and oversampling can take a while. The client, upon seeing the final rendering, thinks that the highlights (specular qualities) are too intense, and would like them to be subtler and more "yellowish." Rendering these 300 frames again would be terribly time consuming. However, if the result shown to the client was a composited result of color and highlight renderings (Figure 8.45), the changes would be fairly simple. All you would need to do is to shift the color of the highlights in AfterEffects, and the recomposited

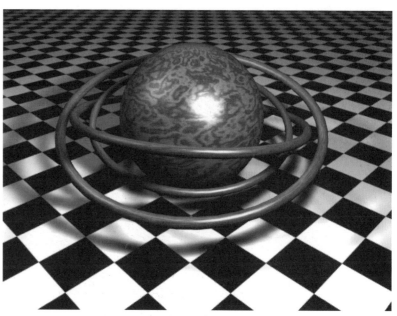

FIGURE
8.44　*Original rendering created with no multipass rendering.*

FIGURE
8.45　*Color rendering, plus highlight rendering, and composited result.*

film would include all the new visual changes without the need for lengthy 3D rendering (Figure 8.46).

Unfortunately, this control comes at a cost of time and extra renderings. However, once these added renderings are done, the flexibility in controlling the strength of reflections, diffusions, and/or specular qualities is endless.

FIGURE *Color rendering, altered highlight rendering, composited result.*
8.46

For a tutorial, we will do a compositing exercise using Adobe's AfterEffects. This project's before and after were presented previously as Figures 8.42 and 8.43. We will be dealing with softening and blurring reflections within a scene to add a nice reflection fresnel effect. This is a more complex set of renderings than most, but it is important to see how everything goes together in such a complex setting. If you plan to use multipass rendering, remember that you must render your entire clip several times. Each clip renders fairly quickly because it does not contain all the information. However, if you never plan to adjust the specular highlights on a project, there is no need to do the rendering passes that allow that sort of flexibility. Plan carefully what sort of flexibility you want or need, and plan your passes accordingly.

The first thing to do is to prepare a rendering pass that defines what parts of the final composited image is to be altered, or which regions of the image will actually need to be affected. The way to do this is similar to creating a transparency map or a mask within Photoshop. The areas of the final render that appear white are alterable; black areas are not. To get a rendering like this, simply turn off all lights, and create a new texture with only the luminance channel activated and set to 100%. If you are working with an animation, you probably want to save this file as a separate file so that you can allow it to batch render later. In the case of this tutorial, we are only working with a still image, so it can be rendered now.

The rendering (Figure 8.47) is rendered at 800 x 600 pixels. The size is arbitrary, depending on the desired final output. Just make sure that if you create one rendering pass at a certain size, all the other planned passes are rendered at the same

size through the same camera. Save this black-and white-image as "MatteMask.tif."

FIGURE *MatteMask.tif.*
8.47

This MatteMask.tif image just shows the areas of the ball that peek out from the columns that surround it.

Next, we need to render an image that has only the characteristic that we wish to alter active. In this case, we want to alter the reflection attributes of the sphere. So, with the rest of the scene set up as though you were going to do a normal render, change the texture on the sphere so that only the reflection channel is activated and set to 100%. Make sure to deactivate all other channels for the sphere. This will give you an image that has the reflection in all its computer-generated glory. This is the setting that we will be altering, but we must have this full-blown version to begin with. Render the scene with these settings and save it as "100Reflection.tif" (Figure 8.48).

While dealing with this image with all the textures intact, we can render out the next needed image. Besides the reflectivity of the ball in the middle of the pillars, the ball has other qualities as well; namely, active color and specular channels. Since this information is important to the final render, we need to create a render that contains this information but not

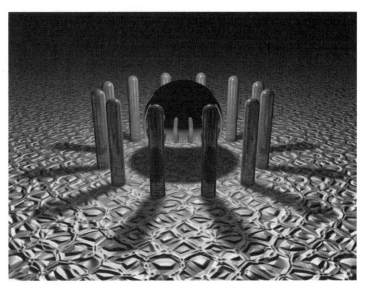

FIGURE *100% reflection rendering.*
8.48

the reflective information. So, reduce the settings of the reflection channel to 0, and render another pass (Figure 8.49). Save the image as "0Reflection.tif."

We need one last pass. The fresnel effect has to do with reflections (or shadows, or light) falling off or softening toward the edges of its range. This last pass will be created in order to define where the fresnel fall-off should be. This will be done by creating a grayscale image that we can use as a mask of sorts within AfterEffects to soften or knock out areas of our 100% reflection image. Usually the fresnel effect causes images to soften around the edge of the reflective surface. So, save a copy of the scene, and then delete all textures. Make one new texture with no channels activated except the color channel. Make the color channel 100% white and apply it to every object in the scene.

Now, delete all light sources and create one new point light that is placed at the same location as your camera. If you were animating this scene, you would want to group the light to the camera if the camera moved. This light source should have no fall-off and no shadows and be at full 100% intensity. Render this pass and call it "Fresnel.tif" (Figure 8.50).

Now, to control the fresnel effect of the reflection, you should have four separate files from four rendering passes:

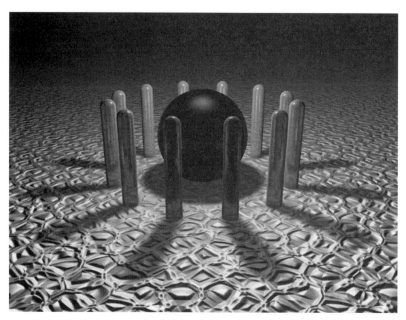

FIGURE *0% reflection rendering with other channels activated.*
8.49

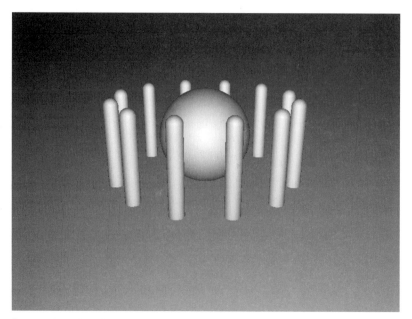

FIGURE *Fresnel rendering pass.*
8.50

Mask Pass, 100% Reflection Pass, 0% Reflection Pass, and Fresnel Pass.

Compositing these passes together can be done in Photoshop or any image editing program that allows for multiple layers. However, it is very straightforward in AfterEffects, and if you are doing animations, AfterEffects is the only way to go. Thus, we will look at the compositing process in AfterEffects.

Within AfterEffects, import all four passes into a project (File>Import>Footage Files). Once they are all imported, create a new composition (Composition>New Composition). Make sure to adjust the size of the composition so that it matches the size of your renderings and the final desired size (Figure 8.51). In this case, the renderings are 800 x 600 pixels large, and since it is a still, the length need not be any longer than one frame.

In this first composition, we will want to begin affecting how the fresnel effect plays out. Drag the 100Reflection.tif file from the Project window into either the Composition window or the Time Layout window. Then do the same with Fresnel.tif.

FIGURE *New composition within Adobe AfterEffects.*
8.51

At the bottom of the Time Layout window is a button labeled "Switches/Modes." Click this button so you can see the Mode and Track Matte functions of this composition. Change the Mode of 100Reflection.tif to "Add," and change the TrkMat setting to "Luma Inverted Matte" (Figure 8.52).

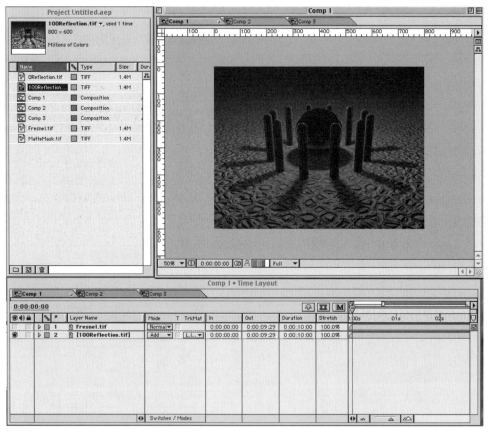

FIGURE *Composition 1 setup.*
8.52

What this does is make the Fresnel.tif (or our fresnel pass) a matte to the 100% reflection pass. A Luma Inverted Matte defines pixels to be opaque when the luminance value is 0%. Notice in the composition window that the center of the ball is now dark and "fresnelled-out."

Now we need to mask out the effects of the fresnel pass from the rest of the image. We do not want the columns to be as dark as they appear in Figure 8.52. To do this, create a new

composition (Composition>New Composition) and place "Comp 1" from the Project window into the Composition or Time Layout window. Now place MatteMask.tif the same way, and click the Switches/Modes button. This time, change the Mode of Comp 1 to "Add," and change the TrkMat to "Luma Matte" (Figure 8.53).

FIGURE *Composition 2 layout.*
8.53

What this does is use the first composition (the one where the fresnel pass was applied to the 100% reflection pass) and mask out everything but where the ball is seen as defined by out MatteMask.tif rendering pass.

Create a third composition (Composition>New Composition), and in this composition first place 0Reflection.tif in the Composition or Time Layout window and then place Comp 2.

This places the pure file with textures and lighting for all objects at the bottom, and then places the little bit of the sphere that has been altered through the layering we did in Comp 1 and Comp 2 over the top. Click the Switches/Modes button and set the Mode for Comp 2 to "Add" (Figure 8.54).

FIGURE *Composition 3 layout.*
8.54

The result is a much softened reflection; in fact, it may be too soft. However, since we have all the files in AfterEffects, we can alter the settings. Click on the Comp 1 tab within the Time Layout window and click the triangle next to Fresnel.tif. This will open a variety of settings for this particular clip or image. Double-click on the 100% setting on the Opacity line and change it to something like 60% (Figure 8.55). Then click on Comp 3 to see the final results of the change (Figure 8.56).

FIGURE *Adjusting fresnel pass opacity to change final fresnel effect.*

8.55

You can continue to refine the effect by applying a blur effect to the reflection. You will want to do this within Comp 2 and apply the effect to Comp 1. To do this within the Time Layout window, click on the line Comp 1 (not the tab) and then go to Effects>Blur & Sharpen>Gaussian Blur. A new window should pop up in your work area that allows you to adjust the degree of this effect. Adjust to your liking, making sure to click on the Comp 3 tab within the Time Layout window to occasionally check the results.

When you like what you see within the final Comp 3, go to Composition>Save Frame As>File…. This will then allow you to save the file as a Photoshop document that you can later save as a jpg, tiff, or whatever format you need. If this were an animation, you would go to Composition>Make Movie. After-

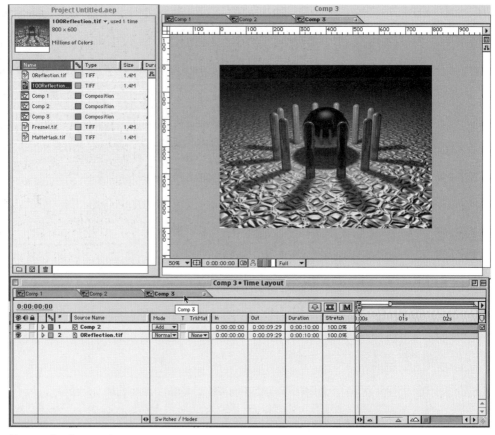

FIGURE *Resultant render.*
8.56

Effects would then take a while to render the adjustments you have made throughout the footage you have imported.

You may think, "Well, if I have to render in AfterEffects anyway, why not just rework it in the 3D application?" In some cases, this may be a smarter way to go; however, in most cases, AfterEffects will render many frames in a minute rather than one frame in many minutes like most 3D applications do with large complex files. In addition, in some situations like the one analyzed here, we are creating effects that cannot be achieved easily within the 3D application, so AfterEffects (or Photoshop) is the only way to do it. It is yet another argument for never getting too tied to any one program. Use the application or combination of applications that get the job done to create the visual effect you want (Figure 8.57).

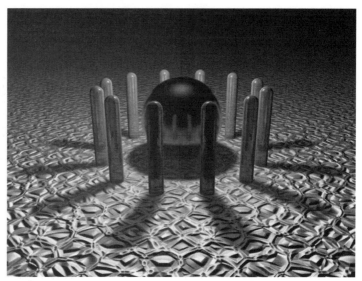

FIGURE *Final render.*
8.57

Exercises

1. Apply depth of field to the camera you are using in the Amazing Wooden Man. Find the best way to position the camera to focus the audience's attention on the wooden man in front of the mirror.

2. Toon shaders or toon renders are rendering engines that attempt to mimic traditional cel animation. The results are usually flat panels of color. If you have access to a toon shader, toon shade a couple of test renders to see how your wooden man textures hold up.

3. If you have a toon shader, as an experiment, render a short animation not as a movie but as a series of images (usually picts or tiffs). If you have Adobe Streamline, try the batch-process capabilities to convert this series of images into Illustrator files. Import these Illustrator files into Macromedia's Flash and create a .swf file for fast Web distribution.

4. Do some test multipass renderings with simple shapes. Try creating a multipass setup that allows for flexibility in highlight colors. Try a multipass setup for reflection power and fresnel effect.

CHAPTER

Moving on to Animation

Animation (at least the cel-based incarnation) is not a new art form. Well, okay, in comparison to other media like painting, it is brand-spanking new, but it has been around long enough for some definite trends to have developed. The most basic tenant of animation is that it is a string of still figures placed together and shown in rapid succession to produce the illusion of movement. This is not unlike all film and television, which take a series of photographs and place them one after another to create motion. The marvel of animation is that each of those rapidly changing frames must be drawn. The number of frames differs from studio to studio and from media to media. Television shows usually run at about 30 frames per second (fps), while film is typically 24fps. Animation can be anywhere from 24fps to as low as 8fps for some forms of Japanamation. Either way, when you begin to add up fps and multiply it by minutes or even hours of animation; well, you are talking about a lot of drawings.

One of the trends in animation that has emerged is the idea of master/apprentice hierarchies within many studios. New animators learn by working under a master animator. When working on a project, the master animator will often draw *keyframes*. Keyframes are frames within a sequence of motion that are most important in defining the moment or motion sequence. For instance, if a character was hopping over a log, the master animator might draw a keyframe as the character begins his leap, at the top of the leap, one as the character hits the ground, and another as he straightens up to walk. Then the apprentice comes in and draws all the frames in between these keyframes to flesh out the animation. These junior animators are often called "in-betweeners." The interesting thing is, the junior animators in a studio will often draw the most frames of a completed animation. However, the movement, timing, and overall feel of an animation are still controlled by the master animator. In computer animation, there exists a similar structure of animating. You are the master animator and define keyframes. The computer then acts as an in-betweener and fills in the frames of the animation.

Animation Standards

Although the specifics among animation packages vary quite a bit when it comes to animation tools, the overall paradigm is fairly constant. 3D applications have what is referred to as a *timeline*. Although called different things in different applications, the timeline is essentially a visual representation of time, and what is occurring within what time. A timeline typically has several important parts (Figure 9.1):

Current Time Marker **KeyFrame**

Objects in Scene

FIGURE *Timeline with pointed-out sections.*
9.1

Objects in Scene. This is typically a list of all the objects or groups of objects that are in the scene. Some programs allow you to hide certain parts of this list for organizational purposes. The important thing to notice is that for each object (or group) there is an individual dedicated line or lines to its right that contain keyframes that represent the action that particular object or group is involved in. Some programs like Strata StudioPro will show only one line that shows if *any* action is taking place for that object, while others like Cinema4D show a different line for each kind of action (e.g. movement, rotation, parameters, etc.).

Current Time Marker. This is represented differently in specific programs, but all 3D applications have some sort of symbol that shows where in time you are. In the case of Figure 9.1, you are at 0 frames in time. If animation has been done within your scene, when you move the current time marker, the 3D application will redraw the editor window to show you the state of the objects at that point in time. With the current time marker, you can jump forward or backward to any point in time within your animation. One note to

mention here is that besides the current time marker, some applications allow you to mark the beginning and end of your animation. Strata StudioPro uses the green and red bookend handles. These allow you to have motion beginning before the animation starts and continuing after it ends if need be. For the specifics, check out your manual for your program of choice.

Frames & Seconds. Not all programs show both frames of the animation and the seconds. Some, like Cinema4D, will show one or the other, depending on how you set the preferences. These hash marks let you know where in the animation you are, what keyframes are happening when, and how far apart keyframes or actions are placed.

Keyframes. Keyframes are the bread and butter of animation. These show you where pieces of information have been given to the computer. If a keyframe appears in the timeline, the computer is letting you know that it has received the information given to it at that point in time. An important note: Almost all action consists of at least two keyframes—one where the action starts, and one where it ends.

The Animation Process

There are several ways to animate or place keyframes. Each program handles it a little differently, but most applications allow for some form of *automatic keyframing*. Automatic keyframing allows the user to simply move the current time marker to a point in time, alter the model, and the 3D application will automatically place keyframes to all altered objects. For example, Figure 9.2 shows the timeline of Cinema4D. In this example scene, there is only a ball present, no action has been recorded, and the current time marker is set to 0 frames. However, in order to allow for movement, a keyframe must be placed to establish a starting position. Figure 9.2 shows a keyframe at frame 0 on the Position Track. With automatic keyframing selected (Figure 9.3), the current time marker was moved to 45 frames—about a second and a half (Figure 9.4). Then the ball was moved to a new position. The result (Figure 9.5) shows a timeline that has placed a new keyframe at the point designated by the current time marker. Notice, too, that the editor window shows an animation path that designates the path (and thus the animation) that the sphere follows.

A couple of important things to notice: 1) There is a keyframe at 0 frames that defines where the object should be at 0 frames. 2) The keyframe at 45 frames tells the object where to be at that point. 3) Since the 3D application now has two different positions at two different points

FIGURE *Cinema4D timeline with no keyframes (actions).*
9.2

FIGURE *Cinema4D automatic keyframing selected.*
9.3

FIGURE *Current time marker moved to 45 frames.*
9.4

FIGURE *New timeline with autoplaced keyframe.*
9.5

in time, it knows that it is to move the object in the frames between keyframes. This is the basis of almost all animation: Tell the 3D application what object is to be animated, tell the object where it is supposed to start by placing a keyframe, then move the current time marker to a new point in time and tell the object where it is supposed to be at that point in time by placing another keyframe. When the computer has two keyframes that have a different parameter for the object (whether position, rotation, or any other parameter), it fills in the transition in between.

We could continue with the example given previously by moving the current time marker to a new point in time (say 90 frames), and then moving the ball to a new point in space. With auto keyframing turned on, Cinema4D places a new keyframe at 90 frames for the sphere, and thus a new piece of information (Figure 9.6). The ball now knows where to be at 0

FIGURE *Third keyframe with Cinema4D.*
9.6

frames, at 45 frames, and at 90 frames. The resultant curve as can be seen in
the animation path is a smooth curve.

Each object in an animation will have its own place on the timeline with
a space that shows the keyframes that it has listed. Different characteristics
of the objects can be changed throughout the animation. The sphere in Fig-
ure 9.6 could be rotating as it moves. It could also be growing in size for the
first half of the animation and then shrinking again for the second half.
Each parameter or characteristic of any object can be animated. Motions
can match up or be offset. The key is that the 3D application will allow you
to see each of these separate animated parameters on a separate track (Figure
9.7). In some applications, these tracks are nested and the objects in the
scene must be expanded to reveal these other tracks. If there is a change in a
parameter, there is a track to show how that change takes place. Knowing

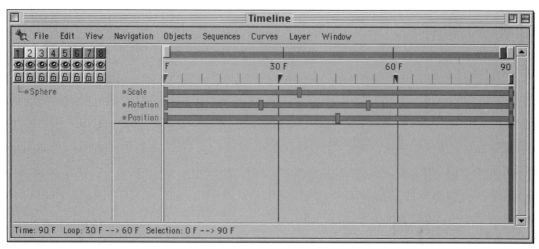

where these tracks are is important as it allows for editing, which is where the true power of 3D animation shines through.

Timing is tough. How long is a motion? Should the punch last 30 frames or 40 frames? How many tenths of a second apart are footfalls when a person walks? All these kinds of questions are little more than guesses when you first start animating. The benefit of 3D animation is that all the keyframes that are placed are editable. If you need the sphere to move faster, you simply move (clicking and dragging) the keyframes closer together so the object does the same motion in less time. Likewise, slowing movement down is just as easy, as keyframes can be moved farther apart. The computer has to do all the hard work of recalculating the frames in between.

Animation Tracks

Each object within an animation has a potential of a variety of *tracks*. A track could also be called an animatable characteristic. Although not all of these tracks are necessarily activated in every animation, it is important to know what characteristics can be animated. The following are some of the most important characteristics that can be animated—or animation tracks.

Position. The example with the ball shown previously uses the position track. This is sometimes called the "Move" track. Whenever an object is moved within digital space, its position track is altered (Figure 9.8).

Scale. Say you want your Sta-Puft Marshmallow Man to begin as a cute little toy in the hands of a child and grow into a horrific monster.

FIGURE
9.8
Movement indicates keyframes in the position track.

The size or scale of each object within an animation can be animated. This would be great for Alice in Wonderland effects, or for simple but important issues like Stretch and Squash (Figure 9.9).

Rotation. When you bounce a ball down the hall, there is an up/down/forward motion (Position) and a scale change (stretch and squash), and the ball is rotating. Rotation tracks are very important to believable movement (Figure 9.10).

Besides these basic tracks, there is a variety of tracks that combine some of the characteristics of these tracks. For instance:

Align to Path. When animating objects that have complex motion, placing a multitude of keyframes for each turn can become a long and tedious process. Imagine you have a dragonfly that is flying around trees, or an airplane that is flying through and between buildings (Figure 9.11). Using traditional animation methods, you would need to place a position keyframe every time the plane needed to alter its path to turn. You would also need to place an additional keyframe to make the airplane turn to face forward in the direction it was traveling. More adjustments would be needed to

FIGURE
9.9　*Growth is a sign of animation within scale track.*

FIGURE
9.10　*When spinning or flipping is desired, Rotation is the track of choice.*

make the airplane bank as it turns. However, with Align to Path or Align to Spline functions and animation paths, you can simply create a path (Figure 9.12) that the object will follow, turning and banking as it goes (Figure 9.13). See your manual for the details on how to use Align to Path functions in your application of choice.

Parameter. Parameters can be a variety of things. The parameter of a primitive torus can be the diameter of the ring. The parameter of a light source would be how bright it is, how wide an angle it entails, and what color it is. The parameter of a camera could include its focal length or depth of field. Deformation animations (animations involving deformation objects described earlier) are done with

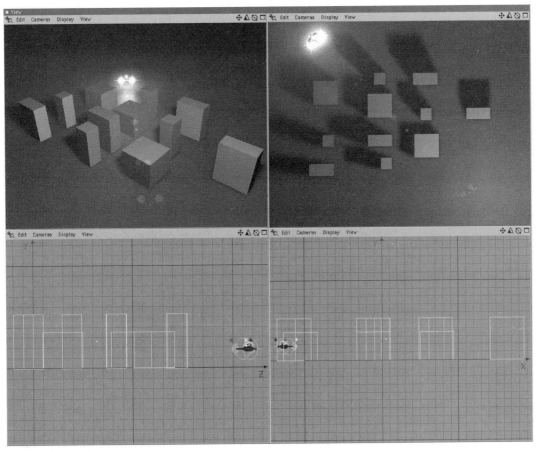

FIGURE *Plane to fly through buildings.*
9.11

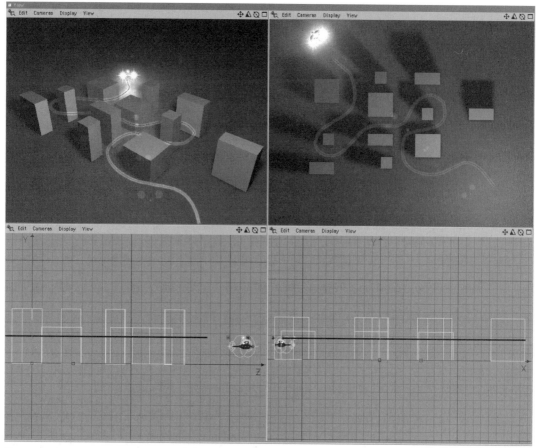

FIGURE *Plane and path it is to follow using Align to Path.*
9.12

Parameter tracks. If altering any of these characteristics, the animation takes place within Parameters (Figure 9.14).

Some 3D applications have other parameter-like animations that need to be mentioned. For instance, LightWave has some deformation-based animations like Serpent, MathMorph, Inertia, and Vortex that all have their own animation techniques. Cinema4D has things like Vibrate, Oscillate, Morph, and Melt. See your manual for the details on these types of shape-changing animation techniques.

Texture. Often 3D applications will allow you to alter the position, orientation, or other characteristics of a texture. Sometimes, this is within the Parameters track, yet most of the time it is a separate

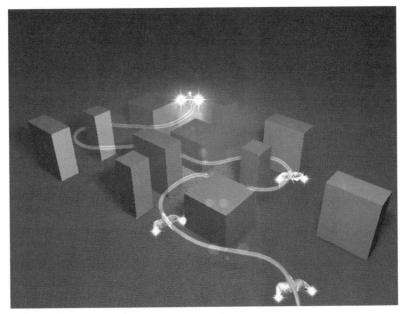

FIGURE *Banking plane following path.*
9.13

FIGURE *Deformation animation is a Parameter Track affair.*
9.14

track. This becomes a valuable resource for things such as displacement maps that are textures used for the creation of geometry. An example would be the use of a displacement map to indicate the fluttering of a flag. Figure 9.15 shows the same flag with the same texture, only the image on the right has moved the texture just a bit over a period of time. The resulting animation would show the ruffles of the flag working their way along the plane of the flag, creating a very nice effect.

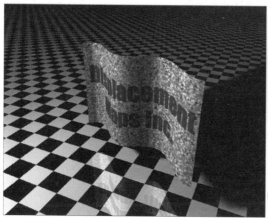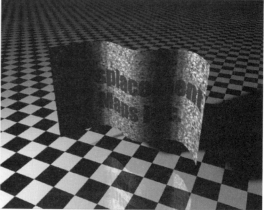

FIGURE *Flag with animated displacement map.*
9.15

Point-Level Animation (PLA). This function is not available in all 3D applications. PLA allows the user to make alterations of a model from the point level or the level of the model where polygons meet. The ability to animate these sorts of movements allows for great facial animation with changes in the visual makeup of the face. For instance, Figure 9.16 shows a simple set of eyeballs made from primitive spheres, and a set of eyebrows constructed from a sweep NURBS object. The spline that defines the curve of the sweep NURBS was animated using PLA to give the eyebrows a wide range of expressive qualities.

FIGURE *PLA through facial animations.*
9.16

Rendering

A basic tenant of animation is that movement is simply a sequence of slightly different images that when shown in rapid succession give the illusion of movement. So, if an animation is displaying 30 frames per second (fps), then a three-second animation has to render 90 frames. These types of rendering times begin to add up. For this reason, it is very important to create "preview" animation of movement. Preview animations are renderings of the motion you have created so far that is rendered using one of the preview renderers (gouraud, OpenGL, wireframe, etc.). Although this will not give you the specifics of how light or textures may be playing off each other, it will give you a good idea of how the timing is working out. It is much less painful to find out that your ball is bouncing through the floor or that the ball is bouncing too slowly after you have waited 30 seconds for it to render as an OpenGL rendering, than it is to find it out after waiting 15 hours for a raytracing rendering. Once you have seen that all the motion is happening at the speed you wish, then do a raytraced rendering.

Movie Formats

Once a project has been animated and it is time to do a raytraced rendering, you need to carefully analyze what you plan to do with this animation. There are a variety of file formats and sizes that you can save your final animation as.

One way to save animations is to save them as a sequential sequence of still images. That is, if your animation is 20 seconds long (600 frames), you could render out Animation001.tif to Animation600.tif. Then, using Adobe Premiere, AfterEffects, or some other digital video editor, you can import this sequence where it can be output to a movie file (QuickTime, AVI, Real, or otherwise). Most 3D applications allow you to designate the saving of such a sequence. The benefit of this sort of strategy is that if you discover you made a mistake in frames 40–90, you need not render the entire animation again—just those 50 offending frames. Once the new frames are rendered, they can be placed within your Premiere file where the movie can be output again. This often results in a large amount of time saved.

Another tangent benefit is that these tiffs or other stills can be converted into Adobe Illustrator files with programs like Adobe's Streamline. The Illustrator files can then be imported as a sequence into Macromedia's Flash or Adobe's GoLive to create very small files (.swf) for vector-based Web distribution.

The drawback is that this series of still images (whether saved as a tiff, jpg, or otherwise) is quite space intensive. Your hard drive can quickly be filled to capacity with such a strategy. However, if you are working on a large project that takes a long time to render each frame, this technique could easily save you hundreds of hours' worth of rendering.

The second strategy is to output the animation as a movie file. There are many formats of movie files, but the two most common are .avi and .mov. If you are on a Mac, you will most definitely output to .mov (QuickTime Movie files); if you are using a PC, you probably have more choices. When you render straight to a movie file, your final product is a short clip where all the frames are already linked together and can be played through some sort of media player immediately to see the results. The benefit to this is you can see the animation instantly, while the drawback is that if there is a small problem, you may need to render the entire sequence from scratch.

When you are ready to render your animation using raytracing or radiosity, you have the choice of rendering using a variety of sizes and compressions. Ultimately, your project is destined for one of several media. Some of the higher range would include 3dmm film, broadcast television,

or digital video. More mid-range would be projects intended for CD-ROM or to be played off a hard drive. The low-end media includes all Web-destined animations. The final destination should determine what size and compression you will use to render your animations.

Size

If you plan to submit your animation on film, the size is 2048 × 1366 pixels at 24fps. If you are planning to render your project for television, prepare your animations at 30fps and render them out at 640 × 480 (standard NTSC) at 30fps. NTSC stands for the National Television Standards Committee that defined the television video signal for the United States. Currently, the defined standard is 640 × 480 for standard television. In Europe, the standard is 768 × 576 at 30fps and is called PAL.

This standard in television is shifting. With the advent of HDTV (High Definition Television) and other forms of digital TV, the standards are already changing. For instance, in programs like Final Cut Pro that deal almost exclusively with digital television formats, the size is 780 × 468 or 780 × 480.

Other forms of distribution media like CD-ROM, Internet, or print do not have standard ruling bodies to define specific sizes. And, as the technology for DVDs and broadband entertainment increases and drops in price, these rough guidelines will change again. However, at the time of printing, there are some general size guidelines for CD-ROM and Internet distribution.

If you plan to distribute your work on CD-ROM and hope to display it full screen on the viewer's monitor, 640 × 480 is still the size to use. However, you may wish to drop the frame rate to 15fps. Or, sometimes the best solution is to drop the size to half-NTSC, or 320 × 240, and leave the frame rate at 15fps. If you know your target audience will have fast equipment that can handle large amounts of data flow, you can even do the projects at 640 × 480 at 30fps. Know your audience. Even the most impressive animations are less than spectacular when all they do is skip and stutter on the viewer's machine because they are too large for the hardware.

Not long ago, many folks discouraged distributing animation online. They felt that the very small trend at the time (32 × 32 pixels at about 6–10 fps) did not do justice to motion art forms like animation—and they were probably right. However, with the increased compression codecs available and the rapidly growing number of cable, ISDN, and DSL connections,

motion-based media at much higher resolutions are possible. Still, for most Web-based media, you probably ought to plan on no larger than 320×240 at about 15 fps. Also make sure that you are using the correct compression.

Compression

When you are preparing to render your project, you can choose to render it as individual still images, or if you are rendering out a .mov or .avi file, many 3D applications will compress the movie file as it renders. We have looked a little at the compression issues around still images. Animation media also has compression formats that make the movies smaller so that they can play smoother on a larger variety of hardware. However, as with any compression, there is a tradeoff of quality. High compression usually means lower quality.

The compression game is an ever-changing one. New codecs (compression methods) are emerging every day that change all the rules. Some compression codecs are so powerful that they allow for streaming media or media upon request over the Internet. Although still in its infancy, these streaming forms of media will undoubtedly mature to the point that most, if not all, motion media will stream.

Until then, there are some basic rules for compressing animation. When dealing with broadcast television or other NTSC/PAL-based media, keep the compression as low as possible. "Animation" compression is a good compression that keeps the integrity of files fairly high. However, the files are large, and often hard drives cannot spin fast enough and computers cannot process the information fast enough to maintain a smooth playback for long projects.

If your final destination is DTV, use the DTV-NTSC or DTV-PAL compressions that are built in to most 3D applications now. This type of compression produces files that are ready to be dropped into digital video editors and need little or no rendering time for simple transitions.

For CD-ROM or Internet-based media, there are many different choices. Some of the most popular formats include Indeo, Sorenson, and mpeg compressions. Some of these compressions are only available via third-party plug-ins, and some can only be used on a file that has been rendered completely and then applied to the entire clip. There are many applications on the market today whose sole purpose is to optimize and compress media for distribution on the Web. If you plan to make an occasional animation post to your Website, just use the compressions built in to your 3D application. However, if you plan to do a sizable amount of Web broadcast-

ing, look into Real Player, Windows Media, or QuickTime Player compatible formats or streaming formats that are playable on these players.

Workflow

Most TV programs or movies usually entail a large amount of cuts from one camera angle to another (see Chapter 13, "Animation Compositions and Editing"). Rapid and numerous cuts are the norm in our cinematographic experience. Keep this in mind as you animate. The process of a final animation project almost always includes some serious editing time in a non-linear digital video editor (NLDV). Do not try to include all the movement and animation of your five-minute story in one long clip. If your storyboard has been carefully thought out and drawn, you will probably find that you never need a clip (a sequence of rendered frames) that is very long. The benefit of this is that a large amount of keyframes can become very confusing as you work with a project. If a clip is only going to be three seconds, only animate those three seconds in your timeline. Then, save a copy of that file, delete your extant keyframes, and begin animating the next clip. Have a separate file for each planned clip. This keeps the files simple, small, and the animation clear in your mind.

Exercises

1. Using the scene in the Amazing Wooden Man, create a simple animation by animating the camera. Have it fly into the room through the doorway or window, and truck or dolly into a close-up of the wooden man.
2. Try creating a quick dance of table items. Do not worry about getting too fancy, but concentrate on getting objects to move, turn, and resize according to your wishes.
3. Animate the camera to create a flythrough of the scene. Be sure to take time to allow the camera to turn to take in all around it.
4. Combine the flythrough and the dancing objects. Create an interesting scene that has great movement of characters and dynamic camera movement.

10 Boning Up on Kinematics

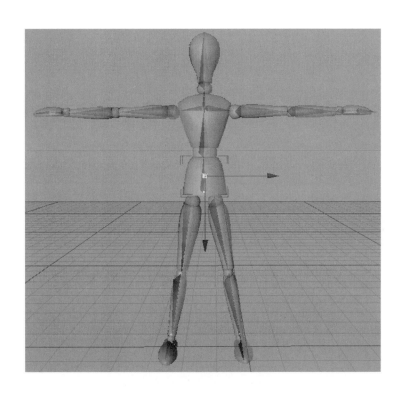

Hierarchies In our wooden man project, we built what is known as a segmented character. That is, there is a different object for each body part: one for the thigh, one for the knee, one for the shin, etc. Now when we come to animating the little fellow, the organization or hierarchy of the different body parts becomes very important. The grouping or hierarchical order of your objects is your way of telling which objects are linked to which objects, and in what order. It is literally like telling your computer that the hip objects are connected to the thigh object, the thigh objects are connected to the knee object, and the knee object is connected to the . . . well, you get the idea. The specific order in which you place objects within their hierarchy will determine which object controls which other objects. Therefore, the hierarchical tree of a leg, for example, would be that the foot is the child of the ankle that is the child of the shin that is the child of the knee that is the child of the thigh that is the child of the hip. Since any changes made to parent objects are inherited by the children, this means that if you rotate the hip at the top of the hierarchy, the foot at the bottom will rotate as well.

The organization of your hierarchy is largely subjective. There are, however, some general rules to consider when creating hierarchies:

1. In a bipedal character (like humans or our wooden man), the center of gravity (or the point around which most action rotates) is about at our pelvis. Because of this, the pelvis is a good parentmost object in a hierarchy.

2. The hips (or pelvic area) support the top of the body and pass the weight of the body as a whole to the legs below them. So, two branches of the hierarchical tree emerge here: the spine above, and the legs below.

3. The spine above the hips acts as the parent to two new hierarchical branches that become both shoulders that naturally parent the arms on either side.

4. The legs below the hips are two hierarchical strings of parent-children combinations, with the thighs at the top and the feet at the bottom.

5. Remember that not every object needs to have its own level in the hierarchy. For instance, the knee joint and shin may be grouped together as one child of the thigh. If two objects are always going to move together, put them on the same level of the structural hierarchy.

6. Pivot points are everything. As discussed earlier, when objects are created or as you begin to group objects, 3D applications set the pivot point at the center of the geometry. The problem is, joints never ro-

tate around their geometric center. Be sure to move the pivot points to appropriate positions. For example, Figure 10.1 shows the arm of our dummy. 10.1a shows the default pivot point and its resultant rotation possibilities. 10.1b shows the altered point and the correct rotation.

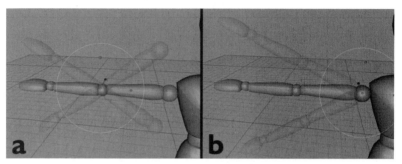

FIGURE *Arm rotations and altered pivot points.*
10.1

7. As you arrange your pivot points into appropriate places for correct rotation, take a second to rotate the pivot points so they are not rotated at all in default position. This will save you time when it comes time to create joint limits and other constraints. It is much easier to determine a range when the joint at rest is at 0 degrees along all axes.
8. The last rule is that there really are no solid rules to hierarchies. You may find as you work that there is no need for some hierarchies for certain shots of your animation. Or perhaps you have a simple character that has a simplified body organization and thus a simpler hierarchy. Keep flexible.

For illustration purposes, Figure 10.2 shows one suggested hierarchy for our Amazing Wooden Man. This is a screen shot from Cinema4D that uses a strict parent-child form of organization. If you are using Strata StudioPro, you will want to adjust the parent-child relationships to groups. You may choose to organize your hierarchy differently, but take time along the way to test your hierarchy by rotating objects to make sure that everything is moving as it should down through the hierarchical ranks.

Although we created a segmented character for our tutorial, single-mesh characters created from one large polygon mesh through HyperNURBS, patches, or some other NURBS method are also a powerful and effective way to create models. With a single-mesh character, there is no hierarchy

FIGURE *Suggested hierarchy organization.*
10.2

available since the entire character is one object. This is where the miracle of *bones* can be beheld.

Bones are an incredibly powerful and important tool in 3D modeling and animation. Bones are essentially object effectors; that is, they can alter the shape of an object within three-dimensional space, but contain no geometry themselves. These bones do not render and are never seen except within the editor window as you work with them. It was not long ago that

bones were only in the realm of very high-end programs. Now, however, any 3D application that is worth its salt has some form of bones in its toolbox.

The specifics of bone creation vary from program to program; however, they all have a similar overall workflow. After a bone is created, new bones can be "grown" from the parent bone (Figure 10.3). These new bones are automatically placed within a parent-child hierarchy. This hierarchy of bones is often called a *chain*.

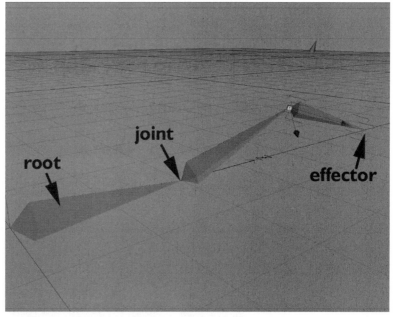

FIGURE *Bone creation illustration.*
10.3

The first bone within a chain is called the *root*. The root should be the parentmost bone in the chain. Therefore, if you are creating a bone structure to be placed within the leg section of a mesh, make the root the thigh and build down from there. The point at which one bone connects to another is called a *joint*. A chain can be very detailed and contain many bones and joints (like the bone structure for a snake), or it can be a simple structure of two bones and one joint.

Bones deform objects in different ways and with different effects. For instance, some objects need to bend like a piece of macaroni (Figure 10.4), while others need to bend like a finger joint (Figure 10.5). The methods to

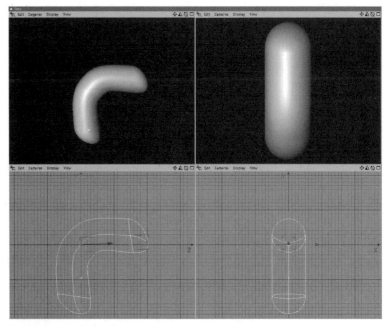

FIGURE *Macaroni bend.*
10.4

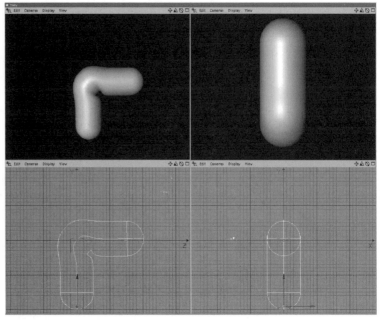

FIGURE *Finger-like bend.*
10.5

control the power or strength of each bone vary greatly from program to program. However, most 3D applications do allow for the definition of how the joints actually bend. Similarly, different 3D applications allow for different methods of bone influence, or the number of polygons the bone actually has pull over, and nearly all allow this sort of control. Some especially effective methods to look for in your index include selection sets, vertex mapping, and weight map. See your manual for the specifics of bone weight, influence, range, and strength.

Bone hierarchy and structure is just as important as the hierarchies of segmented models. Although there is really no need for bones for our wooden man, Figure 10.6 shows what a good bone chain organization would be for a single-mesh character of similar build.

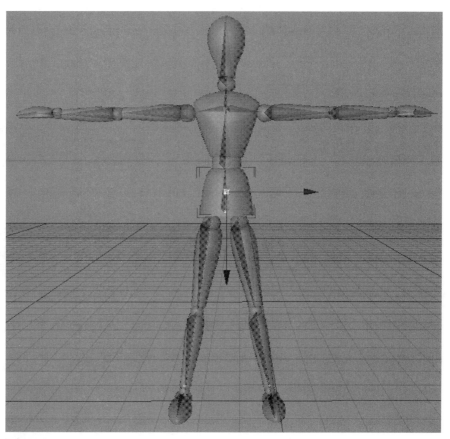

FIGURE *Bone structure for our wooden man.*
10.6

Moving Hierarchies

After segmented models have been appropriately organized, or single-meshed characters have been effectively boned with a chain hierarchy, it finally becomes possible to begin altering these hierarchies to pose characters and produce animation. There are two main strategies for doing this: *Forward Kinematics* and *Inverse Kinematics*. Some animators prefer to use one method or the other, while often it is a good idea to use a combination of both.

FORWARD KINEMATICS

After being deeply immersed in the world of 3D, this is perhaps the most intuitive form of movement. Forward Kinematics (FK) allows for manipulation of sections of hierarchies by working from the parentmost object down. For instance, if our wooden man was going to bend down to grab a pencil, first start with the chest area and rotate it down (Figure 10.7a). Then, by moving down the hierarchy, rotate the shoulder (Figure 10.7b), then the forearm (Figure 10.7c), and finally the hand (Figure 10.7d). Repeat the process for the other arm.

FIGURE *Forward Kinematics process to grab pencil.*
10.7

Notice that FK is a process of continually refining a movement. Start big and finesse down to the end of the hierarchy. FK is very effective for complex series of movements such as the movements of arms.

Conversely, IK allows the animator to alter the childmost object of a hierarchy and the parent objects alter to match the child. To continue with the pencil-grabbing exercise, the principles of IK would theoretically allow

the animator to place the hand on the pencil, and the rest of the joint rotations would be calculated automatically. The problem is, there are a lot of rotations in the simple act of grabbing a pencil, and often the computer guesses incorrectly how those rotations are to take place (Figure 10.8).

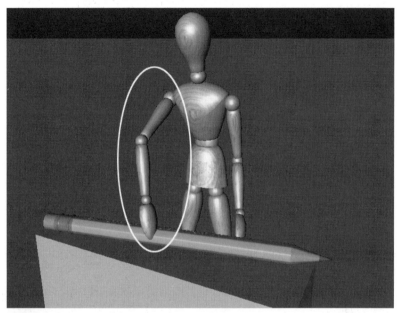

FIGURE *Inappropriate bending as a result of IK.*
10.8

Upper body movement with IK is often frustrating at best. However, IK functions in the lower body where the motion is typically simpler is an animator's dream come true. Grab a foot and move it up, and the thigh and shin bend into place (Figure 10.9).

To assist in IK functions, many programs allow for the definition of constraints and joint limits on an object or bone within an IK structure. Joint limits let you tell a bone how far it is allowed to bend. You can tell the knee bone or object that it can bend along its x axis at –95 degrees, but may not bend in a positive direction or along any other axis (Figure 10.10).

Joint limits must be defined for each joint, which has a bit of overhead. However, once defined, it can make IK functions almost enjoyable. In LightWave, establishing these joint limitations is called "Controllers and Limits" (see page 5.4 of your Motion manual). In Cinema4D, these limits are created by placing an IK tag on the objects or bones.

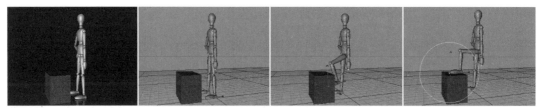

FIGURE *IK and the power in the lower body.*
10.9

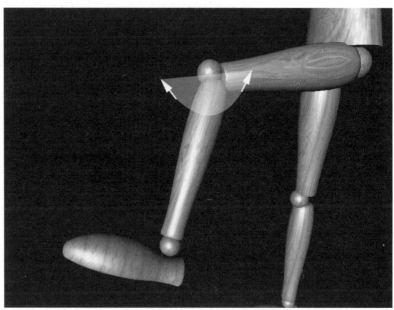

FIGURE *Knee joint with joint limit illustration.*
10.10

Another powerful IK technique is the use of *effectors*. Effectors are often either very small bones at the end of a chain or null objects that have no geometry at all. These effectors can be easily moved as the childmost object, and the parent objects will move to match. The nice thing about creating effectors from null objects is that they can break away from the IK chain. When the effector is beyond the reach of the parent bone just above it, the IK chain will point to the effector itself. Likewise, effectors can be established as IK targets, or goals that are outside the IK chain, to which the chain still points. This allows for the placement of effectors where footfalls

are to take place in a walk cycle. The IK chains will point to these goals and allow for nonslipping feet.

There are real benefits to both FK and IK. IK certainly has a higher overhead, but a greater potential. However, FK is direct, easy to use, and more effective in many cases. Do not be afraid to mix and match methods.

To demonstrate both methods, let's do a little animating on our wooden man. Before we begin, make sure to organize him hierarchically so he can be moved easily. Now, let's rotate him so he is facing the mirror (Figure10.11).

FIGURE *Rotated wooden man.*
10.11

Now we can use Forward Kinematics to rotate the biceps of the wooden man to his sides (Figures 10.12a and b).

Now, record a keyframe for the shoulders to give your computer a starting point. Then move the current time marker to about 30 frames and re-pose the dummy using FK by moving the biceps, then the forearm, and finally the hand into a buff posing position, and then record a keyframe. Repeat the process for the other arm, record a keyframe, and then refine the head and neck so the dummy is looking at the mirror. (Figure 10.13).

We can further refine this particular pose by moving the current time marker back to 0 frames and recording a keyframe for the chest. Then move

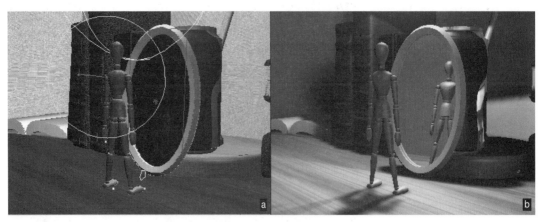

FIGURE 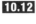 *Rotated arms to sides with FK.*
10.12

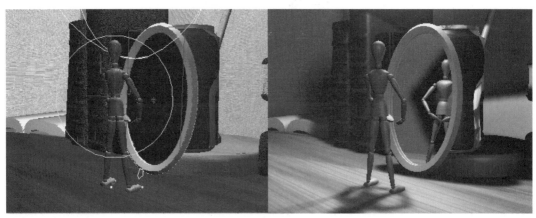

FIGURE *Posed arms.*
10.13

the current time marker back to 30 frames and rotate the chest forward and the head up (Figure 10.14). Record a keyframe.

We will use IK to animate the lower body. First, be sure to create an effector or a null object that will nail down the ankles of the character. Create a goal object, or IK target, at the base of each heel (Figure 10.15). Then, assign each leg to point toward its respective goal or target.

Now, record a keyframe for the target or goal at 0 frames. Move the current time marker to 15 frames, then move the target into the air as the first part of a step forward, and watch the leg follow into position (Figure 10.16). Record a keyframe.

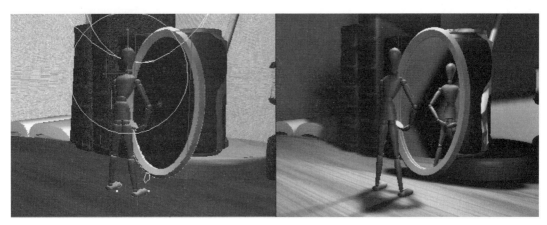

FIGURE
10.14 *Finished upper body with FK.*

FIGURE
10.15 *IK target or goal.*

Next, move the current time marker to 30 frames and place the target/goal on the floor again a little in front of the original position. Record a keyframe and then adjust the angle on the back foot to show that there is no weight on it since all the weight has shifted to the front foot. The motion of the dummy making a pose in front of the mirror is complete (Figure 10.17).

Now that we have spent all this time looking at IK and FK chains and how they work, let's take a look at a couple of ways that bones can be used besides chains.

FIGURE *IK in action with target or goal effector.*
10.16

FIGURE *Posed dummy.*
10.17

When a bone is attached to a group of polygons, all those polygons are affected no matter how the bone is altered. Most IK and FK functions are focused on the idea of bone rotation. However, bones can also be resized, and the polygons attached will resize as well. Figure 10.18 is a simple sphere with one bone set in the middle. Figure 10.19 is the same sphere and bone, but as the bone is resized, the sphere is distorted to match. Similarly, if the bone is lengthened, the sphere is lengthened as well (Figure 10.20). This may seem an overly simple example; after all, this sphere could simply be resized without the use of bones. However, with complex models, one bone can control a multitude of objects and shapes even if they are not grouped.

FIGURE *Simple setup with bones and polygons.*
10.18

FIGURE *Squashed bones and resultant polygons.*
10.19

FIGURE *Lengthened bone and resultant polygons.*
10.20

Bones can also be created and set up in nonchain formats. For instance, see the example in Figure 10.21. These two bones are set up in tangent to the oil tank shape, but still are just as effective. The images in Figures 10.22 and 10.23 are both using rotated or rotated and moved bones that distort the shape.

FIGURE *Bone setup.*
10.21

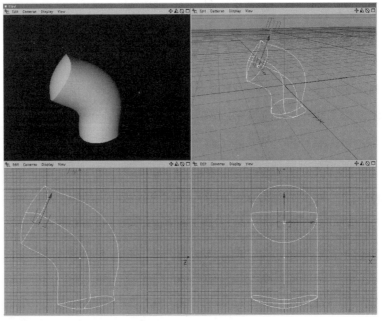

FIGURE *Bone alterations and resultant polygon distortions.*
10.22

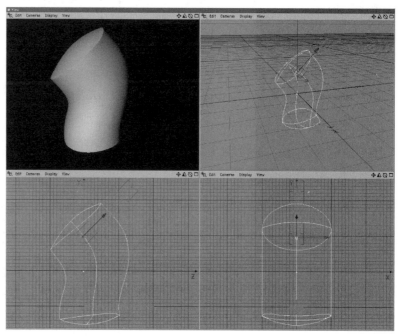

FIGURE *Bone alterations and resultant polygon distortions.*
10.23

Exercises

1. If you have not already done so, organize the hierarchy of the wooden man (and/or woman) to prepare to animate.
2. Create several different flexing poses that a real ham of a wooden man would do in front of the mirror.
3. Bone the lamp's neck and experiment with moving the long lanky neck in serpentine ways as if it were watching the wooden man in the mirror.

11

Concepts of Believable Movement

In his book, *On the Creative Process*, Norman McLaren said, "How it moves is more important than what moves. Though what moves is important, in relative order of importance, it is how it moves that is the important thing…What the animator does on each frame of film is not as important as what he or she does in between." Beautiful models are great, fantastically detailed textures are marvelous, but all is for naught if the movement is unbelievable and stale.

There are so many intricacies to animation that the topic deserves a library dedicated to the art. Many of these intricate details can only be learned through intensive study of real life, footage, and the work of past animation masters. There are, however, a few very important ideas that will assist in creating good animation as you start out.

The Arc

Your 3D application will set in-between frames between keyframes that define where the object should be at every point in the animation. Although often the computer's interpolation is in a rounded path, it tends to choose the shortest path between two keyframes. For example, if you are animating a head turning from side to side, and you set a keyframe at the point where the head is looking one direction, and another keyframe when the head is looking the other direction, the computer's guess of interpolation is a direct curve in the shortest path (Figure 11.1).

Unfortunately, organic motion is rarely in a straight path. Almost always, our motions take place in arcs or curved arcs. The movement shown in Figure 11.1 should be much more like that shown in Figure 11.2.

This dip in the head-turning process is typical of adjustments that need to be made in organic 3D animation. Keep in mind that although your 3D application is fairly good at making curved paths, these curved paths are often inaccurate to portray good movement. Although keyframe economy is good (do not insert more than are needed), do not cheat your movement by not giving enough keyframes to define good, believable movement.

FIGURE *Rotated head.*
11.1

FIGURE *Rotated head with altered arc.*
11.2

Weight

Perhaps the single most important issue of good animation is weight. We all succumb to gravity in every movement we make, and creatures within our 3D universes should do the same. Knowing how to define weight and where to place it will make 3D objects stick to the floor and feel like they are part of the scene rather than a bunch of weightless pixels.

Several techniques have been established through the years of traditional cel animation. Perhaps the most basic and most powerful is the idea of stretch and squash. Stretch and squash is the idea of the transfer of weight in anticipation of a movement (especially a hop), and the movement of that weight through the course of the movement.

One sure sign of a beginning animator is the "computer hop"; the object jumps, crests, and lands all in the same fluid motion at the same speed. It is easy to do. All the animator has to do is keyframe the moment the object leaves the ground crests, and when it hits. Too often, this same evenly hopping object also remains fixed, hard, and looking more like a ball bearing than an animate object.

To effectively define the weight that any object has, we can begin by looking at a hop cycle (from rest to liftoff to crest to landing to rest) of a simple ball. We will use a ball for the illustration because a ball can be easily altered using move, rotation, and scale functions.

A Look at Motion

First, let's look at an example of what a "computer hop" looks like. Figure 11.3 shows a ball making just such a hop. Notice how smoothly the hop goes; all perfectly one speed, perfectly timed, and perfectly phony. Notice how the ball has such a rigid look that it does not appear to have anything that is actually driving it up and driving it forward. It still looks as if the animator is moving the piece rather than the piece actually hopping. Although, this may be the look an animator is going for, it usually makes for very unconvincing motion.

In 1850, the railroad tycoon Leland Stanford asked a photographer named Eadweard Muybridge to settle a long-time debate. The debate had to do with whether a horse ever had all four legs in the air as it ran. Muybridge used a series of glass-plated cameras triggered by rubberbands and wire to photograph the animal. His photographs of the "flying horse" made him an international sensation. As his setup became more complex, he was able to capture more and more series of motions, including human motion. His subsequent discovery that these series of images, when viewed in rapid

FIGURE *Breakdown of computer hop.*
11.3

succession, produced what looked to be motion, earned him the title of "Father of Motion Pictures." His exhibits inspired the likes of Thomas Edison, who soon began his own work on motion picture photography.

Among Muybridge's photography are several series of people in the act of jumping. By analyzing these series of photographs, we can get a good idea of the mechanics behind a body in motion. This sort of study is very important in depicting a self-propelled body. Figure 11.4 gives a good idea of what really happens in the course of a hop.

FIGURE *Muybridge photograph of hop.*
11.4

Some vitally important concepts can be learned from this composited photograph. For instance, an aspect that seems rather intuitive, but often forgotten, is the idea that an object orients itself in the direction that it is propelling itself. One key element behind good motion is that when an object is in motion, it will orient itself in the direction that it is moving. Figure 11.4 shows that as the figure takes off, his head is pointing in the direction it is soon to travel. As the figure reaches its crest, its orientation shifts so that its feet are facing the direction the body is traveling.

Figure 11.5 shows our trusty ball using this concept in different points of its flight. This motion is a good start and certainly better than the original ball animation, but still, the ball is simply too rigid to be believable.

FIGURE *Ball jumping with shifts in direction.*
11.5

Weight is central to the idea of stretch and squash. That is, in order to make an object appear as though it has weight, there must be an anticipation and appearance of stress. In Figure 11.4, we see the jumping man crouching, bending like a spring in anticipation of his leap. This kind of movement signals to the viewer that there is weight that needs to be propelled, and thus the crouching anticipation called the *squash*.

Likewise, when the motion is stopped, or the object lands, there is a similar squashing as the weight comes to bear against the surface that stops its motion.

Just as important in stretch and squash is the stretch that occurs between "lift off" and "land fall." Notice in Figure 11.4 the elongation of the figure, or the *stretch* in anticipation of the coming action.

That is basically the idea behind stretch and squash. An object *squashes* in

anticipation of propelling itself forward/upward, then *stretches* in anticipation of its coming crest, *squashes* as its weight shifts from an upward motion to a downward motion, *stretches* again in anticipation of landing, and then *squashes* when it hits the ground.

Figure 11.6 show the ball using the steps just listed. For this particular animation, I have added little hiccup in the middle of the hop where the squash at the crest of the hop is accentuated to give the character a very rubbery effect, as though its base is heavier than its top. Notice also, the added anticipation leaning that occurs at the beginning of the hop sequence and the rebound after the hop is done. Anticipation and follow-through are always essential to any motion.

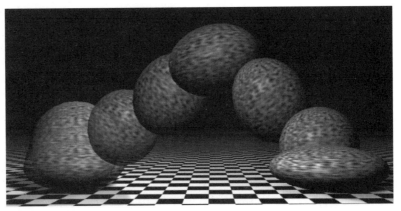

FIGURE *Ball hopping with stretch and squash.*
11.6

Now we have an animation that is quite a bit better at portraying life. There are definite similarities and parallels between the Muybridge photographs and the animations produced. There is one more important aspect to making a believable hop: timing.

Timing is one often-overlooked aspect that is vital to effective motion. A sure sign of amateur hopping is "one speed hops"; that is, a hop that is the same speed when it takes off, crests, and lands. In actuality, an object's speed changes fairly dramatically over the course of almost all motion; and the hop is no exception.

When people jump (as in Figure 11.4), there is an initial burst of speed as they push off the ground with enough force to cause them to be airborne. As their "flight" reaches its crest, their speed slows as their upward momentum tapers off. When they reach the crest of their jump, their speed in an

up-down direction slows to a near stall, as the momentum begins to shift downward. The farther they have to fall, the faster they move, until they are moving quite fast when they hit the ground on the other side of their jump.

Figure 11.7 shows the ball making a well-timed hop. Notice the *fast* launch, the *slowing* as it reaches its peak, its near *stop* at the crest, and the *fast* decent. As a key, remember that in Figure 11.7, the farther apart the shot of the ball is, the faster the object is moving.

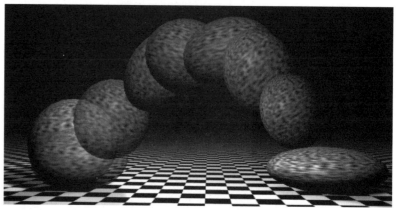

FIGURE *Well-timed ball hop.*
11.7

These is still a multitude of other character-establishing touches that could be added to this particular animation. Objects can actually hop with all sorts of movement that express power, diminutiveness, attitude, and so forth. However, good hops and motion in general are based on some important principles that can be learned from real-world examination. Even if the animated object is far from real world, a viewer will only buy in to the motion presented if he can relate it (even on a subconscious level) to what he knows in reality.

Once the ideas behind stretch and squash are well understood for an object as simple as a ball, they can be translated into use for more complex characters (see Tutorial 11.1). Figure 11.8 is the breakdown of a student animation in which the student, Stuart Moser, took the ideas learned in a previous bouncing-ball exercise and successfully applied it to a bipedal character.

There are many more character-establishing and weight-defining techniques. See Chapter 12, "Advanced Animation Ideas," for more examples of

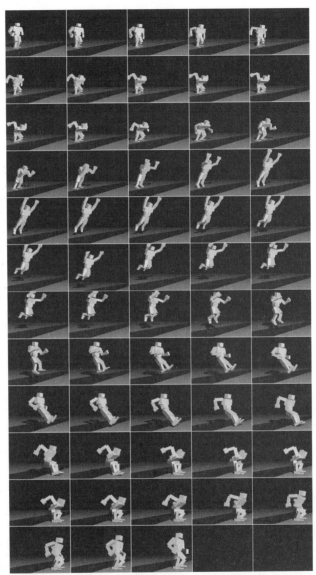

FIGURE *Stuart Moser hop cycle.*
11.8

different movement breakdowns. The hop example given here is a great one to start with because it allows for complete animation with just movement, rotation, and scale tools. Master the concepts behind the arc and stretch and squash, and other movements will come much easier.

11.1: PHYSICS OF THE HUMAN HOP

Stuart Moser's example of the hop is excellent in how it communicates weight and character. As an expansion to the look at the ball hopping shown previously, this tutorial will look at how the simple hop (in a generic sense) can be communicated. The example is based on the Muybridge photograph of the man hopping (Figure 11.9).

FIGURE *Muybridge photograph of man jumping.*
11.9

To begin, make sure you have created a boned figure or one that you have IK'ed that will allow you to concentrate on the motion of the activity rather than spending a lot of time on the technicalities of IK. You may wish to create a set of bones (Figure 11.10), or simply use a character you have already created (Figure 11.11). Either way, make sure that you have defined the appropriate ranges of movements if you plan to use IK. If you wish to use FK, there is no need to define constraints, as you will be totally controlling the range of movement manually.

To begin, let's make sure that the figure is standing appropriately. The stand may seem like an odd place to start the study of motion; however, too many great motions are spoiled by stiff figures that appear unnatural when not involved in a given motion.

FIGURE *Basic IK setup (colored simply to assist in workflow).*
11.10

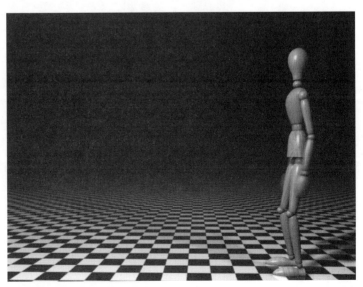

FIGURE *Wooden jumping man.*
11.11

The trick to the stand is to remember that our joints are not often completely straight. Some folks lock their knees when they stand, but usually there is a slight bend to the knee and a slight bend at the elbow. Look at your own elbow as you stand up and you will find that you almost never have a locked elbow. Figure 11.12 shows our Amazing Wooden Man positioned in a poised-for-action stance. The center of weight is directly above the feet, and the legs are slightly spread to further show balance. Also notice that the arms are not laid directly to the side of the body, and that there is a slight bend to the back. If you are using a single mesh for the character for this exercise, consider using a more complex arch of the back (Figure 11.13). Notice that in Figure 11.14, the highlighted bone

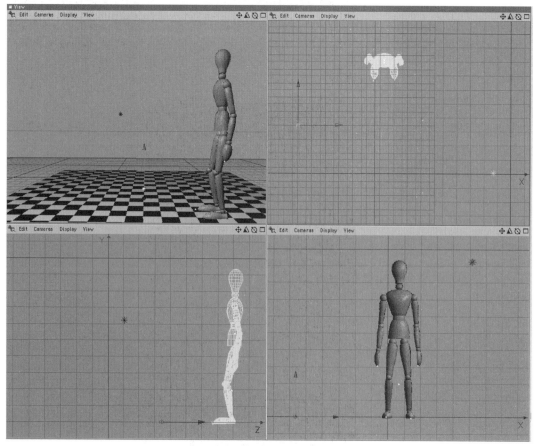

FIGURE *Ready-for-action stance.*
11.12

FIGURE
11.13
Complex back arch.

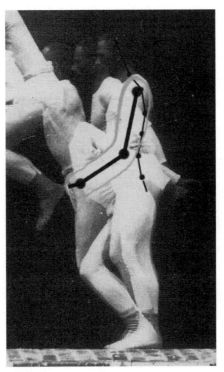

FIGURE
11.14
Anticipation of anticipation forward arm swing.

is the beginning of the small of the back, while a new IK chain runs into the buttocks.

Once your figure is properly positioned to be ready for action, make sure to place a keyframe. Now, we need to allow the character to anticipate the motion he is going to make (in this case, a standing long jump). Too often, animators forget that believable movement starts well before and ends well after the bulk of the movement actually happens.

You may be inclined to begin by animating the arms swinging back as an anticipation of the hop. However, while this may seem the anticipation of the hop, there is actually an anticipation of this anticipation. For instance, a close inspection of the Muybridge photograph reveals that before the man hops, his arms are positioned slightly bent out in front of him (Figure 11.14). This is the anticipatory act his arms make before their dramatic back swing.

Before we even begin the hop, move your current time marker to about 15 frames (about one half of a second), rotate the arms forward, and bend the elbows (Figure 11.15). Remember that no actions go unanswered by other parts of the body. Try standing up and swinging your arms back and forth. Take special notice of what the rest of your body is doing. Typically, as the arms swing forward, the shoulders will actually move back a bit in space. So, at these same 15 frames, make sure to rotate your chest and shoulder region back slightly to counterbalance the arm swing.

Now, in anticipation of the hop the figure is going to make, swing the arms of the figure very far back and make him squat. The arms are one of the most leveraging tools we have in controlling our body and weight. Thus, when preparing for a hop, they swing back in anticipation of swinging them forward and backward to propel the body up and forward.

The legs are not unlike a spring. In order to harness the power, a spring must first be compressed. The legs, when preparing to make liftoff or exert some great amount of force, will also compress or squat. Move your current time mark to 30 frames (another half second from the last keyframe), and with the arms back and legs compressed, record a keyframe (Figure 11.16).

It is important to notice that even though the figure is squatting in a somewhat awkward stance, the center of gravity stays fairly centered over the feet. As part of this shifting of

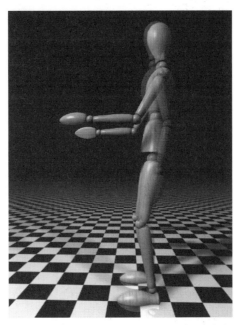

FIGURE *Forward arm swing and body counterbalance.*
11.15

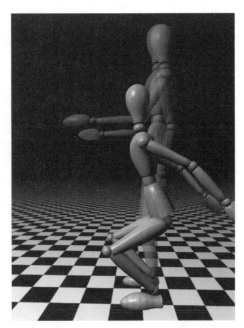

FIGURE *Anticipation back swing of arms and leg compression.*
11.16

balance, the back takes on an arch, the chest leans forward of the center of gravity, and the buttocks lean back. Also notice that the head is tilted back so that the character is always sure to know where he is going.

The next keyframe will be only 10 frames from where you are currently situated. This is because the next motion is the liftoff, and thus is a quick motion of the arms swinging forward and upward and the legs uncoiling to release the energy stored up in the squatting action. At this point, the feet have not yet left the ground, but the body is at its full length pointing in the direction it is headed (Figure 11.17).

There is actually quite a bit that happens at the ultimate crest of the hop. It is at this important moment that the body changes overall shape, and the speed and direction of the body in flight is altered. Since it is such a complex time in the hop process, it needs to be broken down into at least two keyframes. The first of these three crest keyframes is the next keyframe.

The keyframe that occurs at the beginning of the hop occurs within rapid succession of the keyframe before it. The up-

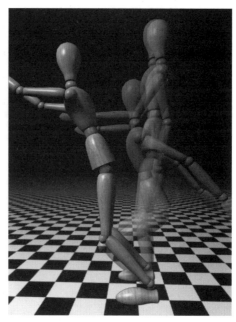

FIGURE *Preflight liftoff where body is stretched to fly.*
11.17

ward travel of the jumping character is fast, accompanying the release of power in the legs. A new keyframe needs to be applied 8–10 frames after the keyframe defining the outstretching that defines the recoiling of the body as its momentum slows and it begins to prepare for the downward travel.

At this point, the legs are beginning to coil beneath the body as they begin to swing around to catch the body as it falls. To counterbalance this shift of lower weight, the arms bend and the back arches. The head remains upright to help in the balancing act. The pose at this point in the hop should appear something like Figure 11.18.

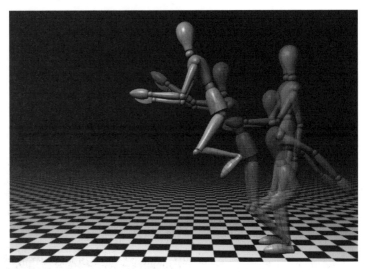

FIGURE *Keyframe at beginning of hop crest.*
11.18

The second part of the hop crest should be about 12 frames from the first. A large amount of time actually transpires during the crest as the upward momentum gives up its strength and gravity kicks in. It is a good thing, as the body must make a lot of changes and get prepared for the downward flight.

Figure 11.19 shows the position of the character at the end of the crest. The legs are swung around in anticipation of landing. The chest is forward to counterbalance this dramatic change in weight of the swinging legs. The arms are

pointed down, helping in the balancing act, and the head is looking toward where it is going. The primary focus of the entire body from here on out is damage control as it comes down, making sure it does not hurt itself on impact.

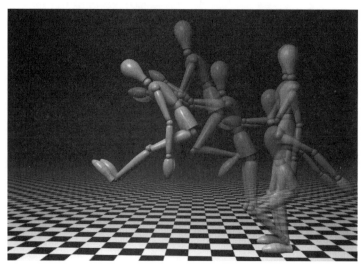

FIGURE *Keyframe at end of hop crest.*
11.19

Now that the shifting of weight has occurred and the body is resigned to the downward fall, the speed at which it is traveling dramatically increases. Gravity is a powerful thing, and once it has a hold of the falling character, it is going to win. Figure 11.20 shows the point at which the body is bracing itself for the fall while attempting to keep its balance within air and keep a good control over the center of gravity. Notice that as the legs kick forward in anticipation of the landing, the arms fall back. This keyframe should be only about 7–10 frames after the end of the crest keyframes.

The next noteworthy keyframe is very soon after the last (3–4 frames), and is simply a rotation of the feet as they strike the ground. There is a slight shift in the body as it continues its forward momentum, but there is a moment of impact when only the feet hit the floor (Figure 11.21).

The next keyframe should be about 10 frames later. This keyframe shows the effect of the floor stopping the body's downward momentum while the forward momentum continues. As the weight lands on the floor, there is a forward rocking of the center of gravity as the body attempts to arrest its

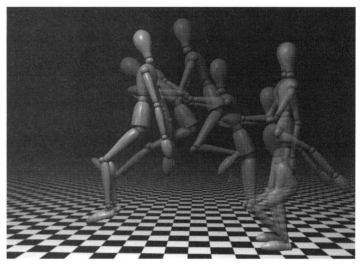

FIGURE *Bracing for impact.*
11.20

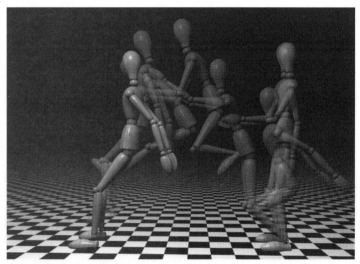

FIGURE *Moment of impact.*
11.21

forward momentum. The arms (that ever-present indicator of
secondary movement) are continuing in the forward momen-
tum and balancing out the buttocks as the body comes to
rest. By this time, the back is curved as it absorbs the power of
the fall, and the head is looking up to see the situation around
it (Figure 11.22).

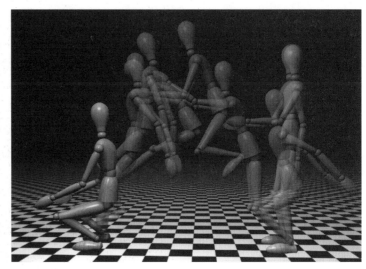

FIGURE *Arrested forward momentum.*
11.22

Now that the danger of the situation has lessened, the body moves a little slower in its recovery. The next keyframe that shows the dummy beginning to stand up can be 15 frames from the last.

When the human form is in the squat shown in Figure 11.22, the center of gravity is fairly well balanced by the head/shoulder/arm combination and the buttocks. When the body stands up, it has to make adjustments to keep from toppling over. A common tool is to hold the arms out in front of the body as it lifts its own buttocks higher. Figure 11.23 shows such a pose as the figure begins to stand.

The last keyframe (another 15 frames) is simply a return to the neutral position. The arms come down, the head is straight up, the back is in a normal arc, the knees are slightly bent, and the elbows are slightly bent off the side of the form (Figure 11.24).

In true Muybridge fashion, if all has gone well, you should have a final animation as depicted in Figure 11.25. Make sure to take plenty of time to tweak the animation. You may find that some of the time between frames is too far apart for your liking, or that you need to add extra frames to ensure that the arms or legs swing in an arc. Make sure that as you are tweak-

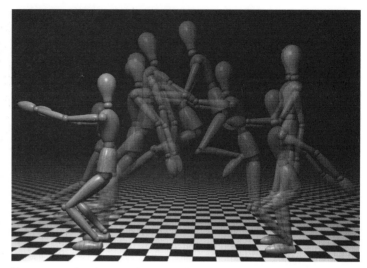

FIGURE *Standing figure with arms held out for balance.*
11.23

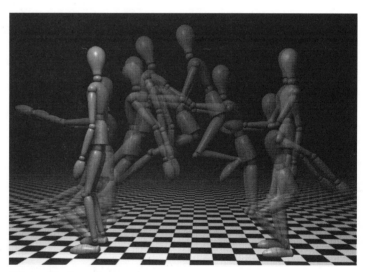

FIGURE *Final standing position.*
11.24

ing, you render test renders, or renders done in wireframe or some other feedback-oriented display. Once you have the timing just right, a full render will finish your masterpiece.

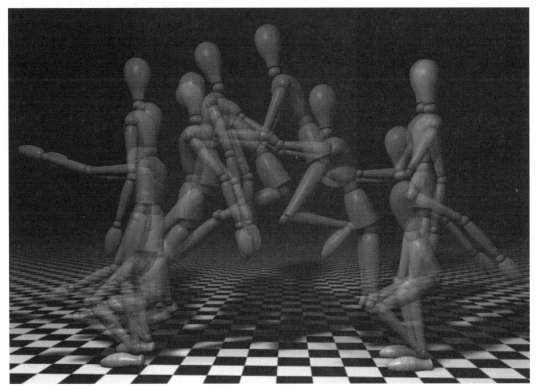

FIGURE *Final hop path.*
11.25

Exercises

1. Animate your wooden man hopping over a pencil on the table.
2. Try animating him hopping again, but this time, make him trip on the pencil and land hard.

12 Advanced Animation Ideas

O nce you have begun to master effect gesturing using arcs, and understand weight and how it affects an object, it will be time to move on to one of the most challenging parts of animation: the walk.

Bipedal creatures (which include us) use an odd form of propulsion. In a sort of controlled fall, we move our weight forward through friction on the ground of one foot as the other moves to catch our weight before we fall again. Such is human walking, running, strutting, sneaking, and every other kind of locomotion. Oh, but that is not all! Through this process of controlled falling, the bipedal creature twists, turns, and distorts along nearly every axis possible in order to maintain balance. It is amazing that although we do it every day without thinking, walking is an immensely complex set of motions.

Center of Motion

As we talked about earlier, we all have weight (at least on our earth). In order to balance this weight in all the twists and turns our body does, nature has provided a fairly central point around which most general motion takes place. This center of motion on humans resides about halfway between our belly button and crotch. It is a bit different for men and women, but generally picking a spot as shown in Figure 12.1 is a safe bet.

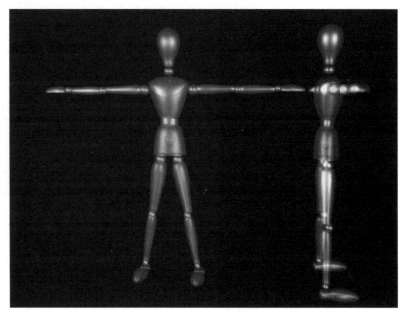

FIGURE *Center of movement.*
12.1

As we turn, we turn around this point. As we bend, we bend at that point. When we walk, our appendages all flail at different speeds; first one foot is charging ahead while the other stays still, and then they swap roles. However, our center of motion always stays moving. Try it. Get up and walk about the room, and notice that from your head to your crotch, you move at a more or less constant rate, while the rest of your body is altering rates or, in the case of your hands, even moving backward.

Because we have this center of weight, we can base most all motion around it.

Walking in Arches

We never notice it, but we walk in arches. Although our mind compensates for the up and down movement, our center of motion and thus our torso and our head gently rise and fall as we walk forward. This is due to the fact that when both feet are on the ground during mid-stride, both legs are bent and at a diagonal to our bodies. Then, as the walk cycle continues and all the weight is transferred to one leg, this one leg is nearly completely vertical and we are nearly fully erect (Figure 12.2).

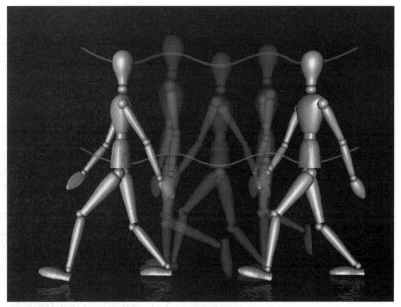

FIGURE *Arches of movement.*
12.2

With this knowledge, this is often a good place to start a walk cycle. With the forward movement gently moving up and down, you have a good start to believable movement. In fact, if the camera is placed from the waist up and we can see the up and down movement, we understand that the character is walking even if we never see his legs.

Rotations during Walking	Walking is really an amazing feat of balance, a complex collection of bending and twisting that keeps our momentum moving forward while keeping our weight centered. The first and most obvious form of rotation occurs with our legs. When we walk, we start from a position of both feet next to each other on the ground. As soon as we begin, we begin the forward movement of our center of motion and the subsequent need to catch the forward-moving weight. One leg (let's say the left leg) valiantly moves forward to absorb the shock of the weight that is now moving forward and downward. For a brief moment, both legs share the weight of the body again before that same weight continues to move forward, now driven by the friction of the recently landed left foot. The right leg then lifts off the ground to play catch-up and prepare for its turn to propel the motion.

While all this is happening, our arms are busy counterbalancing all that swinging that is going on below. As our left leg moves forward, our right arm swings forward to balance the shift in weight. Then, as the right leg moves forward, the left arm counters.

In addition, having all our weight on one leg does not go unnoticed by our hips. As the left leg plants on the ground and absorbs the weight of the body, the left hip rises as it shares in the load. Subsequently, the right hip drops as it is not supporting the load of the body, but is now carrying the right leg. To counter all this hip swinging, our shoulders move up and down just opposite the hips. As the left hip rises upon weight absorption, the right shoulder rises and the left shoulder drops (Figure 12.3).

Sound complicated? It is. However, it is not impossible. If your character is properly organized in hierarchy, then it is simply a matter of picking important points in the walk and posing your character as it should be there, recording a keyframe, and then repeating the process for the next point. Figure 12.2 shows semitransparent poses of key positions where keyframes should exist.

The actual process of creating these poses is up to you. Some folks find Forward Kinematics (FK) the way to go. Simply start by animating the center of motion moving forward by animating the most parent object of the

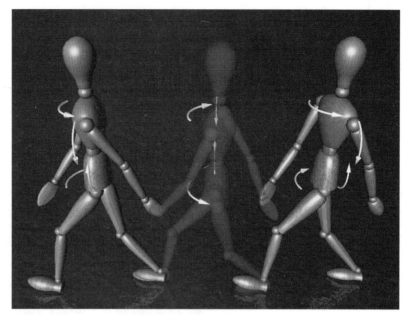

FIGURE *Rotating hips and shoulders.*
12.3

hips. Then animate the swing and rotation of the hips and shoulder as they are next in line in the hierarchy, and continue down the row through the legs and arms and finally to the hands and feet.

Inverse Kinematics (IK) is also a powerful tool. In this way, poses can be created by simply grabbing the hands and feet (or their goals, targets, or effectors) and moving them into place to define the pose. If all the joint restrictions are appropriately set up, the parent arms and legs will move into position. You will probably still have to animate the center of motion moving forward and especially with its arcs, but this problem can be partly solved by creating an effector for the hip area that can be animated in an arch path to define the needed movement.

Character Is in the Details	Think of George Jefferson from *The Jeffersons*. Now think of Charlie Chaplin, Groucho Marx, Dick Van Dyke, Marilyn Monroe, Loretta Lorraine, and Jar Jar Binks. It is phenomenal how easy it is to picture these characters and their attitude just from how they walk. An amazing amount of character and personality can be defined by just altering slight details of a walk cycle.

Figure12.4 is a sequence of frames from a motion study by Stuart Moser. Notice how this figure has a large swinging of shoulders, wide arcs in the

swinging arms, and low bend in the knees upon leg impact. The model is simply comprised of boxes, yet we know it is a big character with a lot of weight. Further, we know that with the bent forward stance and downward tilted head, we best not get in this character's way or else we will be crushed. This sequence uses the same motion we described previously, and was even animated in the simple FK style described earlier, but now we get an entirely different feel.

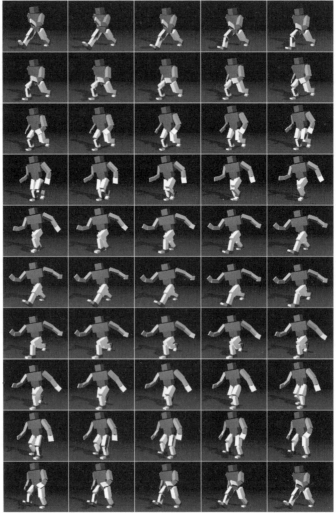

FIGURE *Stuart Moser's heavy walking man.*
12.4

On the other hand, Nathan Tufts' goofy walking man immediately lets us know that the character at hand is a goofball (Figure 12.5). With its swinging wrists and arms close to the body, we know that this figure has neither tremendous weight nor power. The loosely bobbing head and flapping feet alert us further to the nonsensical nature of this figure.

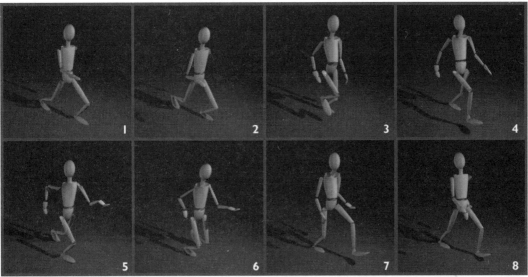

© Copyright Nathan Tufts 2000

FIGURE *Nathan Tufts' goofy character study.*
12.5

One other nice example is Nathan Tufts' character study of a confident mime (Figure 12.6). Even without the expressive face, the arms that end their swing up around the character's chest show a cocky, swaggering character. The arms maintaining a curve at the back of the swing further define his confidence.

Besides character-establishing walk cycles, there are a multitude of other movement patterns that humans are capable of and that help establish character. Figure 12.7 is a skip cycle again using the same simple box model, but still easily establishing a mood and character.

Figure 12.8 is a full-out run. There is nothing subtle about it with its sprawled legs in mid-flight and exaggerated takeoffs and landings. This clear definition of form and pose makes the motion clear and interesting to watch. A more subdued set of poses might also be appropriate for perhaps a female character or a child.

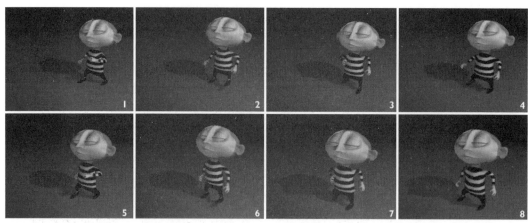

© Copyright Nathan Tufts 2000

FIGURE *Nathan Tufts' mime.*
12.6

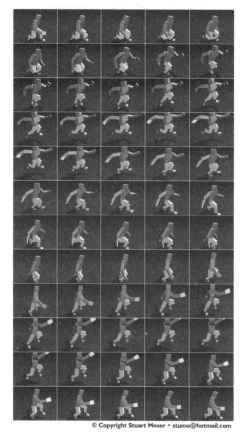

© Copyright Stuart Moser • stumo@hotmail.com

FIGURE *Stuart Moser's skip study.*
12.7

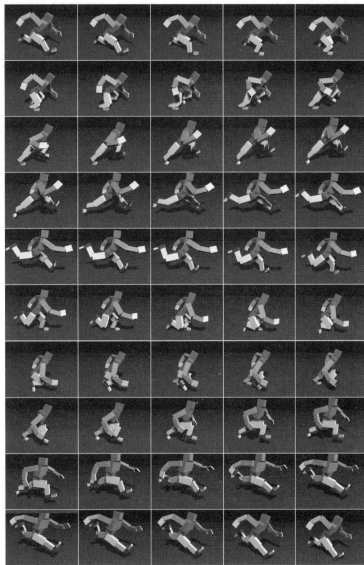

FIGURE *Stuart Moser's run study.*
12.8

Characters that are even more outlandish can be created by moving completely out of the realm of two-legged movement. Nathan Tufts' crawling man shows a dynamic and flexible character with a sinister tone (Figure 12.9). By keeping him low to the ground with extreme stretching of all the joints, we are immediately reminded of a spider and become fearful.

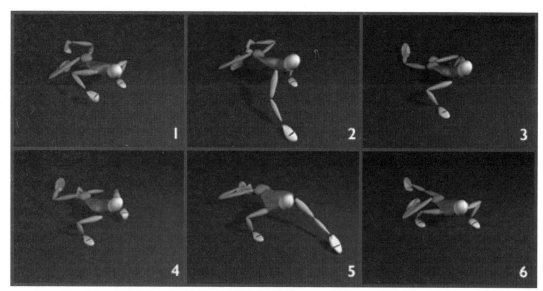

FIGURE *Nathan Tufts' crawl study.*
12.9

These examples are simply studies whose purpose is to find movement that works without worrying about models, textures, or lighting. Studies are a good way to quickly define how your character is to move and act, without the heavy polygon and rendering-time overhead of full-blown models.

The key to effective movement is to observe and do. It is humorous to walk into a computer lab and see 10 to 20 students wandering about the lab looking at their own arms, hips, and feet. Often, they are counting aloud, trying to determine the timing of their walks. Even funnier is the animator walking down the hall trying to define a character walk. Funny as it may be to watch, there is no better way to understand movement than to do it yourself. Make sure to get up and get moving when animating bipedal movement.

T
U
T
O
R
I
A
L

12.1: WALKING STRATEGY #1—ANIMATED IK TARGETS

Without a doubt, the walk cycle is a tremendously complex collection of movements. The careful shift of weight and swinging of arms, legs, and hips are tough to take in when simply observing, let alone trying to animate.

Early in the process of learning to digitally walk, most animators create the *stationary walk*, one in which the character is making all the motions of a walk except that it is not moving in relation to its surroundings. This is a great beginning exercise to further understand the motion of walking. You can even make this sort of walk cycle almost usable by animating the character as a whole moving forward, or animate the environment moving around the character. However, the result is often the sliding feet that were so bothersome in those old episodes of *Scooby Doo*.

So, how do you make a character walk and exhibit the physics of moving forward because of the friction that the foot on the ground provides? One strategy involves actually animating Null objects or IK targets (objects with no geometry of their own) and having IK structures move in response to the object; the idea being that you assign each leg to a different target object. You can then animate this target moving, stopping, and moving again. Then, as the body moves along, the feet always appear planted. Let's look at how this strategy works.

To begin, create a simple IK structure. Figure 12.10 is a simple IK setup with simple bones. These bones could just as well be inside a mesh, but for illustration's sake, it is easier to show just bones. Notice that one side of this collection of bones is colored red. This is a simple texture applied to the bone and will not render (none of these bones would render, for that matter), but it allows you, the animator, to be able to tell easily from any viewpoint which joint is out front, in back, or out of place.

Next in the setup for this technique is to create four Null objects or IK target objects. Place one at each heel of each foot (Figure 12.11) and another at the toe of each foot (Figure 12.12). Make the toe object a child of the heel object. You want to be sure that when you move the Heel IK target that the toe goes with it. The reason for two IK target shapes is to allow you to control how the foot bends during the walk cycle.

FIGURE *Simple bone setup.*
12.10

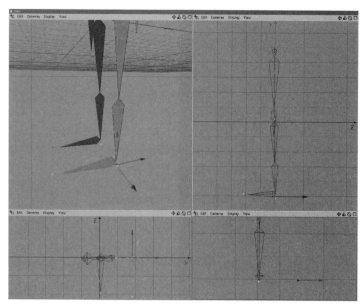

FIGURE *Null or IK object heel placement.*
12.11

FIGURE *Null or IK object toe placement.*
12.12

Once these Null/IK objects are created, set up the IK constraints for the legs. Activate these newly created IK/Null objects as IK targets to begin animating.

Now the idea is to animate the Heel targets as they rise and fall, as a foot would do. For instance, using a 30fps paradigm, place a position keyframe at 0 frames for the Right Heel target and one for the Left Heel target. Place another position keyframe at frame 15 with the Right Heel target at the top of its stride (Figure 12.13) and another at frame 30 when it strikes the ground plane (Figure 12.14). Place a position keyframe for the Left Heel target at frame 30 so that it knows it is not to move during those first 30 frames. Then place a position keyframe at 45 frames at the top of its stride and another at 60 frames when it hits the ground. At this 60th frame, also place a keyframe for the Right Heel target so it knows that it is not to move between frames 30 and 60, and then repeat the process. Remember that for this sort of IK animation, you are animating the position of the targets, not the actual joints. As the joints realign to point at the targets, the pose and movement are complete.

An important thing to notice about Figures 12.13 and 12.14 is that the top of the body or the center of weight is

FIGURE
12.13
Right Heel target animated at top of stride (frame 15).

FIGURE
12.14
Right Heel target animated at footfall (frame 30).

moving along as well. This is because a keyframe was placed at 0, 15, and 30 frames, respectively, to give the body the lift and forward movement to match the footfall (Figure 12.15).

FIGURE *Body moving with footfalls.*
12.15

Figures 12.16, 12.17, and 12.18 show the walk cycle over the course of three steps, or about 5-6 keyframes. Notice the arch of the Heel IK targets. Remember, to animate the legs with this method, the leg bones themselves have no keyframes assigned to them; the 3D application is simply moving them as it goes along to match the animation keyframes of the targets.

It is important to notice that, thus far, only the lower body has been animated; the upper body has not been touched with IK or any sorts of targets. Often, upper-body movements are best handled using Forward Kinematics(FK). The big difference here is that you start by animating the shoulder's swings, and then move down to the upper arm, forearm, and hand. When animating with FK, make sure that you place rotation keyframes. Once the placing has been established for the lower body, it becomes very easy to go back and place keyframes (in this case, at frames 0, 15, 30, 45, 60, 75, 90) where they need to be. The result should be swinging arms and turning shoulders (Figure 12.19).

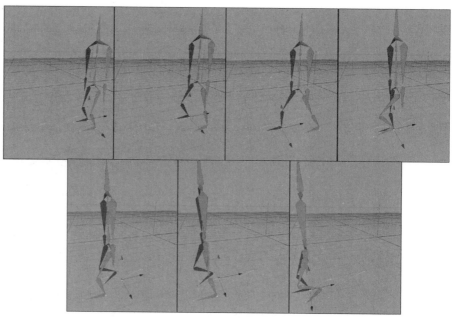

FIGURE **12.16** *Right Heel walk cycle over three steps.*

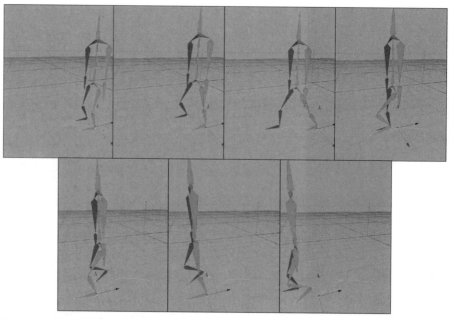

FIGURE **12.17** *Left Heel walk cycle over three steps.*

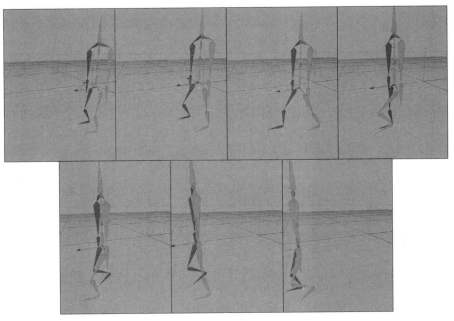

FIGURE *Body shift and path over three steps.*
12.18

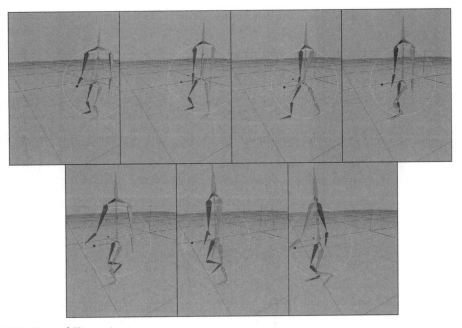

FIGURE *Forward Kinematic arms.*
12.19

12.2: WALKING STRATEGY #2—CHANGING IK TARGETS

In Tutorial 12.1, we animated the walk by moving the target at which the IK structure of the leg was pointing. This is not a bad strategy, as it prevents slipping feet and gives good control over foot motion and weight shift. However, sometimes this method falls victim to problems of uneven steps because the user must manually animate all the motion.

Another approach, which we describe in this tutorial, uses a parallel but different method. Instead of animating a target shape that the IK structures follow, we will create a series of virtual footprints, each of which will become the IK target for a brief moment of time.

To begin, create a simple IK structure. The same structure as was used in Tutorial 12.1 would be fine as well, except make sure to delete the IK target shapes. This is because you will be creating new shapes (Null/IK objects) to define the position of the legs.

Next, create a simple shape for each foot that you can use to visually plot the footsteps of the character. In Figure 12.20, a flat cube is used, although the actual shape is arbitrary since it is to be hidden later.

Naming your shapes appropriately is important for later in the process. Name these shapes "R-FS0" and "L-FS0" for Right Footstep #0 and Left Footstep #0, respectively. Once they are labeled, make careful note of their position.

Now, copy and paste L-FS0, and move it along one axis (along the axis/direction you wish your character to follow—in the case of Figure 12.20, the steps are moved along the z axis) to a good position where the right foot would take its first step. In the example, the character is starting from a still position, so you may want to make the first step small. This first step would be one half of the total stride length, or 400m. Make careful note of how far this stride is from the first. In the case of the IK structure shown in Figure 12.20, it is 400m. Name this new footprint "L-FS1."

Now, copy and paste R-FS0 and move it along the axis your character is moving twice the length that you moved L-FS1. This copy is moved 800m because the left foot is going to be traveling a full-stride length along the z axis. In Figure 12.20 ,

FIGURE *Flat footstep shapes*
12.20

it would be 800m, which means that the total stride length is 800m. Rename this new left footprint "R-FS1."

Now take L-FS1 and copy and paste it 800m further along the z axis and rename the new copy "L-FS2." Take R-FS1 and copy and paste it 800m along the z axis and rename it "R-FS2." Continue this process, each time moving the new footprint 800m along the z axis and renaming it. The visual result thus far should look something like Figure 12.21.

This is a good start as now we have established where each foot is to make landfall. Later in the process, we will tell the IK chain of each leg to point to each of these footprints at different times in the animation. However, without additional information, the feet would simply slide or shuffle along the ground to meet each of these target shapes. To prevent this, we need to create a new set of target shapes that define the movement of the foot at the top of its stride. Imagine this new set of target shapes as "air-footsteps."

It turns out that where the foot is at its highest corresponds to where the other foot hits the ground. This is convenient, since we know the distance between footfalls is 800m. Create a copy of R-FS0 and move it along the z axis 400m, or half the

FIGURE *Footsteps completely plotted.*
12.21

length of a full stride, so that it lies even with the footprint of the left foot (Figure 12.22). Then move this new shape up along the *y* axis to define where the foot is to be at the highest point of its path between footfalls. In Figure 12.23, it is about 100m. The height that you choose is largely subjective. How high the character lifts his leg during a walk is actually a very good indication of attitude (low lift = grouch bum, high-lift = drum major). Name this new foot position "R-FH0" for Right Foot Height #0.

To continue with the right foot, make a copy of R-FH0 and move it along the *z* axis 800m. 800m is the full length of the stride, and exactly the distance between foot crest to foot crest. Rename this new target "R-FH1" (Figure 12-24).

Continue copying and pasting these air-footprints and moving them 800m along the path of movement until you have enough Right Foot Heights to match Right Footsteps (Figure 12.25).

For the left foot, there needs to be a slight alteration. Since the first left footstep is only a half-stride from the starting point, the first left air-footprint needs to be half the length of half the stride (1/2 of 800 is 400, 1/2 of 400 is 200m), or

FIGURE *22 R-FH0 from copy of R-FS0.*
12.22

FIGURE *R-FH0 moved up along the y axis to define highest point of stride.*
12.23

FIGURE *New foot high point 800m from previous.*
12.24

FIGURE *Completed Right Foot Height target shapes.*
12.25

200m. So, create a copy of L-FS0 and move it 200m along the z axis and 100m up along the y axis. Rename this new target "L-FH0." Copy and paste this shape 800m further along the z axis and rename it "L-FH1." Repeat this process with the Left Footsteps, making a series of L-FH#. The progress thus far should appear something like Figure 12.26.

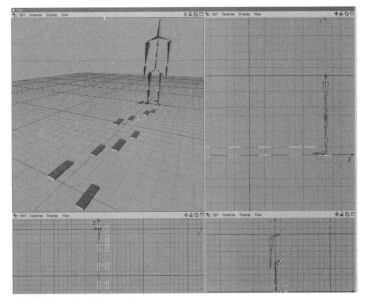

FIGURE *Completed Foot targets.*
12.26

Now we simply need to point the IK structure of each leg to these different targets at different points in time. However, before doing so, let's move the entire body along the path that it will take through the walk cycle.

As we saw earlier, the center of gravity in a walking humanoid bobs up and down through the course of the walk. Make sure all the bones are grouped together, and check to see that no bones are targeted at any shape yet. This will allow you to animate the path of the body as a whole without worrying about the legs pointing in some strange direction at an IK target.

Assuming we are using the same timing as the last tutorial (one step every second, or every 30 frames), we can figure on a keyframe every 15 frames. This works out to a keyframe at

the top of the center of gravity's arc, and one at the bottom. The key is to make sure that the keyframes that designate a high point in the walk correspond to the points where a foot's high-point target is located. The important thing to remember is that the center of gravity always stays balanced between the two feet. In other words, if the right foot is sitting on the ground (0 along the *y* axis) at the starting point (0 on the *z* axis), and the left foot is at its first high-point target (100 along the *y* axis and 200 along the *z* axis), then the center of gravity should be right in the middle at 100 along the *z* axis.

So, record a keyframe at 0 frames for the complete IK structure. Then move the character forward 100m and up slightly, and record another keyframe. This indicates a rise in the overall form of the character at the top of the stride, with the center of balance between the last footstep and the next foot high point.

Continue with this process by placing another keyframe at frame 30, moving the IK structure forward 100m along the *z* axis and down slightly; at this point, both of the character's feet will be on the ground and the center of gravity will be at its lowest. Remember this first step is typical for the rest of the walk cycle, so the values the character moves forward are half of what they will be for the rest of the character's walk.

Record another keyframe at 45 frames with the character's IK structure moved another 200m. This places him 400m from his original position. Now continue with this process at 60, 75, 90, and 105 frames (or however long your character is walking for), each time moving him forward 200m and up or down depending on whether it is the point when both feet are on the ground (IK structure's low point), or if one foot is at its high point (IK structure's high point). The path should look something like Figure 12.27.

Now comes the time when it all comes together. With the target points laid out and defined, at 0 frames assign the IK target for the left leg to be L-FS0, and record a keyframe. Assign the IK target for the right leg to be R-FS0, and record a keyframe. Now at 15 frames (the high point of the first step by the left leg), change the IK target of the left leg to L-FH0, and record a keyframe. At 30 frames, change the IK target for the left leg to L-FS1, and record a keyframe. These three keyframes defining different targets animates as a moving foot as it moves from one target to the next—and, of course, the leg follows.

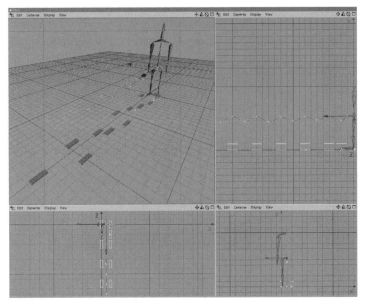

FIGURE *Figure's body path.*
12.27

At 30 frames, make sure to place another keyframe for the left leg, again defining the same R-FS0 as the IK target. This tells your 3D application to use the same target of the right leg for the first 30 frames, thus keeping the foot stationary. At 45 frames, change the target of the right leg to R-FH0 (record a keyframe), and then at 60 frames, change the IK target for the right leg again to R-FS1. At 60 frames, record a keyframe for the left leg, telling it to keep L-FS1 as its IK target so it knows not to move between frames 30 and 60. Continue the process. Simply record a keyframe defining a new IK target that moves on down the line of footsteps and foot heights.

Your timeline should look something like Figure 12.28. Although this is a shot of Cinema4D, other programs are not that different when altering IK targets. Notice that something is happening to one leg or the other every 15 frames. Also notice that every 30 frames, when both feet are on the ground, both legs have a keyframe set. The result should be smooth motion through the legs (Figure 12.29).

Now we are left with two problems. The first is those pesky footprints floating around the scene. Without deleting these IK

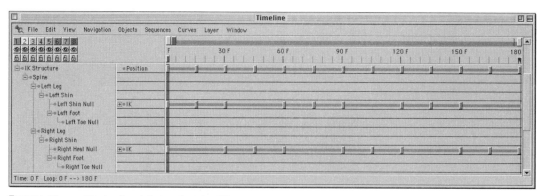

FIGURE *Cinema4D timeline defining changing IK targets.*
12.28

FIGURE *Figure in mid-stride using shifting target method.*
12.29

targets, hide them so they do not show in the editor or the render. Even though they are hidden, they still will guide the feet as they travel (Figure 12.30).

The second problem is there is no motion in the upper body. Use the same method of Forward Kinematics (FK) to define the rotation and movement of the arms, shoulders, and hips to create good counterbalance and motion.

This method can be tremendously powerful in that you can define footstep trails that curve, climb stairs, and avoid other obstacles before you ever place the character in a scene. Once all the targets are placed, the character will fall right into line walking where it ought to.

FIGURE *Hidden footprints.*
12.30

Exercises

1. Animate the wooden man in three distinct walking styles. Whether you use FK or IK is unimportant, but pay special attention to where the feet land and how the weight plays out.
2. Using the hopping-over-the-pencil scene in the last chapter, have our wooden man skip up to the pencil, hop over it, see something, and then run off. Do this animating out of the scene we created in earlier chapters so you do not have to worry about slow redraws or renders.
3. Try experimenting with various ways of establishing character walks. Have the dummy sneak out of the scene, and then skip. Try a dead run.

13 Animation Compositions and Editing

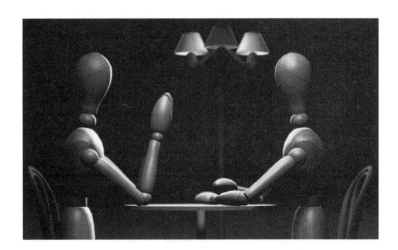

Shot Strength

After the scene has been modeled, textured, lit, and animated, it comes time to decide how to show the scene to its best advantage. Many a still rendering and great animation has been ruined or weakened by poor choice in camera placement, cropping, or angle. It is for this reason that it makes sense to take time to look at the techniques commonly used in TV and film.

Shot Size

A basic tenant of design is that of composition. The careful placement of key elements that assist in communication and aesthetic beauty is a well-documented and studied field in the world of painting, photography, and layout (among others), as well as areas of film and traditional animation. It is important that we as animators consider its power.

The first important issue of composition is shot size. Sometimes called "Figure size," shot size refers to the size of the objects within the picture frame. Different shot sizes portray different degrees of scope and scale. In general, we see three main types of shot sizes in today's moving media: the long shot (LS), medium shot (MS or MD), and the close-up (CU). Figure 13.1 shows a breakdown of this shot size standard.

Extreme Close-Up

Close-Up (CU)

Wide Close-Up

Medium Shot (MS)

Medium Shot (MS)

Long Shot (LS)

FIGURE *Shot size breakdown.*
13.1

Different shots are used for distinctly different purposes. Each purpose has a different communicative goal for the audience. Joseph V. Mascelli's influential book, *The Five C's of Cinematography*, lays out some of the important uses and purposes for each of these shots:

Long shot. There are two kinds of long shots. One is an *extreme long shot* used to depict very expansive areas usually at a great distance. Most early westerns start out with this broad shot of the endless plains with the little wagon train crawling across it. This sort of shot instantly orients the audience to the vastness of this sort of scene and grabs their attention. If a long shot is in your narrative goal, keep in mind that they typically work best when done from a high vantage point (Figure 13.2).

The second type of long shot, the *standard long shot*, is used to give the audience an understanding of the area in which the upcoming action is to take place. Long shots give information as to if the action is going to happen in a store, a factory, a house, which room in the house, etc. Long shots give

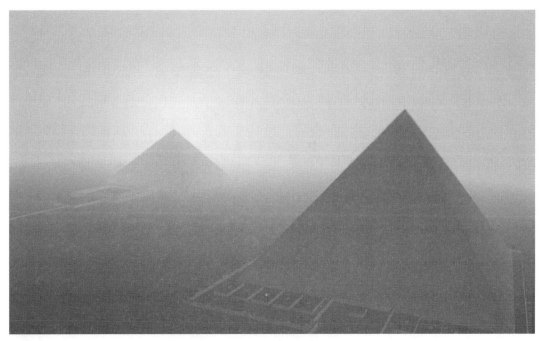

FIGURE *High camera angles assist extra long shots in establishing scope.*
13.2

us a quick understanding of who is in a situation—how many characters are there? Are they close together?

Typically, a sequence of scenes begins or ends with a long shot. Long shots act as the exposition of the visual storytelling. It sets the stage for actions to come.

Medium shot. This shot is essentially a transitionary shot between a long shot and a close-up. However, do not underestimate its importance. Medium shots give the viewer the vital pieces of information of how characters are grouped, what gestures they are using, and for whom those gestures are intended. Medium shots often capture facial expressions and movements of characters within the scene. In fact, medium shots are often used as a way to keep the audience oriented if a character moves from one part of the environment to the other.

The most common form of the medium shot is the *two-shot*. The two-shot is the basic scene in which two characters are facing each other while exchanging communication, usually in the form of dialog. Figure 13.3 shows an example of this popular shot.

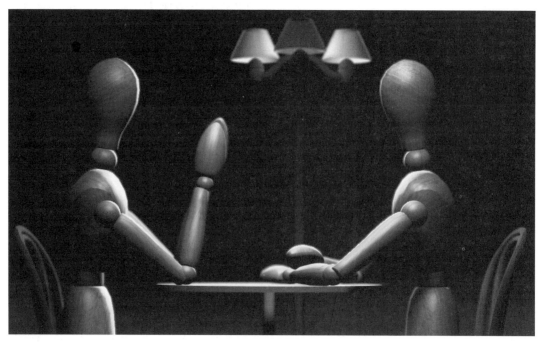

FIGURE *The "classic" two-shot.*
13.3

Close-up. This intimate shot has been standardized by television. It is so standard, in fact, that we as an audience expect to be close enough to see the intricacies of the scar on the villain's twitching face or the lack of blemishes on the placid skin of the heroine. The most important part of the close-up is the intimacy it gives us with a character's eyes.

In his book, *Film Directing Shot by Shot*, Steven D. Katz says, "Not only can the close-up reveal the intimate, it can make us feel as if we are intruding on moments of privacy or sharing a moment of vulnerability—as if the person on the screen has opened himself to us. We can be made to feel detachment or an emotional involvement with events and subjects on the screen largely through the manipulation of space with the lens of the camera."

Shot Combination

Although all of the shots listed in the preceding section have tremendous power in their own right, none can stand alone. Nearly every TV show or movie that we see is a wide variety of camera shots that first establish locale, then establish physical relationships of characters, and then pull the audience in with close-up shots of the characters. We may not have noticed it consciously, but shots rarely last more than a few seconds.

We forget in 3D animation the power of shifting shots. Figures 13.4 through 13.6 place a couple of Amazing Wooden Men in a scene that can be broken down with a sequence of shots to better understand the visual narrative. A combination of shots is usually more effective than one long shot that tries to accomplish everything. A good formula for shot combination is as follows:

1. Begin with an expositionary long shot that orients the audience to where the action is taking place (Figure 13.4). This shot may be a slight pan or zoom shot.
2. Cut to a medium shot that allows the audience to understand where your characters are in relation to each other (Figure 13.5). Are there any characters that are close enough to hit or hug another character? Do any seem to be clinging to other characters, or are some avoiding some characters?
3. Move to a close-up that allows us insight into how the characters feel about the present situation. Are they playing emotional games? These sorts of shots can give us information about a character and his state

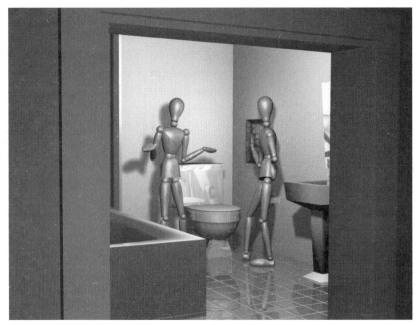

FIGURE *Long shot to establish locale.*
13.4

FIGURE *Medium shot establishing characters' relationships.*
13.5

of mind that may not be available to other characters in the scene (Figure 13.6).

FIGURE *Close-ups showing character's feelings.*
13.6

Once close-up shots have been established and we know where everyone is in relation to one another (from the long and medium shots), most of the rest of the scene is a series of close-ups. Occasionally, when the entrance or exit of another character is relevant, a long shot to show it may be appropriate.

The important thing to remember about formulas in 3D is that they should never be viewed as absolute. The whole point of new media is the ability to push things in new directions; however, we should not make such large jumps that our audience is confused and unable to understand the visual narrative of our animations.

NLDV (Non-Linear Digital Video)

After completing all the modeling, texturing, lighting, rendering, and rerendering, it finally becomes time to put it all together. The editing process is one of the most important parts of a project, yet it often receives the least amount of time. For some reason, as the animation process moves along, we get so wrapped up in the intricacies of motion or the technical concerns of good lighting that we leave little or no time to put all these works of art together. Do not cut yourself short when it comes to editing. Good editing can make a bad project look good through clever cutting and good sound, and make good projects better by assisting in the story flow.

Editing in 3D is usually done in software that allows for placing clips (both movies and sound) together to produce one cohesive story. Adobe's Premiere, Apple's Final Cut Pro, iMovie, or QuickTime Pro are all good consumer-level editing packages that are fairly easy to work with and have an easy learning curve. The process in all packages is similar: Collect your movie and sound clips into "bins" and then place them within a timeline. Many of these editing applications will allow for a variety of transitions between clips. Beware, though: Use transitions sparingly. Audiences today are not used to a lot of different transitions, and they come across as simply tacky. Unless you have a very strong reason to do otherwise, keep transitions to "quick-cuts" (cutting directly from one clip to the next) and "cross-dissolves."

Take one segment of any television show—say, between commercial breaks—and count how many cuts the editor has placed. Often, there are more than 70 such cuts in one short segment from different camera angles. We as an audience are used to seeing the same scene from different angles. It keeps us interested as the visual elements shift and keeps us oriented as we aren't limited to just one point of view. With this established convention of lots of quick-cuts, keep your own cuts short and the narrative moving.

Beware of "seasick scenes." The power of a virtual camera often seduces animators to have the camera moving in so many ways and flying throughout the scene with such abandon that the audience loses track of both what is going on and their lunch. Unless the clip is a point-of-view shot for a fly, keep narrative shots as still as possible.

A good storyboard is of paramount importance when it is time to edit. If the storyboard was carefully conceived and followed through your workflow, it can provide a road map of what to put where and in what order to place clips. If your storyboard held up as you showed it to friends, family, and colleagues, do not deviate from it as you begin to edit. If you begin to redesign on the fly, you will often end up with sloppy storytelling that loses the tightness established through the storyboard.

As you work with your project and grow to love the characters you are bringing to life, the finished animated clips become like children. You are proud of them and would like the world to see them. However, just like the plethora of pictures that pour forth from the lady on the bus, usually fewer is better. Realize that your first edit of a project is always too long. Show it to your friends and family, and watch for when they begin to lose interest. Ask them to tell you when they are bored. If they get bored through a section of your animation, chances are the clips are too long or your

audience knows too much of the story too soon. I have seen many a student animation have a first edit of 8–10 minutes and end up being 45 seconds after all the extraneous scenes and footage is cut out. Much of this pain can be avoided by having a tighter storyboard, but some simply cannot. Be willing to part with dearly beloved chunks of animation.

One last note about editing: Consumer-level packages almost all require a bit of rendering time to process the transitions and compress the animation files into a finished format that will play smoothly (compression). Be prepared to have some downtime as your computer renders your edits together and compresses them. He who waits to edit until the last minute is a late animator. Be careful with the types of compressions you use with your final renders. Keep in mind that a DV-NTSC compressed file is great when outputting to S-VHS, but the 45-gigabyte file is probably less than effective for Web distribution. Likewise, an mpeg movie transfers great over the Web, but looks terrible when output to tape. Optimize your rendering sizes. If your project was meant for tape, make sure you have been rendering your animations at 640 × 480. If it is meant for the Web, keep it at 320 × 240 or below. If working for video, render your source clips in your 3D application and your final movie in your editing program at 30fps. Web projects should be closer to 12 or 15fps.

Exercises

1. Watch a half-hour television show or a movie on television from commercial to commercial. Keep track of how many shots take place, and how many are long shots, medium shots, or close-ups. Record the order in which these shots are presented to see the pattern.

2. Create an animatic. Animatics are essentially moving storyboards that include sounds and transitions. Simply scan your storyboard one frame at a time. Then if the camera pans, use the Pan tools in Adobe Premiere (or whatever NLDV tool you are using) to pan the image. Try adding the sound that would be present in the project. See how the animatic assists in revealing holes in plot and problems in timing.

CHAPTER 14

Special Effects

A n exciting and rapidly growing area of 3D animation is not in storytelling at all. Special effects, whether it is blowing up a ship, melting a building, or killing a person, are hot and becoming incredibly possible in a digital 3D environment. Having some experience in special effects is a good idea for any demo reel. However, as the entertainment industry pushes the 3D industry, and vice versa, the paradigm and techniques are forever changing. Do not spend too much time on any one technique; it may be antiquated before you even finish your project.

Students ask all the time for general rules for doing special effects. The general rule is that there are no rules. Digital effects are so often mixed with real-time effects or cinematography that it becomes nearly impossible to tell which is which, and which is happening when. The general consensus seems to be: Use whatever tool works best for the specific chunk of the effect at hand.

If you are really interested in special effects, spend some time working with real film or digital video equipment. It is difficult to digitally recreate live scenarios for a special effect to take place in, so it becomes easier and more effective to digitally place computer-generated effects into real footage. Being familiar with film terminology and techniques becomes very important when dealing with special effects.

General Special Effects Types

In the realm of animation mortals, three general categories of special effects can be realistically produced:

1. **Purely digital.** Those special effects where all the characters and surroundings are all only extant within the digital world (Figure 14.1).
2. **Live characters—digital surroundings.** Virtual sets are becoming one of the hottest areas of 3D in general. Placing actors in front of a blue or green screen and then filling in the background digitally allows for quick and wide variation for a fraction of the price of building the sets with traditional nail and hammer. Scale of surroundings and the actual material are limited only by the imagination when the set is virtual (Figure 14.2).
3. **Digital characters—real surroundings.** As character animators have become better at their digital craft, and as the digital hardware has begun to catch up with the craft of character animators, the reality of purely computer-generated characters that interact with live actors has begun to be realized. Digital characters can fall off the edge of the

FIGURE *Purely digital special effects from Dave Tracey's* Frontier.
14.1

FIGURE *Live characters with digital surroundings in Dave Tracey's* Frontier.
14.2

Grand Canyon, be smashed by an oncoming truck, or fly. The insurance is quite a bit cheaper, and the makeup crew can take a break (Figure 14.3).

FIGURE *Digital character, live surroundings.*
14.3

Of course, there is a variety of hybrids of the scenarios just described. Often, digital characters can step in for live actors in especially dangerous or messy situations. Similarly, sometimes real characters will interact with digital characters in a real environment in one scene and a virtual one in the next. As the technology increases and catches up with the special effects visionaries, the boundaries between real and virtual are sure to be bent and blurred further still.

There is tremendous art in the areas of filming live actors for use with digital characters or for placement in virtual sets. The lighting alone could take volumes of text. Because it is such an in-depth subject, it is well beyond the scope of this book. However, the digital end of creating clips of animation that are usable in your own special effects is something worth mentioning.

Compositing

Compositing refers to the process of combining two different clips together. Almost all special effects are heavily reliant on good compositing skills. Traditionally, it has been used to describe mixing digital and real footage together. There is a wide variety of composting software that allows you to chroma key live action or place alpha-channeled digital files in live footage.

Chroma key is the technology whereby a live actor is filmed in front of a blue or green screen, and then the blue or green screen is dropped out to be replaced by whatever backdrop the compositor wishes. There are quite a few blue and green screens on the market, but you can build your own low-budget version by hanging a blue or green sheet and filming in front of that. Another inexpensive solution is to purchase linoleum that can be hung from a ceiling, dropped to the floor, and extended out along the floor. This provides a smooth transition from back wall to floor that, after being painted with a chroma key blue or green, works well as a small blue screen. Remember to keep the blue screen on the floor clean, as any dusty footprints make for very difficult chroma keying.

Another form of compositing is to place digital characters into real footage. To do this, animation clips must be rendered with an *alpha channel*. Alpha channels are black-and-white channels that define which parts of an image are to be seen and which are to be dropped out. Alpha channels can be embedded within the clip or rendered as a separate clip. The key is to make sure your 3D application knows you wish to create an alpha channel, as trying to knock out a black background from a clip without an alpha channel is next to impossible.

Software

There are as many compositing software packages as there are 3D packages. The selection is quite varied and increases yearly. Adobe's AfterEffects is probably the most popular consumer-level compositing package. However, Adobe's Premiere and Apple's Final Cut Pro are also good choices for compositing.

Owning one of these software packages is a good idea, even if you do not plan to use real footage with digital files. Compositing can also be used to composite several digital files together. Different 3D packages do different functions better than others. Often times, the best 3D projects are created in a variety of packages, and then the results are composited together into one animation.

General Rules to Consider

The available special effects vary widely from one 3D application to the next. Further, third-party plug-ins can increase the flexibility and capability of any given software. The variety is so great that it would be futile to attempt to classify them. However, there are a few effects that come standard in most 3D packages that you can use to create fairly nice special effects for your demo reel.

> **Explode/Shatter.** This is essentially an animation function that takes the polygons of a shape, splits them apart into their own constituent shapes, and then flings them about (explode) or collapses them (shatter). The specifics vary from program to program, but keep in mind that low poly-count objects may render quickly and explode quickly, but the resultant explosion often looks like just a bunch of triangles floating around (Figure 14.4). Higher poly-counts mean heavier models and longer rendering times, but they produce finer chunks of polygons and thus more effective explosions (Figure 14.5).
>
> Even with a high poly-count, it is often easy to see the telltale square or triangular segments of the source shape. To hide this, try adding a texture that glows to the object as it explodes (Figure 14.6). The resultant glow of the shards can hide the shape of the shards as can be seen from Anson Call's excellent space explosion (Figure 14.7).

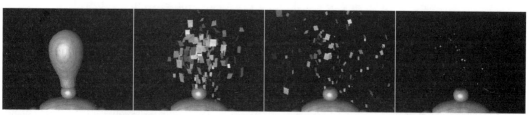

FIGURE **14.4** *Low poly-count explosion.*

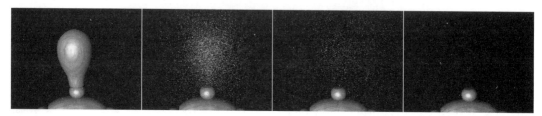

FIGURE **14.5** *High poly-count explosion.*

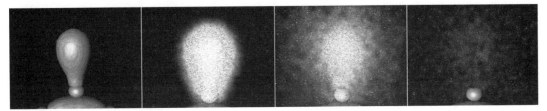

FIGURE *High poly-count explosion with glow.*
14.6

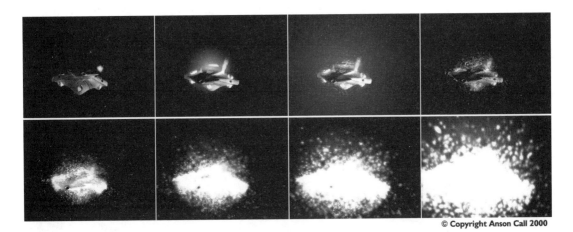

© Copyright Anson Call 2000

FIGURE *Anson Call's space explosion.*
14.7

Morph. Morphing is the smooth transition between shapes. There are many different reincarnations of this effect, from shatter morphs to endomorphs (used heavily in facial animation). In special effects, this usually refers to the unworldly changing of recognized shapes to unforeseen forms. Figure 14.8 shows the head of our wooden man being morphed into other shapes, and the shapes in between.

Not all applications have this restriction, but many 3D applications morph best between NURBS, and more specifically, morph most effectively between shapes with the same number of control points or rendered poly-

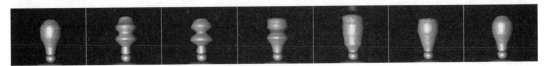

FIGURE *Morphing head.*
14.8

gons. If possible, create all morph targets by altering copies of the original shape.

Particle Emitters/Fountains. Particle emitters are construction shapes that spew forth objects according to the settings you define. Often, particle emitters allow for variety of speeds and sizes of the particles emitted. Some programs (like Cinema4D) allow you to place any shape you wish as the particle to be emitted (Figure 14.9). One obvious use of particle emitters is water fountains (Figure 14.10); however, they can also work very well for the creation of a variety of special effects, from smoke to the spurting of blood.

FIGURE *Particle emitter with custom shape.*
14.9

FIGURE *Alec Syme's use of particles for bubbles.*
14.10

FIGURE *Jeff Carn's illustrative use of particle emitters.*
14.11

There is tremendous power and flexibility in particle emitters. Remember to place appropriate textures on the particles you are emitting, and if possible, animate the particle before placing it in the emitter so it has life of its own besides the travel caused by the emitter.

Many people wait until a plug-in becomes available before they create special effects. Keep in mind that the most memorable special effects are those that have not been seen before. Often times, these hitherto unseen effects are just new ways of using old tools. Be flexible, and think of ways to bend the rules of the tools to create effects that move beyond passé to works of art.

Exercises

1. Just for exercise sake, find some excuse to blow up a piece of your wooden man set. Perhaps the light bulb bursts, or maybe the wooden man trips on the light cord and his foot fries. For a short skit, animate the dynamic effect and the wooden man's reaction.

2. If you have a video camera, a means of digitizing your footage, and a blue sheet, videotape yourself walking. Then, using AfterEffects' Chroma Key technology, drop the background out and add yourself to the wooden man scene.

3. Animate the wooden man in a scene with no props. Animate him moving, or shaking hands. Render the motion with an alpha channel and place the clip over real footage of you or a friend. Perhaps you need a chance to duke it out with the little wooden fella.

15 Getting the Job

No matter which level or target level of 3D you are at or are aiming for, there are some definite considerations when preparing yourself for work and portraying yourself as a viable resource. In the early days of 3D, rumors emerged that anyone with any animation experience could snag a well-paying job, even if they did not have a large degree of computer experience. The rumors of big numbers for little experience (which were probably half true to begin with) got out, and the frenzy of something for nothing began. Now, with the veritable flood of raw resources (wanna-be animators), animation houses, special effects companies, or pre-visualization companies can afford to be careful about who they hire and even who they interview. Without a solid research, self-promotional packaging, and demo reel, you better not quit your day job.

3D Job Types

Few places cover the entire gamut of 3D possibilities—the hardware and learning requirements are just too high. Most animation houses have specialties and target clients. Because of this, they often have target potential employees. Part of the challenge of preparing to put yourself on the 3D market is realizing who you are and what kind of 3D you do. Although difficult to solidly classify, some fairly broad arenas of 3D are emerging. Be sure to create a demo reel that targets the area in which you are most interested.

Character Animation (CA). This is the big one that everyone is talking about. The issue of when we will have completely computer-generated characters was answered long ago through the work of Pixar and others. The realization of photorealistic characters in a full-length film is more a question of "when" than "if." However, although this is a popular form of 3D right now, it is also very difficult. We have touched on some basic CA techniques in this book, but those techniques are literally a snowflake on the tip of the CA iceberg.

CA breaks down into either much-exaggerated movement that works for cartoonish characters, or extremely realistic movement in the pursuit of photorealistic excellence. Without some serious study, CA may be an unrealistic goal of animation. However, with good study (perhaps including formal training through animation schools), CA can be very fulfilling.

If you are interested in a CA job, make sure you have lots and lots of characters moving, fighting, jumping, running, falling, and every

other ing verb you can think of. Be sure you know whether your potential employer wants to see rotoscoped or motion-captured animation. Some CA jobs will be very interested in mo-cap produced animation, while others will be completely turned off.

Special Effects. Because of its high profile and glitter factor, this is a very seductive realm of 3D. Everyone wants to see his or her name at the end of a movie. Remember that all special effects does not mean blowing stuff up, though. Employers are interested in seeing intelligent movement, camera work, model construction, and texture creation. If this is your goal, be sure to have a firm grasp on fog, smokes, pyrotechnics, and compositing techniques.

Be prepared with examples of compositing prowess. Show complete digital scenes and hybrid scenes. Have interesting explosions, but have down-to-earth subtler effects as well. After all, not every special effects house does space explosions all the time.

Pre-Visualization. Most every tool, toy, or object we see manufactured today has been touched in some way by a computer. Increasingly high-tech or high-fashion objects are being created digitally before they are ever realized tactilely. From theatres to architectural firms to engineering facilities to package design houses, the power and flexibility of computer-visualized design is taking hold. The ability to switch a color on a box, or try a different wallpaper in seconds rather than hours, is making the investment in time and resources worthwhile.

If you are interested in this sort of 3D, make sure you have superb model and texture work. Visualize both designs of your own and objects around you digitally. Produce cutaway illustrations, ad mockups, and, above all, make whatever it is that you are visualizing attractive to look at. Even if the firm is designing wrenches, someone is going to buy those wrenches, and people buy what they are attracted to.

Architecture pre-visualization is a strong area of 3D. For some odd reason, clients like to see a design before they sink millions of dollars into it. For this reason, architect firms are very interested in packaging a design in an attractive manner that not only showcases a good design, but also sells the product. If you are interested in architectural pre-vis, make sure you have a good understanding of architectural detail. Know that rooms have floorboards, and know what a

dado-rail is. The ability to speak the same language as your employer is half the battle.

Know Your Audience

Once you have found the areas of 3D in which you are interested, make sure you know who else is interested in it. Watch for job listings at sites like 3Dcafe, HighEnd3D, and in magazines like *3D Magazine's* annual "Get a Job" supplement. Read the descriptions carefully. Note their likes and dislikes. Watch for software preferences. Check out target company Websites to see work they have done and where they are going.

Once you understand what your target employers are looking for, give them what they want. If you know that you want to work in architectural pre-visualization, and every firm you have looked at uses Viz and AutoCAD, do not spend the next year becoming incredibly proficient at LightWave.

Developing your craft as a 3D artist is a never-ending process. Although the speed at which 3D technology is changing may eventually slow, it certainly is not showing signs of it now. The modeling techniques of today are the antiquated clichés of tomorrow. Seeing what is down the pipeline, and watching for emerging trends and riding those trends helps keep you employable and the 3D romance alive. Change is a big part of 3D—be ready for it.

However, after having said that, make sure that you are not just a 3D technician. Incredible proficiency at a software package, but poor vision and design, does not bode well for a demo reel.

Things to Do

Do target your demo reel. If you want to animate characters, create a demo reel strong in lots of moving characters. A house looking for character animators probably does not care if you have a perfect grasp of different refractive qualities of different sorts of glass—so do not include a lot of glass renders. If you want to be a compositor artist, have lots of compositing examples. Animation houses are deadline oriented, and as such, do not have a lot of time to waste on chunks of demo reel that have nothing to do with the job at hand.

In addition, some animation houses have very specific requirements for reels. Some want to see completed stories, some want to see snips of lots of different projects, and some want to see a project from wireframe renders to final raytraced versions. Some want reels

less than one minute, while others want to see more. Find out what your target wants and make it right.

Do develop your own style. Artistic vision is often lost as beginning 3D artists struggle with grasping the technical demands of the software. Break through the level of work listed in software or book tutorials. Without your own style of modeling, texturing, animation, or design, your demo reel will feel like the other 50 reels the employer received that day.

Do learn from those who came before. If you are character animating, study the work of cel animators diligently. Watch every piece of hand-drawn character work you can. Reap the effective techniques as you find them, and make a note of ineffective efforts so you can avoid them. If you want to create video games, know the history of the industry. Who is who? What is hot? What sells?

Do get feedback as you go along. 3D is a collaborative art. Gone are the days of a 3D artist sitting in a studio for days at a time, only to emerge with a glowing masterpiece. Most large animations of today are completed by large teams of animators. Being familiar with the jargon and getting the perspective of others as you prepare your demo reel gives you practice in being a team player and can only make your work better. There are many feedback forums, 3D newsgroups, and 3D galleries where you can post or show your work. Listen to the feedback and take it all into consideration, even if you eventually discard much of it. The key is, new perspectives from new eyes can provide new insights to give your work that extra edge.

Do package yourself. Like it or not, you as an animator are a product. You are presenting yourself to employers who you are asking to lay down a lot of money. When your reel is clearly marked with your name and a memorable image or logo, and the theme is carried through to your resume and cover letter, it will make an impact. Make sure it's not all smoke and mirrors, though. Too much slickness and it may be interpreted as covering up lack of real content. However, everyone likes a little class.

Demo Don'ts

Do not use abnormal camera movements. The flexibility of virtual cameras is often abused, and projects end up being a wild ride that leaves the viewer sick and confused. Animation houses are usually creating content for the entertainment industry—which means your

parents. If the motion is wild and not in line with the cinematic conventions of today, viewers (including potential employers) will distance themselves from the visuals and thus from you.

Do not use stock textures or models. Animation employers see many demo reels. Yours is not the first and will not be the last. If all your textures are the same as the reel before, it shows that a) you cannot do your own textures, or b) you are too lazy to create your own content. You never want your reel to be remembered because it looked just like the one before it.

Do not present yourself as something you are not. If you really do not know character animation, do not throw together a shoddy project just so you can have it in your reel. If you do not know anything about architecture, do not include a sloppy visualized building. Those reviewing the reels know what they are looking for. Poorly done projects included in a reel can do as much damage as beautifully done ones. If it is not strong, leave it out. Produce a reel that is one strong project after another.

Do not use lens flares, lighting bolts, and explosions unless applying for special effects jobs. Well, okay, maybe once in a while might be alright, but most special effects in 3D are viewed as gratuitous by employers because they know how easy it is to use the plug-in you used to create it.

Do not include space battles or flying logos. Some animation houses will specifically mention that they do not want to see these. One of the first things every animator does is the obligatory space battle—almost every animator has one and they are fairly easy to do. The problem is, space battles are well defined in the entertainment industry. Some incredibly strong masterpieces are clear in everyone's mind. If you cannot compete with the exploding Deathstar, stay clear of the genre.

On the other hand, if you are applying to do commercials for the local television station, make sure to have plenty of flying logos so they know that they can count on you to do them. Or, if you are applying to a house deep in the process of creating a TV series based in space, a space battle or two may be appropriate.

Conclusion

Basically, the more you know about your potential employer, the better off you are. Know your audience, and then spend some good time creating good content to impress that audience. You do not need to have the greatest and latest in hardware or software to create a good demo reel. However, you do need to have a good understanding of 3D that can be seen in your work. Create, create, create. Do not get bogged down in the technicalities of always knowing the newest gizmo and plug-in. Remember, an employer can always give you a couple of days of cross-over training to learn their proprietary software package, but if you cannot animate, you are of no use to them—no matter how well you know Maya's soft bodies interface.

Above all, make sure you are having fun through the process. If you are having fun creating, your work shows it. If you are not having fun creating 3D, do not do it. Keep yourself happy and interested by continually thinking of and realizing dynamic and unique projects. That way, the process of learning and creating a demo reel remains enjoyable, your work looks good, and you remain sane—or reasonably so anyway.

About the CD-ROM

The CD-ROM that accompanies *3D Animation: From Models to Movies* includes all the images from the book in full color. Some of these pictures are the work of talented artists from around the world that need to be viewed in color for full enjoyment. Others are illustrations of the concepts discussed, and still others are to be used for following tutorials or comparing your results against those intended in those tutorials.

Also included on the CD-ROM is a small gallery of some very impressive work submitted by very talented artists that did not find their way onto the pages of the book. However, even though not printed in the book, there is no lack of beautiful or useful content. Because of this they are contained here for your enjoyment and learning experience.

This CD includes two software applications for you to use while following the tutorials in the book and to get your feet wet in 3D. The first is a demo version of Cinema 4D XL v6 that allows you to model, texture, animate, and render. However, you will not be able to save your projects with this demo package. Contact *www.maxon.net* to get student or full prices if you are interested in purchasing this powerful package. For more information see the "Read Me" contained in the Cinema 4D folder.

The second application is a full version of Strata 3D, a fully functioning package that although missing some functions available through its big brother Strata 3D Pro, still allows you to get going in 3D. Strata 3D is a web enabled software application and will attempt to access the web when you launch the package. This will give you access to some of the products and projects Strata is working on. See *www.3d.com* for more information on Strata products and manuals.

System Requirements:

FOR CINEMA 4D XL v6 DEMO

Windows 95/98/NT/2000

Pentium Processor+
CD/HardDrive
64 mb RAM
20 mb free disk space

Mac OS 7.61+

PowerPC+
CD/HardDrive
64 mb RAM
20 mb Free HardDrive Space

FOR STRATA 3D

Windows NT 4.0 (with Service Pack 3) or Windows 98/2000

Pentium Processor+
64mb RAM
CD/HardDrive
64mb free disk space
Quicktime 3.0 or later

Mac OS 8.5+

Power PC
CD/HardDrive
64 mb RAM (above system requirements)
64 mb free disk space
Open GL 1.1.2 or later
Open Transport

Index